The

ULTIMATE AIRBRUSH HANDBOOK

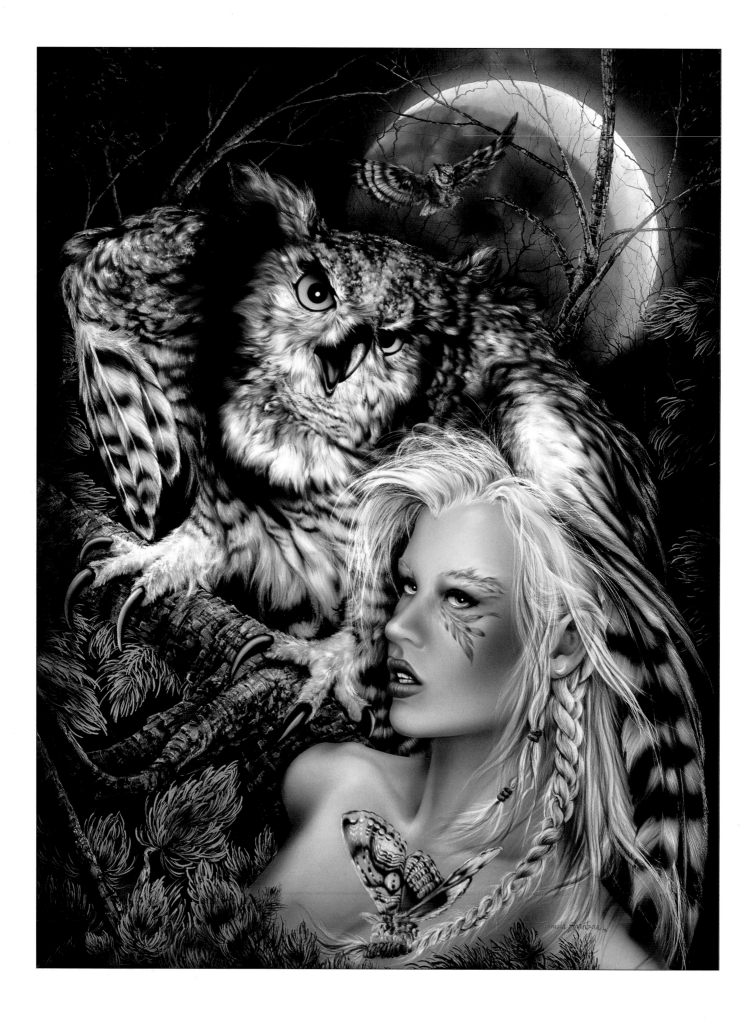

The ULTIMATE AIRBRUSH HANDBOOK

Pamela Shanteau

WITH *Donn Shanteau*

WATSON-GUPTILL PUBLICATIONS / NEW YORK

Senior editor: Joy Aquilino
Production manager: Ellen Greene
Designer: Leah Lococo and Jennifer Moore

First published in 2002 by Watson-Guptill Publications,
a division of VNU Business Media, Inc.
770 Broadway, New York, N.Y. 10003
www.watsonguptill.com

Library of Congress Cataloging-in-Publication Data

Shanteau, Pamela.
 The ultimate airbrush handbook / Pamela Shanteau.
 p. cm.
Includes index.
 ISBN 0-8230-5574-4 (pbk.)
 1. Airbrush art. I. Title.
 NC915.A35 S5 2002
 751.4'94—dc21

 2001005607

Printed in Malaysia.
First printing, 2002
3 4 5 6 7 8 9 / 10 09 08 07 06 05 04

PHOTO CREDITS Unless otherwise credited, all photographs in this book were taken by Donn Shanteau. For
the chapter-opening photographs, the title and artist are also listed. Page numbers on which the photos
appear are in **boldface type**.

2, "Dark Side of Violet Moon," Pamela Shanteau, photo by Donn Shanteau. **10,** "Noise from a Parallel Universe,"
Kirk Lybecker. **14,** "Zebra Profile," Richard Sturdevant. **58,** "A Circumstance As Yet Unforeseen," Kirk Lybecker
(courtesy Gail Severn Gallery). **64,** Dolphin on Leather Jacket, Mark Rush. **67 to 69,** Mark Rush. **70,** "Granite Bay
Fruit Basket," Sheri Hoeger. **73,** top, Sheri Hoeger; bottom, Hugh Hoeger. **74,** Ferrari Color. **75,** top, Dave Adams
Photography; bottom, Ferrari Color. **77,** 1 to 5, Sheri Hoeger; 6, Dave Adams Photography. **79,** top, Sheri Hoeger;
bottom, Dave Adams photography. **80,** Dave Adams Photography. **83,** Sheri Hoeger. **85,** 7 to 13, Sheri Hoeger; 14,
Dave Adams Photography. **100 to 103,** Lybecker Studios. **104,** Buck Roger's Starfighter, Thomas A. Grossman,
HummingLine Creative Works. **110 to 113,** Thomas A. Grossman, HummingLine Creative Works. **116 to 121,** A. D.
Cook. **122,** "Another Day at the Hotel Rorschach," Harry Rockwell. **123,** "Looking Through the Glass," Kirk Lybecker
(private collection, Michael Early); "North Light," Kirk Lybecker. **124,** "An Empire for the Forsaken," Harry Rockwell
(private collection, David Gustafson); "Whispering to an Indifferent Moon," Kirk Lybecker. **125,** "A Gathering
Storm of Unusual Shape," Kirk Lybecker (courtesy Gail Severn Gallery); "A Touch of Effortless Grace," photo,
Harry Rockwell (courtesy Gail Severn Gallery). **127 to 129,** Andrea Mistretta Illustration Studio. **134 to 141,** Richard
Sturdevant. **142 to 143,** Robert Anderson.

This book is dedicated to five people who have shaped my career and my life:

SISTER GENEVRA, art teacher and mentor, who sparked and fed the early flames of creativity.

CARRIE PATTERSON, my great-grandmother, a wise woman whose spirit is always with me.

ROGER AND ARLENE BOWERS, my father and mother, who made sure I had the education and tenacity to realize my potential.

DONN SHANTEAU, my husband and soul mate, whose strength and support helped turn my dreams into reality

PREFACE 9

NUTS & BOLTS 11 *Chapter 1*

Basic System Components 12
Air Sources 13
 Canned Propellants 13
 Electric Air Compressors 13
 Compressed CO2 Tanks 15
 Air Lines 15
Airbrush Options 16
 External versus Internal Mix 16
 Single versus Dual Action 17
 Feed Styles 18
 Airbrush Holders 19
Airguns 20

Choosing Your Airbrush System 22
Setting Up to Paint 23
 Taking It on the Road 23
 Small Studios 23
 Medium-Size Studios 24
 Large Shops 24
Essential Supplies 26
 Paints 26
 Surfaces 29
 Art Supplies 30
 Masking Supplies 31

OPERATING YOUR AIRBRUSH 35 *Chapter 2*

The Basics 36
 Getting Ready: Setting Up Your System 36
 Spray Patterns and Overspray 37
Single-Action Airbrush Exercises 38
 Dots 39
 Lines 39
 Gradations 40
Dual-Action Airbrush Operation 41
 Dots 41
 Lines 42
 Dagger Strokes 42
 Gradations 43

Working with Masks 45
 The Jigsaw Puzzle Approach 45
 DEMONSTRATION: *SUN AND RAYS* 45
 DEMONSTRATION: *DESERT LANDSCAPE:*
 PAMELA SHANTEAU 46
Working with Blended Color 50
 DEMONSTRATION: *APPLE:*
 PAMELA SHANTEAU 50
Cleaning Your Airbrush 54
 Reassembling the Airbrush 55
Using an Airgun 56
 Cleaning Your Airgun 56
Troubleshooting 57

DEVELOPING IMAGES 59 *Chapter 3*

Reference Materials 60
 Taking Photographs 61

Transferring Images 63
 DEMONSTRATION: *TRANSFER BY*
 GRAPHING: PAMELA SHANTEAU 63

TEXTILES 65 *Chapter 4*

The Basics 66
 Textile Airbrush Paints 66
 Textile Airbrush Mediums 67
 Finishes 67

Airbrushing Textiles and Leather 68
 DEMONSTRATION: *CANVAS TOTE*
 BAG: BEACH SCENE AT SUNSET:
 MARK RUSH 68

MURALS & SIGNS 71 *Chapter 5*

Airbrushing Interiors 72
 Surface Preparation 72
 Essential Equipment 72
 Working with Stencils 74
 DEMONSTRATION: *SHEAF OF CORN:*
 SHERI HOEGER 76
 Color 78

Composition 80
Creating Shadows 81
Masking Your Work Area 81
 DEMONSTRATION: A TROMPE L'OEIL
 GERANIUM: SHERI HOEGER 81
Special Effects for Signs &
 Other Uses 86

Chapter 6 | **BODY & FINGERNAIL ART** | 91

Body Art | 92
 Temporary Tattoos | 92
 Essential Supplies | 92
 Stencil-Style Tattoos | 93
 DEMONSTRATION: *BUTTERFLY STENCIL*:
 PAMELA SHANTEAU | 94
 Transfer-Style Tattoos | 95
 DEMONSTRATION: *TRIBAL DESIGN*
 TRANSFER TATTOO: PAMELA SHANTEAU | 95
 Freehand Body Art | 96

DEMONSTRATION: *TIGER GIRL*:
 PAMELA SHANTEAU | 96
Nail Art | 97
 Choosing the Right Equipment | 97
 Mediums and Supplies | 97
 Airbrushing Nails | 99
 DEMONSTRATION: *SUNSET*:
 LAURA MORGAN-GLASS | 99
Professional Tips from
Laura Morgan-Glass | 102

Chapter 7 | **SCALE MODELS & CRAFTS** | 105

Scale Models | 106
 Essential Supplies | 106
 Airbrush Effects for Scale Models | 110
 DEMONSTRATION: *STAR BLAZERS GAMALON*
 BATTLE CARRIER (BANDAI): TOM GROSSMAN | 112

DEMONSTRATION: *SKIN TONES: MUSETTE*:
 TOM GROSSMAN | 113
Airbrushing Woodcraft Items | 114
 DEMONSTRATION: *BIRDHOUSE BAG*
 DISPENSER: LINDY BROWN | 114

Chapter 8 | **FINE ART & ILLUSTRATION** | 117

Creating Reflective Effects | 118
 DEMONSTRATION: *"PASSING TIME"*:
 A. D. COOK | 118
Airbrushing Watercolors:
 KIRK LYBECKER | 122
Combining Flat
and Gradated Color | 126
 DEMONSTRATION: *LA VENEZIANA*:
 ANDREA MISTRETTA | 126
Airbrushing on Scratchboard | 130

DEMONSTRATION: *FAERIES WEAR*
 BOOTS: PAMELA SHANTEAU | 131
Airbrush in Mixed Media | 134
 DEMONSTRATION: *OIL AND WATER*
 DO MIX: RICHARD STURDEVANT | 134
 DEMONSTRATION: *MIXED-MEDIA*
 MASCOT: RICHARD STURDEVANT | 136
 Portrait Studies | 141
Of Cows and Cowboys:
 ROBERT ANDERSON | 142

Chapter 9 | **AUTOMOTIVE AIRBRUSHING** | 145

Surface Preparation | 146
Automotive Painting
& Masking Techniques | 147
 Paints | 147
 Masking Materials and Techniques | 148

DEMONSTRATION: *INDIAN PRINCESS*
 MOTORCYCLE MURAL:
 PAMELA SHANTEAU | 149
DEMONSTRATION: *57 CHEVY MINI*
 FUNNY CAR: PAMELA SHANTEAU | 152

SOURCE DIRECTORY | 156
INDEX | 159

Preface

The airbrush is a tool with practically unlimited uses, one appreciated by artists, crafters, and hobbyists all over the world. Although the uninitiated are likely to view airbrushing as a skill requiring extensive technical knowledge, in fact painting with air is a simple process. The first known example of airbrushing can be found in ancient caves in southern France, where in addition to the now-famous animal renderings, there is an outline of a hand. Someone—I like to think of that person as the original airbrush artist—placed his hand on the cave wall and blew natural pigments through a hollow bone to cover both hand and the surrounding cave wall. When the hand was removed, a unique signature remained. Today, millennia later, we have airbrushes with sophisticated controls and paint-feed and air-control systems, but the basic principle is the same: air propels pigment onto a painting surface.

Operating today's airbrushes is also relatively simple, and the same airbrush-control techniques are used for every type of airbrushing. In this book, I have tried to distill over 25 years' experience as an airbrusher, and to adapt the teaching methods I have developed during that time so that novices and more experienced airbrushers alike will be armed with the knowledge they need to use the airbrush successfully for any one of a myriad of applications.

Chapters 1, 2, and 3 cover the nuts and bolts of airbrushing: basic equipment; basic principles of operation; how to develop a stockpile of images and how to transfer those images to the painting surface. The remaining chapters are devoted to specific applications: airbrushing textiles; wall and ceiling painting for interiors; sign-painting techniques; body and nail art; fine art and illustration; and automotive airbrushing. Each of these chapters provides both general information about the field and step-by-step lessons that systemically guide the readers through fundamental and advanced airbrush techniques. All of the chapters were written with the layperson in mind, and readers don't need a master's degree in art to understand the text and examples. Novices will be able to use the early chapters to master basic airbrush skills. Once learned, the new skills can be applied to the more advanced airbrush disciplines covered in the later chapters. Experienced airbrushers will appreciate the professional tips offered by the seasoned experts who have contributed their wisdom and artwork to this book and will almost certainly become acquainted with some new techniques. The contributors—Robert Anderson, Lindy Brown, A. D. Cook, Tom Grossman, Sheri Hoeger, Kirk Lybecker, Andrea Mistretta, Laura Morgan-Glass, Mark Rush, and Richard Sturdevant—are all highly respected professionals in the airbrushing world. The opportunities to use the airbrush for fun or profit are greater today than ever before, and the wealth of knowledge offered by these experts should help anyone down the road to airbrushing success.

May you paint long and prosper.

PAMELA SHANTEAU

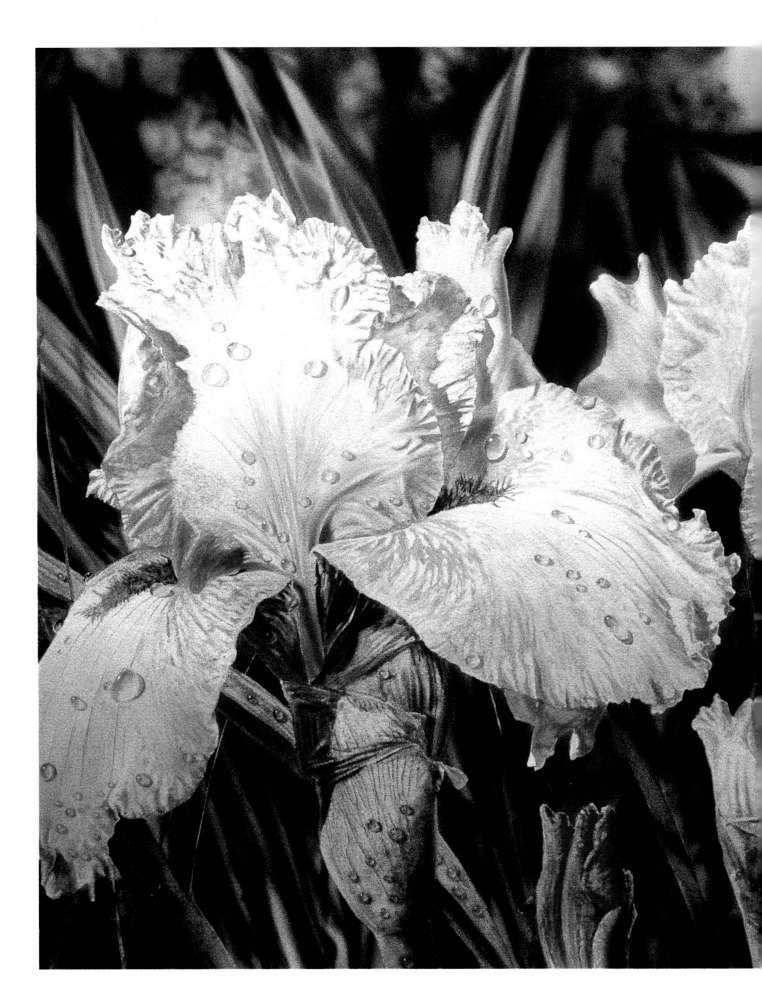

NUTS
&
BOLTS

To become proficient at airbrushing, you must first have an understanding of how an airbrushing system works and then determine what type of system will best suit your painting needs. Matching your equipment to the application at hand is crucial. You must use the right tool for the job. Airbrushes and air compressor systems are available in an enormous variety of sizes and styles. The information in this chapter will help you choose the painting system that is right for you.

Basic System Components

The basic components of all airbrush systems are a source of pressurized air, a pressure regulator, the airbrush (or airgun) itself, and a paint medium. What type of painting a given system can do depends on the interrelationships between several factors:

- **The horsepower of the compressor.** (See Box: How Airbrushes Work.)
- **The size of the storage tank.** The storage tank, the reserve for the compressed air, must be large enough to hold the compressed air until it cools, allowing the moisture contained in it to condense. Once the reserve tank is full, the electric motor shuts off and cools until it is called upon to recharge the air system. The greater the horsepower, the bigger the storage tank must be. A $1/4$-gallon storage tank is adequate for a $1/10$-hp compressor, while a 25-hp compressor may have a 125- to 150-gallon storage tank.
- **The components of the airbrush or airgun, including nozzle size and the nozzle-needle assembly.** The diameter of the opening (orifice) of the airbrush's paint nozzle determines the volume of paint that the airbrush is capable of spraying. An airbrush with an 0.5-mm opening in its paint nozzle will spray twice the amount of paint that an airbrush with a 0.25-mm nozzle can spray. The capacity of the paint nozzle–orifice assembly needs to be considered when choosing an air source. For example, airguns with 1.0- to 1.5-mm orifices (typically used to paint murals or large backgrounds) require a compressor with a much higher horsepower rating than an airbrush with an 0.18-mm orifice (commonly used for fine detailing).

Ultimately, the system you choose, and the paints and other art supplies that you find most useful, will depend on the kind of work you want to do.

HOW AIRBRUSHES WORK

Airbrushes and airguns work on a simple principle: Compressed air propels pigments in a controlled pattern. In modern internal-mix airbrushes the paint nozzle–needle assembly controls paint flow rates. The air pressure a paint is sprayed at, in pounds per square inch (psi), determines the fineness of the spray pattern. High air pressures (50 to 100 psi) will spray a much finer dot pattern (atomization) than paint sprayed at 10 to 20 psi.

The viscosity, or thickness, of the paint being used determines how high the psi rating will need to be in order to spray the paint efficiently. The viscosity of paint mediums designed specifically for airbrushes is approximately 20 to 60 times greater than the viscosity of water. A typical latex house paint is thousands of times more viscous than water. For precision spraying, an airbrush with a fine needle and paint nozzle (0.18 to 0.35), operating at 15 to 40 psi, will give good results using a low-viscosity paint. For T-shirt painting, which requires a relatively thick paint, air pressures of 60 to 100 psi are required to atomize the thick textile paints and penetrate the fabric.

The maximum air volume a given compressor is capable of producing is directly related to the compressor's horsepower rating and air storage capacity. In addition, the higher a compressor motor's horsepower rating, the higher the maximum psi the compressor is capable of producing. Horsepower ratings range from $1/10$ to 25 hp or more. For extended periods of airbrushing or for jobs requiring relatively high air pressures, a $1/2$- to 1-hp air compressor, with a storage tank capacity of at least 1.5 gallons, is adequate. For jobs that require large volumes of paint, such as painting murals or large backgrounds with a large airgun, you will need at least a 5-hp air compressor with a minimum 20-gallon tank capacity.

An air-pressure regulator designed to be attached to the air line of a compressor that is not equipped with its own regulator.

Air Sources

Airbrushes use either compressed air or compressed carbon dioxide (CO_2) as the propellant for the paint they spray. Any air compressor or CO_2 tank that is in good working condition can power an airbrush.

CANNED PROPELLANTS

Small compressed-air canisters can be used for simple projects, in cases in which no electricity is available, or by anyone who wants to try airbrushing without investing in a compressor system. These small cans are convenient, but are by far the most expensive air source over the long term, since the cans are quickly depleted and are not self-replenishing.

ELECTRIC AIR COMPRESSORS

As the name suggests, electric air compressors, whether diaphragm-type or piston-driven, require a source of electricity to run. Whatever type of electric air compressor you are using, and whether or not it has a storage tank, it should be equipped with a moisture filter, an automatic shut-off switch, and an air-pressure regulator. Oil-lubricated piston-driven electric compressors should be equipped with an oil filter.

Electric piston-style and diaphragm compressors are available at arts and crafts stores, hardware stores, appliance stores, and automotive paint stores. All electric air compressors are self-replenishing, making them the most cost-efficient air source available over the long term.

AIR-PRESSURE REGULATORS. Air-pressure regulators control the air pressure at which the paint is sprayed. They are normally installed on the compressor or in the air line leading to the airbrush or airgun; they can be adjusted to increase or decrease air pressure to suit the painting application or medium.

MOISTURE TRAPS/FILTERS. After air is drawn into a compressor, the moisture in the air condenses into water droplets as it cools.

The droplets accumulate in the air storage tank and the air line between the compressor and the airbrush. If water reaches the airbrush, it wreaks havoc with the paint chemistry, causing the airbrush to spit water droplets onto the painting surface. A moisture trap/filter is essential to capture the moisture in the air line, especially when there is no storage tank in the air system for the droplets to settle into.

OIL FILTERS. For piston-driven air compressors that are lubricated by oil, an oil filter should be installed between the compressor and the air line leading to the airbrush. All oil-lubricated compressors consume some oil with normal use. The consumed oil enters the air supply as oil vapor. It only takes a small amount of oil in paint to create problems. If

OVERHEATING: A SERIOUS PROBLEM

Overheating can seriously damage the motor of your compressor. In addition, an overheated compressor superheats the air it is compressing, so that the air cannot cool enough for the moisture in it to condense into droplets that can be trapped by the storage tank or moisture filter in the air line. The unfiltered moisture contained in the the compresed air blocks the air passageway, which causes the airbrush to spit water droplets in addition to propelling paint. This is, incidentally, a classic symptom of overheating. To prevent overheating:

- Make sure your compressor is properly matched to your airgun or airbrush; that is, it can replace air as fast as it is being sprayed.
- If possible, plug the air compressor directly into the electric outlet. If you must use an extension cord, make sure it is heavy-duty, and use the shortest length possible.
- An automatic shut-off switch is almost a necessity if you want to keep your compressor from overheating. These switches can be set to shut off a compressor when the maximum psi in the air storage tank (or air line) has been reached. The switch then turns the compressor back on when the air level reaches a preset lower limit. Note that automatic shut-off switches for hobby-grade diaphragm air compressors are usually preset at the factory and cannot be adjusted later.
- Purchase a compressor with a high-temperature-limit safety switch, which shuts an overheated motor down automatically if it has been overworked or has been operated on low voltage. Once the overheat switch engages, the electric motor cannot be restarted until it has cooled.

an oil filter does not come with the air compressor you intend to purchase, you should purchase one separately.

Diaphragm Compressors

Diaphragm compressors, which use a reciprocating diaphragm to pump air into the air system, are relatively inexpensive and can be purchased at craft and hobby stores. Diaphragm compressors are acceptable for projects that do not require large volumes of air, working air pressures over 45 psi, or extensive nonstop airbrushing. Diaphragm compressors can be purchased with or without a storage tank. Models without a storage tank draw air into the pump, compress it, and expel it directly into the air line. Since the air line holds only a small volume of air, the pulsing effect caused by the diaphragm's expansions and contractions is noticeable in the spray pattern. A pressure regulator reduces the pulsing slightly, but does not eliminate it. If there is no air storage tank, any moisture that may be in the compressed air has nowhere to go but in the air line and out of the end of the airbrush.

Diaphragm compressors generally are able to deliver a minimum of 30 psi of working air pressure up to a maximum of 45 to 50 psi depending on the make and model. Diaphragm compressors are notorious for replacing air at

a slow rate; in general, only one airbrush at a time should be used with a diaphragm compressor even if it has a storage tank. If two airbrushes are used at the same time, determine if the compressor has the capacity to replace the compressed air at the rate the airbrushes are depleting it. You are overtaxing your compressor if it runs constantly while painting because it cannot fill the tank as fast as you are depleting it. The larger the paint orifice on the airbrush or airgun is, the more air volume will be required to spray paint with it. The compressor's pump should be able to fill the storage tank to capacity with compressed air and rest for a bit before it cycles back on to recharge the depleted air system.

Piston-Driven Compressors

With piston-driven air compressors an electric motor drives a piston or pistons to pump air into a holding tank. With this type of compressor, the air exits the cylinder, enters the storage tank, and passes through the regulator, moisture filter, oil filter (for oil-lubricated systems), and air line on its way to the airbrush. The tank neutralizes the pulsing effect from the air being pumped into it, and the moisture contained in the warm pressurized air has a chance to condense as it cools inside the air storage tank. The water that condenses in the tank is drained via a valve on the bottom side of the tank.

With enough horsepower and a large enough storage tank, piston-powered tank-style compressors can accommodate multiple airbrushes spraying at the same time, or provide enough air volume for one or more large airguns. Diaphragm compressors rarely generate enough air for more than one airbrush, unless they are spraying at low—10 to 20—psi.

Large piston-driven compressors often operate at a high decibel level. If you are using a noisy compressor, you may want to purchase a long air line to separate your work space from the compressor's noise. However, top-of-the-line compressors for airbrushing are virtually silent. Various models will accommodate from one to eight airbrushes spraying simultaneously,

Tip

Diaphragm compressors that have no air storage tank will run as long as air is used by the airbrush. If it has an automatic shut-off switch, the compressor will turn off immediately when you stop spraying. It will turn back on as soon as spraying begins and stay on as long as the airbrush requires air to spray. Most diaphragm compressors do not come with a storage tank, pressure regulator, or moisture filter as standard equipment, and you should purchase these items separately.

Diaphragm compressor with air storage tank.

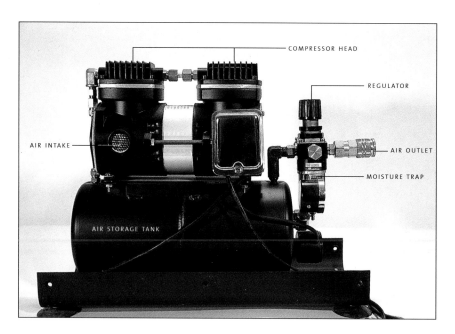

COMPRESSOR HEAD

REGULATOR

AIR INTAKE

AIR OUTLET

MOISTURE TRAP

AIR STORAGE TANK

depending on the psi each airbrush is spraying at. Horsepower ratings on silent compressors range from $^{1}/_{10}$ to 1 hp, and storage tank sizes range from 0.5 gallon to 4 gallons. Silent compressors are available at better arts and crafts stores.

COMPRESSED CO₂ TANKS

Compressed CO_2 tanks are perfect for airbrushing on a small to medium scale. They are clean and quiet and require no electricity to operate, and the large sizes last for months when used with a single airbrush. They are also relatively inexpensive. Because CO_2 tanks are available in many sizes, it is easy to match their reserve capacity to the type of painting you are doing. No moisture traps or oil filters are needed for CO_2 since the gas contains no water vapor or oil. The downside is that when the tank is empty, it needs to be refilled or exchanged with one that is full. Carbon dioxide is not a viable option if you are using a large-volume airgun because the CO_2 will be quickly exhausted.

Welding Air-Pressure Regulators

A full CO_2 tank contains pressures up to 1200 psi, and air-pressure regulators designed for electric compressors cannot withstand that kind of air pressure. When airbrushing with CO_2, you need a welding-style regulator designed to safely control the extremely high air pressure the tanks contain. The welding regulator screws onto the top of the CO_2 tank.

Welding regulators are designed to allow only small amounts of CO_2 gas to pass through them. Airbrushing, however, consumes far more CO_2 than welding does. If more than two people are airbrushing on a single CO_2 tank at once, a clamp light will be needed to heat the regulator so it does not ice up. With a 100-watt light bulb positioned to heat the regulator, up to eight people can airbrush simultaneously on one CO_2 tank without causing it to ice up. Once the regulator is in place, open the air valve on the top of the tank only a small crack. This acts as a sort of "preregulator" that limits the amount of CO_2 gas that enters the regulator in the first place.

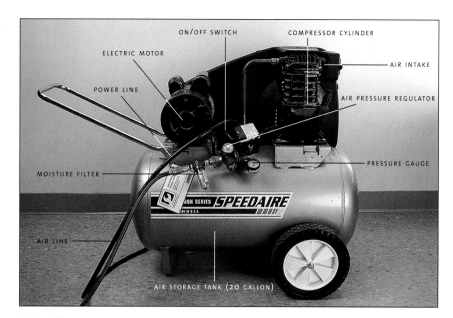

A piston-driven compressor

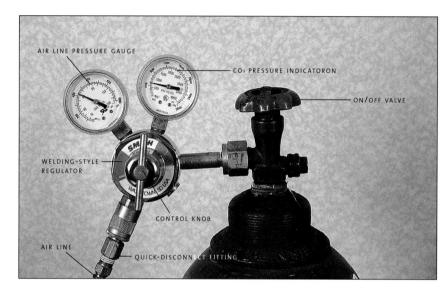

Close-up of the top of a CO₂ tank.

AIR LINES

The air line from the air source to the airbrush can be plastic (PVC) or braided nylon or cotton over rubber tubing, in lengths from 6 to 20 feet. Either type can be used with CO_2 tanks or electric compressors. Braided nylon air lines are easier to handle and more flexible than plastic air lines, and are tangle-resistant. For most projects, a 10-foot air line is sufficient. For airbrushing large objects, such as an automobile, where it is necessary to extend the line around the object being painted, a 10- or 12-foot airbrush air line can be attached to a standard $^{3}/_{8}$- or $^{1}/_{2}$-inch-diameter air line with a quick-disconnect fitting.

From left to right: braided nylon air line designed for Iwata automotive airguns, small-diameter PVC airline, large-diameter air line with a quick-disconnect fitting.

Airbrush Options

All airbrushes can be divided into two main groups, internal mix and external mix. The difference between them is how the air and pigments are mixed and sprayed. Either kind can be single- or dual-action and both are available in gravity-feed, side-feed, or siphon-feed designs.

EXTERNAL VERSUS INTERNAL MIX

External-mix airbrushes combine air and paint just beyond the tip of the paint nozzle outside the airbrush. The paint volume is controlled by adjusting a knob on the paint reservoir. Because internal-mix models offer far better control over paint application rates, external-mix models are fading from the airbrushing landscape.

Internal-mix airbrushes introduce the paint and air at a precise point just beyond the tip of the paint nozzle inside the airbrush. The paint nozzle is conical in shape. It is open at both ends and serves to funnel the pigment passing through the airbrush to the orifice at the tip of the nozzle. Paint enters the nozzle through the larger end of the cone and exits through the orifice, where it mixes with air and is atomized. Orifice sizes for an airbrush normally range from 0.18 to 0.50 mm.

A tapered needle that is matched to the taper of the paint nozzle seals against the inside edge of the nozzle orifice when it is in the forward position. It acts as a valve that serves two purposes. First, it turns on and shuts off paint flow by blocking or unblocking the orifice. When the airbrush's trigger is in the forward position, the needle is also in the forward position and its tapered point seals the orifice opening. As the needle is retracted by rocking the trigger on the airbrush backward, the seal between the tapered needle and tapered paint nozzle is broken, which allows paint to mix with the air as it exits the orifice. The air is channeled through the airbrush and

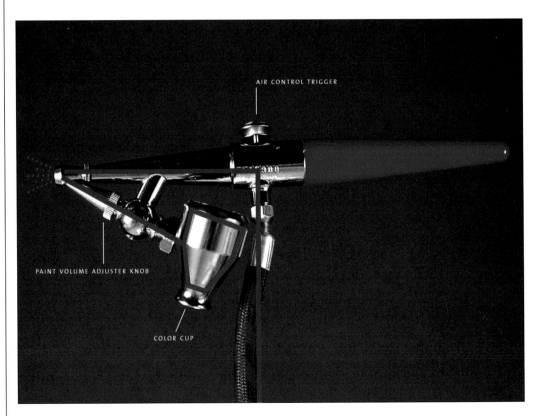

An external-mix siphon-feed airbrush.

directed through the airbrush's head, which surrounds the paint nozzle. After the air exits the head of the airbrush it is in position to exit the airbrush at the same point that the paint exits the paint nozzle orifice. This is the point that the paint and air combine to form the spray pattern.

Secondly, the needle precisely meters the volume of paint sprayed according to how far it is retracted or inserted into the orifice during the painting process. All of the exercises in this book are painted with an internal-mix airbrush.

Note: In most of the photographs of airbrushes and airguns in this chapter, the path of paint flow is shown in red and the airflow path in blue. When applicable, the needle-nozzle assembly is shown in black.

SINGLE VERSUS DUAL ACTION

An airbrush's *action* is how the trigger is manipulated to control the spray pattern. There are two types of actions for airbrushes: single action and dual action. Only one movement of the trigger is needed to operate a single-action airbrush, which is why this model is so popular with beginners. Single-action airbrushes work on the same principle as a can of spray paint, but with the ability to adjust paint volume and air pressure. When you push down on the paint trigger of a single-action airbrush, paint begins to spray immediately. You curtail paint flow by lifting your finger off the paint trigger and letting the air valve spring return the trigger to the off position. You control how much paint comes out of the gun by turning a control knob, which is usually on the rear of the tailpiece, which presets the airbrush to deliver the same amount of paint every time the airbrush's trigger is pushed down. Turning the control knob clockwise decreases paint flow and turning it counterclockwise increases paint flow. It does this by retracting or inserting the needle in or out of the paint orifice.

Single-action airbrushes are ideal for repetitive assembly-line uses, such as painting factory parts, taxidermy, and painting fishing lures. Crafters, hobbyists, and airbrush novices like single-action airbrushes because they are relatively easy to control without special instructions or techniques. The downside of the single-action airbrush is that as you paint, you must use two hands and keep adjusting the control knob to accommodate the spray width and paint volume requirements. This limits the airbrush's ability to adjust and adapt quickly, which in turn, slows the painting process.

Dual-action airbrushes are the choice of

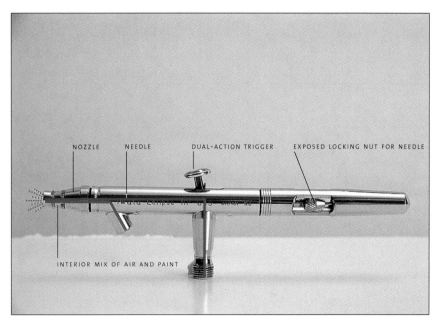

NOZZLE NEEDLE DUAL-ACTION TRIGGER EXPOSED LOCKING NUT FOR NEEDLE

INTERIOR MIX OF AIR AND PAINT

A dual-action airbrush.

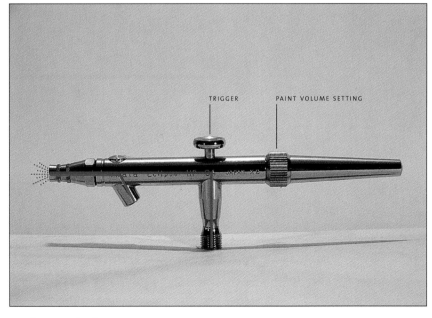

TRIGGER PAINT VOLUME SETTING

A single-action airbrush.

professional artists, professional painters, and commercial illustrators. Unlike their single-action cousins, dual-action airbrushes give the artist the ability to continuously adjust the paint volume during the painting process with the slightest trigger-finger movements. Seasoned painters can make countless adjustments in paint flow or spray characteristics as they are painting. Often, the trigger movements are so slight that they are indiscernible to a casual observer. The ease of adjusting paint flow without stopping to adjust knobs or change needles makes it easy for artists to "remain in the creative flow" as they paint. Note that the trigger of a dual-action airbrush does not adjust air volume or air pressure. The regulator handles that function.

Dual-action airbrushes require more practice and skill to master than single-action models because this type of airbrush requires two different movements of the airbrush's trigger to get paint to spray out of it. The first movement is to push the trigger all the way down. This sprays "air only" out of the airbrush tip. The second movement is to pull or rock the trigger backward while continuing to hold it down. This mixes paint into the air. As the trigger is pulled back further, more paint is mixed in. Pushing the trigger forward reduces the paint spray and eventually shuts it off. All airbrush techniques and applications are built on these basic triggger movements. The air and paint are efficiently metered with one finger. Because all of the airbrush control is done with just one finger, airbrushing with a double-action airbrush lends itself particularly well to artistic applications where constant adjustments of spray widths and volume are needed. There is no need to stop painting, adjust a setting, and do a test spray because continuous adjustments of the paint volume and spray width can be made while painting. A dual-action airbrush is illustrated on page 17.

The skills needed to use the dual-action airbrush are simple, but must be understood precisely. First, always hold the trigger down fully, so clean air is constantly exiting the air-brush. Second, learn to rock the trigger backward and forward to initiate and curtail paint flow while continuing to depress the trigger to deliver the air. Always remember that the spray pattern is determined by how far from the surface you spray, and paint volume is determined by how far back the trigger is pulled. Pushing the trigger forward reduces and finally eliminates the paint from the air exiting the tip of the airbrush. All airbrush techniques and applications are built on these basic trigger movements. For a detailed explanation of how trigger position controls paint flow in dual-action airbrushes, see the series of illustrations in Chapter 2 beginning on page 41.

FEED STYLES

There are three styles of airbrushes: siphon feed, side feed, and gravity feed. Any of these can be external mix or internal mix, and either single or dual action.

Siphon-feed airbrushes are the most adaptable style. The advantage of a siphon-feed airbrush is that a large variety of paint jars can be attached to them—little jars for small paintings or large bottles for murals or large backgrounds. The paint bottle connects to the bottom of the airbrush with a paint tube that extends from the bottom of the bottle and through its cap. The paint is siphoned from the jar and into the airbrush body via the paint tube. It is then mixed with air and exits the airbrush. Siphon-feed airbrushes are available with nozzle sizes from 0.1 to 0.5 mm, but for most purposes, you will need a nozzle that is at least 0.35 mm.

The side-feed airbrush features a color cup that attaches on either side of the airbrush's body. The cup can be rotated 360 degrees, which enables the painter to work at odd angles or even overhead. The path that the paint follows to exit the airbrush is shorter than the path followed in siphon-feed models, making it more efficient for fine detail work. The cups for side-feed airbrushes are smaller than those for siphon-feed models; nozzle sizes range from 0.10 to 0.35 mm.

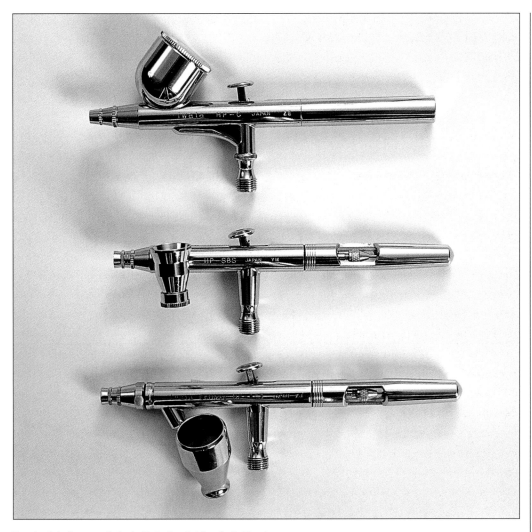

From top to bottom: gravity-feed, side-feed, and siphon-feed airbrushes.

The gravity-feed airbrush is the most efficient style of all in terms of paint use. The paint lies directly over the paint nozzle so it has to travel an extremely short distance to mix with air and exit the airbrush. This makes gravity-fed airbrushes the most consistent, responsive, and detail-oriented airbrush style available. One drop of paint into the paint cup gives one drop of paint out of the airbrush. No paint is lost in a siphon system or paint tube. The orifices of gravity-feed models range from 0.10 to 0.35 mm.

AIRBRUSH HOLDERS

This "must have" item is often forgotten when purchasing an airbrushing system. A suitable airbrush holder will safely store your airbrush and free your hands for other tasks as you work. Different models can hold from one to four airbrushes.

The airbrush holder shown here can accommodate two airbrushes.

Airguns

Airguns are designed for large painting projects, such as spraying automotive basecoats or clearcoats, gesso on canvas, varnishing paintings, spraying murals, and painting backgrounds and banners. Airguns operate on the same principles that airbrushes do, and can be internal or external mix and siphon feed, side feed, or gravity feed. The trigger action varies between models and manufacturers. Some models resemble a single-action airbrush, and others have a two-step trigger. Airguns require large volumes of compressed air to operate properly. They consume far too much air to be powered with CO_2 tanks. For these airguns a minimum 1- to 5-hp air compressor with a large storage tank (20 gallons minimum) is advised. It is essential to have an air pressure regulator, moisture trap, and oil filter installed in the air line.

A type of airgun called the low-pressure high-volume (HVLP) airgun, which was originally used only in automotive basecoat and clearcoat applications, is fast becoming the choice of fine artists and muralists because of

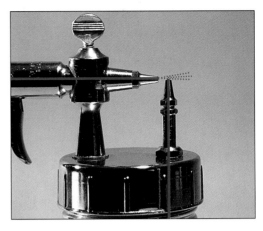

Detail of an external-mix airgun, showing air and paint flow.

its efficient design. Low-pressure high-volume airguns are gravity fed and spray liquids at low air pressures (no more than 10 psi at the nozzle cap). This minimizes paint overspray and maximizes efficient use of materials. Over 80 percent of the paint sprayed out of an HVLP airgun stays on the surface that is being painted, making them relatively environmentally friendly. They feature superior paint atomization and can be adjusted to spray up to 12 inches in width.

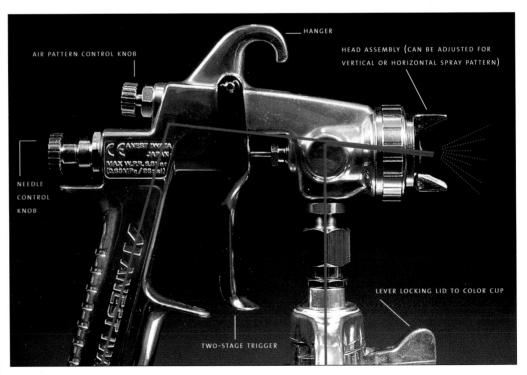

AIR PATTERN CONTROL KNOB

HANGER

HEAD ASSEMBLY (CAN BE ADJUSTED FOR VERTICAL OR HORIZONTAL SPRAY PATTERN)

NEEDLE CONTROL KNOB

LEVER LOCKING LID TO COLOR CUP

TWO-STAGE TRIGGER

Internal-mix airgun.

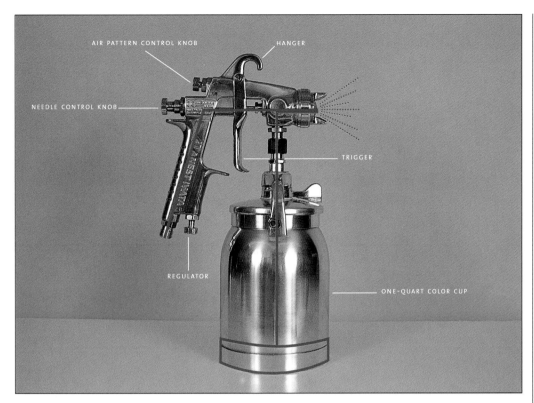

Siphon-feed airgun. The spray pattern for siphon-feed airguns ranges from 8 to 12 inches wide. Siphon-feed airguns can be used for any type of painting for which an airgun is preferable to an airbrush.

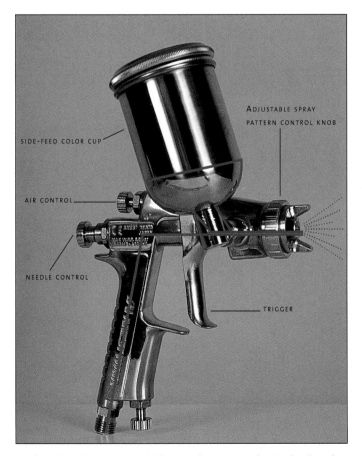

Side-feed airgun. The spray pattern of this type of airgun is ⅛ inch to 8 inches depending on the model; it is well suited for automotive touch-up, large studio paintings, gesso coatings, or murals.

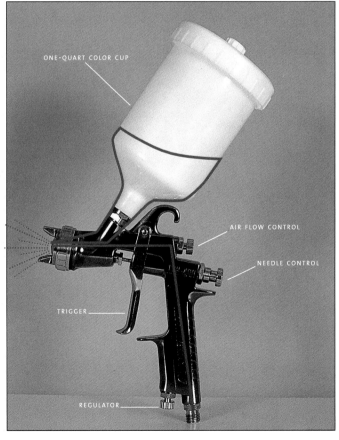

Gravity-feed HVLP airgun.

Choosing Your Airbrush System

Choosing an airbrush system, like choosing a computer system, depends on what you want to do with it. Before making a purchase, answer the following questions:

Are you planning to use the airbrushing system to paint projects that require high air pressures (50 to 80 psi) or large volumes of air (murals or automotive base-coating and clear-coating)? If so, you will need a minimum 5-hp compressor with a 30-gallon storage tank. Smaller assignments, such as a commercial illustration or motorcycle detailing, can be done with compressor systems with ratings as low as $1/8$ to $1/2$ hp. Whatever the job, you must choose a system that allows you to airbrush without fear of overworking the system. The rule of thumb for air compressors is that if the motor runs continuously while painting, which indicates that the air is being used faster than the compressor can replace it, or the compressor cannot maintain the desired air pressure, you need a compressor with more horsepower and air storage capacity.

Will you always be working in a place with a reliable source of electricity? If not, you will need a source of pressurized air that does not require electricity, such as a CO_2 canister. Situations that may require a CO_2 canister are painting in public buildings where noise may be an issue, as well as any location, e.g., fairgrounds, street fairs, airport tarmacs, and boat marinas, with no electricity available. Note that if you need to use a large airgun, or the work requires more than one airbrush, you will need more air than CO_2 tanks can provide. In those cases, you can use a gasoline-powered portable generator to supply power for a portable 5-hp compressor with a 20-gallon storage tank.

Would the noise of a loud air compressor disturb friends, family members, neighbors, or co-workers? Standard piston-driven tank-style compressors are very loud when they are in operation. Diaphragm compressors are quieter than the tank compressors, but they still produce substantial noise. Carbon dioxide tanks, on the other hand, operate silently. "Silent" air compressors operate at various decibel levels depending on model and style. Generally, the quieter an air compressor is, the more it costs.

How much money are you able to spend? Always purchase the best equipment that you can afford. A quality airbrush and air compressor will last a lifetime. Air lines, regulators, moisture traps, and oil filters will also last a lifetime if properly used and cared for. These items are normally sold separately, unless you are purchasing a top-of-the-line air compressor that includes all of the accessories that airbrushing requires.

Entry-level airbrush systems with a diaphragm compressor without an air storage tank and a quality dual-action airbrush, like the Iwata Eclipse or Paasche VL, are priced in the $300 to $400 range. Medium-sized systems with a 5- to 10-hp compressor with a 20-gallon or larger air storage tank, coupled with a professional-grade airbrush like the Iwata HP series or the Paasche VSR90#1, are in the $600 to $800 price range. Professional painting systems for use with multiple airbrushes at once can run into thousands of dollars, depending on the horsepower rating of the compressor, the size of the air storage tank, and the number of airbrushes required. A good "silent" compressor for use in a studio will cost between $600 and $1000 depending on the model. Large automotive air painting shops that are capable of painting whole vehicles, coupled with a state-of-the-art compressor and air filtration system, can cost tens of thousands of dollars.

Setting Up to Paint

Setups for studios—or "mobile" units—vary widely, but basic hardware and accessory choices remain constant.

TAKING IT ON THE ROAD

When painting or applying body art at public events, a portable "mini" airbrush system can be used. Portable systems can also be used for cosmetic applications such as fingernail painting, model painting, crafting, taxidermy, stenciling, art paintings, automotive airbrushing, and textile airbrushing.

A supple 10-foot braided nylon air line is ideal for mini systems. Folding tables provide the work surface and a stable platform on which to mix paints and work with stencils. Sturdy steel folding chairs are a good choice for your clientele to sit on if you will be applying temporary tattoos or body art. This reduces the chance of the chair collapsing during use.

SMALL STUDIOS

A "small" studio can be as small as a table in the corner of the basement. It can also be a space dedicated to airbrushing that is large enough to display all the necessary tools and still leave ample room to paint. The studio shown here, which is Pamela Shanteau's, measures 375 square feet. Only airbrushes and nonsolvent paints are used in this space, so a huge compressor and air exhaust system are not required. An electric air filter that clamps onto the side of the drawing table captures paint overspray. This size studio is suited well for any kind of body art (temporary tattoos, fingernails, custom body art), paintings up to 4 by 8 feet, and craft and model painting. The Medea 0.50-hp Hammerhead air compressor provides the compressed air for this studio. When painting with one airbrush with a 0.35-mm paint nozzle, it maintains over 100 psi. Because it is equipped with a regulator, moisture trap, and oil filter, the air that mixes with

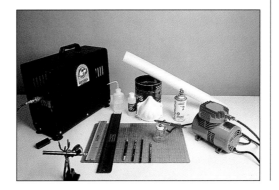

A portable system, including a light, compact, oil-less compressor with a protective steel shroud that maintains 45-psi pressure (extreme left); a mini compressor (extreme right); airbrush and holder; and various basic tools, including frisket film, spray mask, cutting tools and cutting rail, and a cutting mat. The oil-less types are recommended because if a compressor that contains oil is tipped or upended, as can easily happen during transit, the oil will leak into the compression cylinder and contaminate the air system.

Pamela Shanteau's small studio.

paint is contaminant-free. The noise emitted by a Hammerhead compressor in operation could be compared to a refrigerator cycling on and off, making it one of the quietest compressors available.

The light fixtures in the ceiling and on the drawing table have bulbs that are balanced for daylight color so the artist can accurately judge the color values being sprayed. An adjustable drawing table and comfortable adjustable chair are also standard equipment. Both an easel, for large paintings, and a drawing table, for smaller projects, are available. The drawing table is equipped with a side tray that holds most of the tools needed during a painting session. The table is large enough (4 by 5 feet) to hold the paints and tools that will be used for a given project, but small enough to allow the artist to reach them easily.

MEDIUM-SIZE STUDIOS

Medium-size studios (750 to 1500 square feet) are perfect for cycle parts, T-shirt painting, crafting, stenciling, sign work, commercial art, and fine art. This size studio could accommodate any airbrush assignment that a small studio could handle in addition to painting objects the size of an automobile. For medium-size shops, a 5-hp compressor with a 20- to 30-gallon storage tank that is on wheels is a good choice, since it can power a large airgun or run 10 or more airbrushes spraying at the same time. If you will not be spraying with large airguns, you can use a smaller compressor with a smaller storage tank (1/2 to 1 hp with a 1- to 5-gallon air storage tank), but you will still need an exhaust fan or air filter to take care of paint overspray. Benches and tables can be permanent fixtures or break down for storage. Color-correct lighting is recommended.

LARGE SHOPS

Large studios start at 1500 square feet and can range from 5000 to 10,000 square feet or more. Large painting systems require high-volume equipment. Piston-style compressors are the norm because they pump far more air volume than the diaphragm style. A 10-hp piston style air compressor with a 40-gallon air storage tank is the smallest air system you should consider for a large paint shop, especially if you will be using large airguns, which have a huge appetite for air. The compressor should be equipped with an air-pressure regulator, moisture filter, and preferably an oil filter. If you are working in a large shop, you will need plenty of air line footage. For example, if you have an airbrush with a 20-foot air line, you could connect it to a 40-foot compressor with a quick-disconnect fitting, giving you 60 feet of mobility.

If you are using automotive basecoats and clearcoats with large airguns, you will want to set up a spray booth. A spray booth encloses the vehicle within a paint shop to keep dirt from settling into the fresh paint. Air is pulled into and through the paint booth during the painting process by an exhaust fan located in

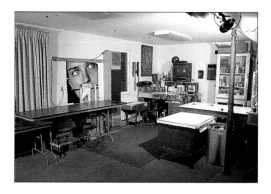

A medium-sized studio.

the opposite side of the booth from the air inlet. Heated air is drawn into the booth from inside of the shop through filters and exits through an exhaust port on the opposite wall from the air intake.

Sophisticated shops employ down-draft paint booths with floating floors, like the one shown on the opposite page. These are by far the most efficient way to evacuate dust and overspray from the painting area. Filtered air is pumped into the paint booth from the ceiling and pulled through a grated floor into a shallow pool of filtered water beneath the floor. The water captures and holds paint overspray. Once captured, the water can be filtered or disposed of properly. This type of ventilation /air filtration is the most efficient and environmentally friendly system available today.

The exhaust fan of a large shop or studio needs to be powerful enough to evacuate the large volumes of overspray that airguns create. Unfortunately, these fans also pump huge amounts of air (heated or cooled) out of the shop when they are operating. To be sure that your heating and cooling systems are capable of replacing the conditioned air pulled out of the shop by the exhaust fan, monitor the paint booth temperature as you are painting to make sure it remains constant. Because most paints used in large shops are solvent-based, and thus toxic, even if the studio is equipped with a high-volume air exhaust fan, and whether or not the work is being done in a down-draft paint booth, the painter must wear an air filter or respirator that has been approved for the type of paint being sprayed. (See Chapter 2, Safety Tips, page 38.)

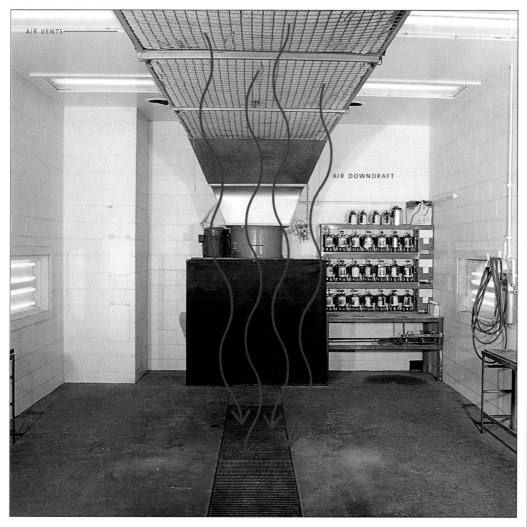

AIR VENTS

AIR DOWNDRAFT

A downdraft paint booth.

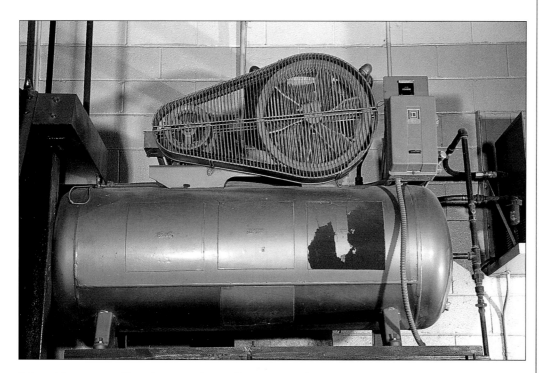

A piston-style compressor with a 25-hp motor and a 125-gallon air storage tank.

This 4-foot-diameter exhaust fan is capable of evacuating hundreds of square feet of air per minute and would be appropriate for large painting applications with powerful airguns.

Essential Supplies

Many of the following materials can be found in the art supplies or stationery sections of retail stores that stock a variety of merchandise. Others must be purchased from specialty shops, such as drafting, art, and automotive supplies stores. For specific information, see the Source Directory that begins on page 156.

PAINTS

Regardless of the type of paints, dyes, or pigments you are using, they will fall into one of two main categories: opaque and transparent. Opaque paints are generally thicker than transparent paints. Because they contain much more pigment, it is more difficult to spray them without clogging problems. Opaque colors do not blend well to make a third color. In most cases, an opaque pigment applied over another pigment will cover the underlying color completely. Depending on the colors used, multiple applications may be required to completely cover an underlying pigment (e.g., opaque yellow over opaque black). Transparent colors usually flow more smoothly through the airbrush because they are less viscous. Blending transparent colors creates additional color values in the areas of paint that overlap. Multiple colors can be overlapped with spectacular results. Transparent colors do not cover well, which means that they will not block out an underlying color.

Inks and Dyes

Inks have the consistency of water. They spray through an airbrush effortlessly with no additives. Their main feature is transparency, which allows the artist to blend colors easily. Cleanup is accomplished with warm water.

Watercolors

These water-based paints are well suited to airbrushing. They are thin enough to spray smoothly and predictably. Because of their transparency, light coats of color can be layered with remarkable effect. Watercolors are available premixed for airbrushing or can be purchased in tubes and reduced with distilled water (50 percent paint, 50 percent water). Experiment with the mixing ratio to determine the viscosity you prefer.

Gouache

Also known as tempera, gouache is a watercolor paint with white pigment added to make it opaque. It is sold in tubes and then diluted with water to the proper viscosity for

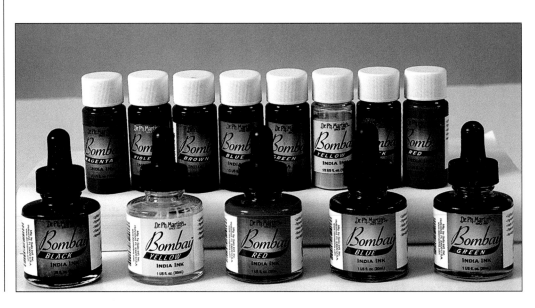

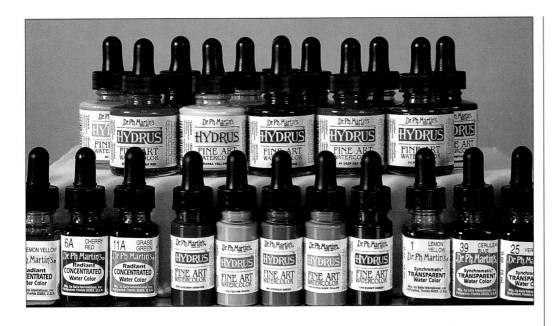

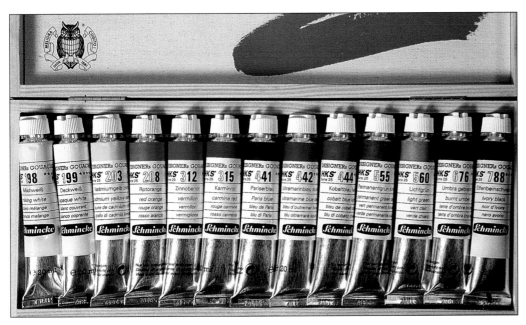

airbrushing. Start at a 50:50 mixing ratio of water and pigment and modify the ratio to suit your personal preference. The paint flow of gouache is similar to that of watercolor, with easy cleanup with warm water. If the gouache dries in the airbrush, it will become a solid block of paint. Be sure to clean any pigment out of the airbrush immediately after spraying.

Acrylics

Premixed airbrush acrylics are available in transparent and opaque versions. These fast-drying, long-lasting paints are the choice of many artists and illustrators. They can be sprayed on virtually any surface. Tape, frisket film, or other adhesive masks will not pull up dried acrylic paint when removed. Acrylic paints sold in tubes can be used in the airbrush after the paint has been thinned to the proper consistency. High-viscosity acrylics are thinned with water and a solvent made by the manufacturer. Low-viscosity acrylics are thinned with water only. Start at a 50:50 mixing ratio and modify the ratio to suit your preference. Any acrylic paint, whether it is premixed, low-viscosity, or high-viscosity, needs to be cleaned out of the airbrush imme-

diately after use or it will dry into a solid block of paint. Acrylics can be cleaned up with warm water.

Some acrylics are designed specifically for painting on textiles. For best results with these thick water-based paints, an airbrush with a 0.5-mm paint nozzle and a regulator setting of 50 to 75 psi is recommended. Once applied, they are heat-set into the fabric with a heat setter or heat gun. Textile acrylics must be cleaned from the airbrush immediately after use. If allowed to dry, they will cause severe clogging. Make sure to shake the paint bottles often since the heavy pigments in these paints have a tendency to separate.

Oil Paints

Oils are thinned 50:50 with turpentine or mineral sprits to airbrushing consistency. The colors are fabulous. The downside is that they dry much more slowly than other pigments. Oils can be either opaque or transparent depending on how much they are thinned. For a demonstration of a mixed-media airbrushed piece that combines oils and acrylics, see Chapter 8, page 134.

Sign Paints

Airbrushing signs and banners requires special paints. The most common sign paint in the United States is One Shot enamel paint. Normally applied with a paintbrush, it also can be thinned to proper viscosity for airbrushing with One Shot 6000 reducer. Sign paints take much longer to dry than lacquer or enamel paints. A catalyst (One Shot hardener 4007) may be added to shorten the drying time of the paint if required.

Deka makes a product called Sign Air, a water-based enamel paint that is premixed for

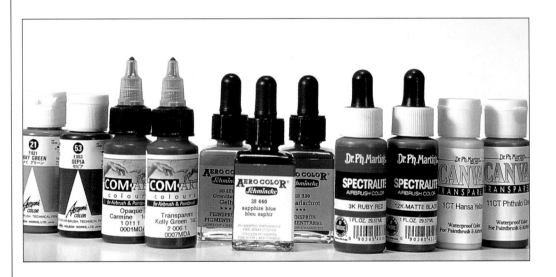

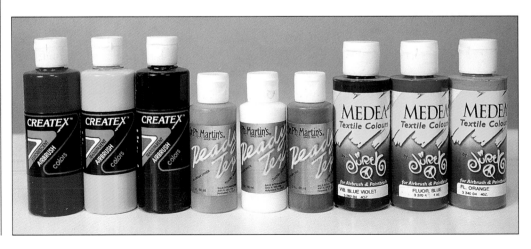

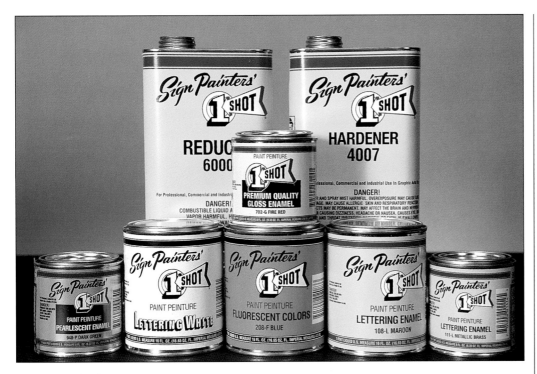

1-SHOT sign paint products.

use with an airbrush. Sign Air can be used to good effect on cement block walls, fabric backdrops, and vinyl letters. It dries very rapidly after spraying, which is ideal when you need to finish a piece in a short period of time, but the quick dry time can lead to clogging in the airbrush. Deka makes a retardant that slows the drying time of the paint if needed to improve paint flow and reduce clogging. The colors last for 3 to 5 years outdoors.

For information on automotive lacquers, enamels, and urethanes see Chapter 9, page 147.

SURFACES

Airbrushes can be used to spray paint on any surface, from small craft items to automobiles. The standard art surfaces that are used for airbrushed paintings include cold-press and hot-press illustration board, canvas, and different types of scratchboard. Inexpensive paper, such as newsprint, can be used for practice sessions and to test airbrushes.

ILLUSTRATION BOARD. Illustration board is a nonabsorbent paper-based product that is approximately 1/8-inch thick. It is offered in standard sizes (9 by 12 inches, 11 by 14 inches,

etc.) and is suitable for use with tape and adhesive masks. Cold-press illustration board has a slight texture, giving it enough tooth (texture) to hold graphite. Hot-press illustration board has a smoother surface than cold-press board, and so does not hold graphite very well. It is a superior surface for more technical renderings because it works so well with masks.

CANVAS. Many artists who began painting with paintbrushes on canvas and learned to airbrush at a later time are more comfortable working on a familiar substrate, so they stick with canvas. Canvas to be used for airbrush painting must be stretched just as it would be for any other medium and prepared with gesso.

SCRATCHBOARD. The term *scratchboard* refers to a coated surface on which images or highlights are created by scratching out areas that have been painted to expose the underlying coated substrate. In the mid-1990s, Texas artist Charles Ewing patented a totally new scratchboard called Claybord. It is a sturdy hardboard that is coated with a white Kaolin clay. It is available in many styles for various mediums. Claybord is discussed in detail in Chapter 8, "Fine Art and Illustration."

ART SUPPLIES

EASELS. Use an easel with a rigid backing panel to hold illustration boards, canvases, or clay-coated boards for large paintings, and to hold rag paper for practicing techniques.

BRUSHES. Even for artists who consider themselves primarily airbrush artists, it is essential to have a range of paintbrushes, from big fan brushes to the smallest sizes available (20/0 to 1). Often, a paintbrush will handle a particular task better than an airbrush will. It may be much simpler to add a fine hair or add tiny eyelashes on a portrait of a woman with a paintbrush as opposed to the airbrush. If you use both airbrushes and paintbrushes, you can select the proper tool to render the detail efficiently.

PENCILS AND MARKERS. Colored pencils and graphite pencils range from soft (B to 9B) to hard (H to 9H). Softer graphite pencils can be used to achieve a wide range of values. When drawing on drafting film, use harder graphite since it does not smear easily. Markers work well on acetate and can also be used to render quick color compositions.

The smallest-size brushes (20/0 to 1) are indispensable for painting in fine details on tiny subjects such as scale models. The ones shown here are manufactured by the DaVinci and Silver brush companies.

PAPER TOWELS. Paper towels are indispensable. Hold one in your off hand to catch drips or use it to clean your paint needle tip. They also make a great test pad for practice and testing airbrush settings. Do not use paper towels to protect the areas surrounding where you are spraying. They are absorbent and easily transfer moisture to the surface they are supposed to be protecting.

HEAVY STOCK PAPER. Paper of heavy stock can be cut to make simple hand-held

Top, then left to right: turkey feather, which can be dipped into paint and used to create feathered effects; large fan brush; a long, flat brush for washes; small flat-edged brush; angle shading brush; ultrathin fan brush for details; Da Vinci #10 watercolor brush; Da Vinci Cosmotop Spin watercolor brush; medium-size liner brush.

shields or masks for many nonautomotive air-brush applications (see "Hand-Held Shields," page 33). Watercolors, gouache, acrylics, and textile paints, when not overapplied, work well with paper masks made of heavy stock paper because they dry quickly and do not bleed into or under the mask. Repositionable adhesive sprayed on the paper mask will make it adhere to the painting surface and avoid paint underspray.

OTHER DRAWING AIDS. Projectors are useful for enlarging and projecting drawings to scale. (See Chapter 3, "Developing Images.") A compass, protractor, and assorted straight-edges aid in rapid development of sketches. The transparent plastic versions make them easier to use than ever.

MASKING SUPPLIES

CUTTING TOOLS. X-Acto knives cut any tape, drafting film, or frisket film cleanly and efficiently to fashion masks and stencils. Masks cut with an X-Acto knife have sharp, crisp edges. You can use an electric stencil burner to create softer effects, for example, for hair, fur, feathers, and foliage. The heated tip of the burner melts the material rather than cutting it. The melted edges of the mask create a softer, more natural look. Sturdy, sharp scissors are a must.

CUTTING RAILS. Cutting rails, which are usually made from aluminum, help in making straight cuts quickly and safely. They also keep your hand and arm from dragging over previously painted areas.

REPOSITIONABLE SPRAY ADHESIVE. Repositionable spray adhesives are used to affix stencils made from Mylar (drafting film), acetate, or paper to a painting surface. A product preferred by many airbrushers is 3M SprayMount artist's adhesive. Spray a light coat of the adhesive on the back of any masking material, let it dry a few minutes, and stick it in place. It leaves minimal residue. When used on automotive surfaces, the residue cleans up with any mild wax and grease remover.

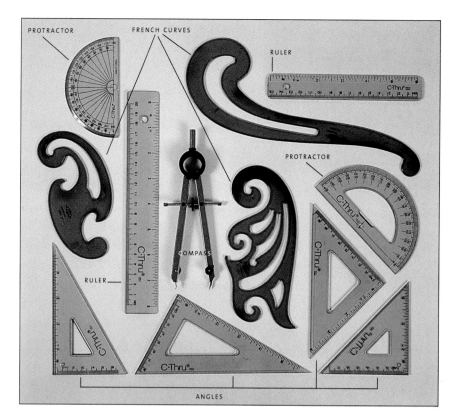

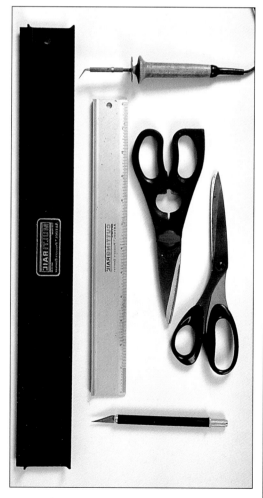

Cutting rails, straightedges, stencil burner, scissors, X-Acto knife.

MYLAR DRAFTING FILM. Mylar drafting film is the best choice for fashioning automotive masks or stencils. It cuts easily with a razor or X-Acto knife and burns well with a stencil burner; it is also solvent-resistant, so it can be used with any type of paint. Mylar drafting film is extremely pliant, yet so strong that it will not tear, making it the perfect material to use when masking on curved surfaces. To minimize the possibility of leaving high paint edges after the masking is removed, use 0.003-mil film. Mylar drafting film comes in several forms: matte on both sides, slick on both sides, or matte on one side and slick on the other. The matte/slick type is most useful for airbrushing. You can draw on the matte side, which has enough texture to hold graphite. The slick side offers less resistance to a blade, so cut your designs with the slick side facing up. After the design is cut, 3M artist's repositionable adhesive is sprayed on the slick side. When the adhesive tacks up, the mask can be transferred to the painting surface without fear of distortion. Use a utility knife to pick up and place smaller pieces on the painting surface.

ACETATE. Clear acetate is sold in sheet form or by roll. Like Mylar, it does not stretch and is solvent-resistent. However, it is more brittle than Mylar, and more easily torn. Acetate is slick on both sides, and so does not hold pencil graphite well; markers are a good medium to use for drawing on acetate. Since acetate is slick on both sides, you can cut or apply adhesives to either side. If drafting film is not available, acetate is a good second choice.

FRISKET FILM. One of the most common materials for mask making, frisket film is a transparent film with a low-tack adhesive backing which is exposed when the backing is removed and which keeps the mask in place as you airbrush. Frisket film leaves no residue once it is removed. It is not solvent proof, so it cannot be used with automotive solvent-based paints. It is perfect for most other mediums. Frisket film can be purchased in individual sheets or in rolls.

MASKING TAPE. Common paper-based masking tape comes in widths of $1/16$ inch to 3 inches. Paper masking tapes are not pliable, so they do not follow curves very well; the wider the tape, the less easily it conforms to curves. Masking tape is useful for masking straight lines or securing masking paper. Paper masking tape is relatively thick; using it as a mask may result in paint build-up along its edges that will be visible after the tape is removed and will

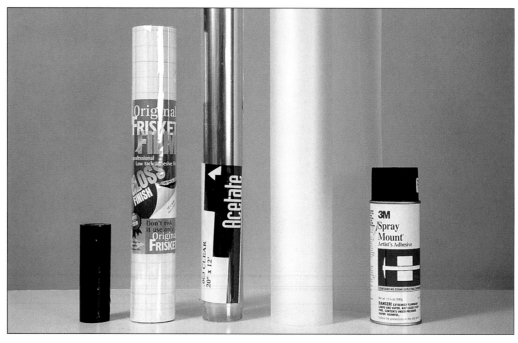

Left to right: blue-colored film, frisket film, acetate, mylar, spray adhesive.

Masking tapes of different sizes used in masking. From top to bottom: $1/16$-inch fine line; $1/8$-inch fine line; $1/4$-inch fine line; $1/8$-inch plastic; $1/4$-inch plastic; $1/2$-inch plastic; $1/2$-inch masking tape; $3/4$-inch masking tape.

interfere with the clear-coating process. To avoid paint build-up, you can attach fine-line tapes at the border between the masking tape and the area you are spraying.

FINE-LINE MASKING TAPE. Fine-line masking tapes are available in blue and green versions, in widths ranging from $1/16$ to $3/4$ inch. These tapes have an extremely low profile, ensuring minimal paint build-up against their edges. The blue fine-line tapes are thin and flexible enough to conform to extremely tight curves while maintaining their grip on the surface. This type of tape is the best choice for masking out flames and other intricate designs that have no straight lines. The green fine-line tapes have limited flexibility and are better suited for masking arcs and straight lines. For more information on the use of fine-line tapes, see Chapter 9, "Automotive Airbrushing."

MASKING PAPER. Specially coated non-absorbent masking paper can be used to protect the area immediately surrounding where you are painting from paint spray. Coated masking paper is normally used for automotive airbrushing and sign painting. Uncoated paper, such as newsprint, should never be used for this purpose.

PLASTIC SHEETING. Plastic sheeting is great for covering large areas quickly and cheaply. It can be used to extend the coverage beyond the masking paper that immediately surrounds the painting area, keeping overspray from settling on other parts of the vehicle or in the shop.

HAND-HELD SHIELDS. You can fashion your own shields out of heavy stock paper, acetate, Mylar, or found objects. Reusable solvent-proof commercial-grade hand-held shields are available at arts and crafts stores. These stencils are thick enough to be held firmly to a surface and pliant enough to follow a curve.

A variety of commercial hand-held sheilds

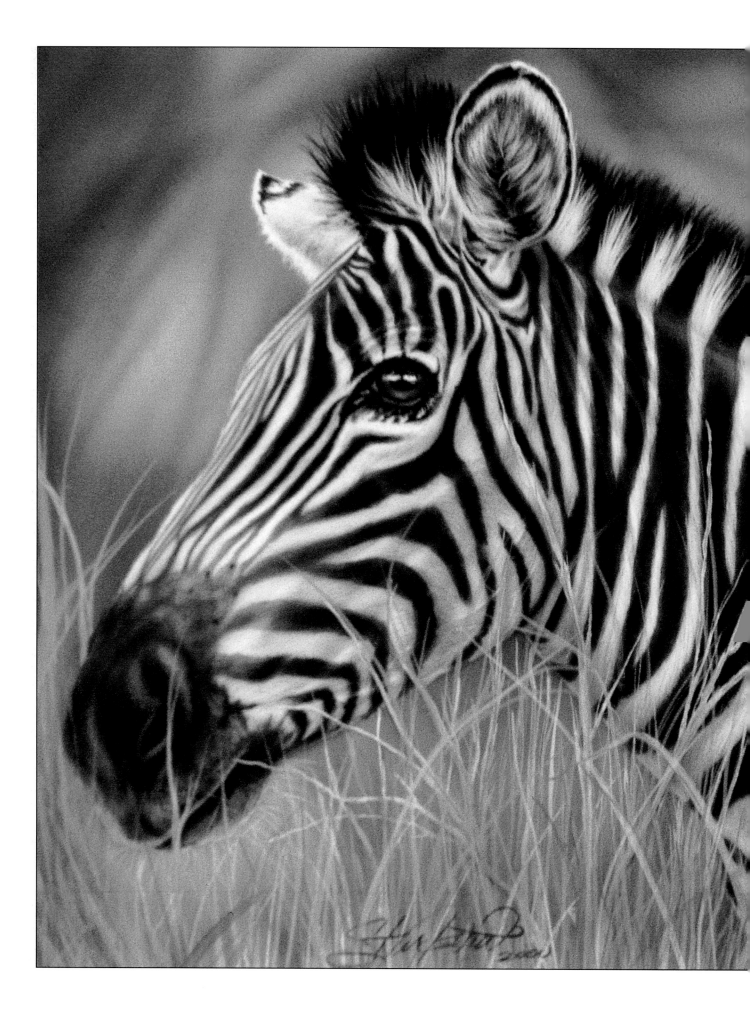

OPERATING
YOUR
AIRBRUSH

Unlike paintbrushes, which most of us learn to wield in early childhood, airbrushes are inherently intimidating. Artists, especially those who have an aversion to all things technical, assume that learning to operate an airbrush will be more trouble than it is worth. In fact, airbrush-operating techniques are not all that complicated. With the right materials, a comfortable grip, and a working knowledge of a handful of basic principles, anyone can employ the airbrush for fun—or for profit.

The Basics

Gripping the airbrush properly is a must. As you become more adept at using the airbrush, you will develop the grip that suits you best. What grip you use will depend on the size and flexibility of your hand, the type of airbrush you are using (siphon-feed, side-feed, or gravity-feed), and the size of the paint jar or paint cup that is attached to the airbrush.

For a good basic grip, pinch the neck of the airbrush between the tips of your middle finger and thumb, with the tailpiece resting in the space between your thumb and index finger. Your hand will be behind the trigger under the body of the airbrush, and your index finger will extend forward to engage the trigger. This grip, which opens the hand up so it has maximum trigger-finger mobility, is best for painters with large hands or long fingers.

If you have a small hand, you may be more comfortable holding the airbrush by its neck so that more of your fingers and hand are in contact with the airbrush. With this grip, your hand is placed under the trigger and your index finger extends upward to engage the trigger.

As an option, you may use your off hand (the one not holding the airbrush) to steady the airbrush as you paint. The off hand can also act as a bridge that maintains a constant distance between the tip of the airbrush and the painting surface.

GETTING READY: SETTING UP YOUR SYSTEM

1. Check out your air source. If you are using an electric air compressor, make sure it is equipped with both an air pressure regulator and a moisture filter. If the compressor unit is oil lubricated, check the oil level and consider installing an oil filter in the air line between the storage tank and airbrush. Remember that CO_2 tanks do not require any filters because the gas contains no moisture or oil. You do, however, need a welding-style regulator to contain and adjust the tank's extremely high pressures.

2. Connect the airbrush to the air source. Use the air line that is designed for your brand of airbrush. A large-diameter air line may be used between the compressor and the airbrush hose to extend your reach. Quick-

Modified grip for people with smaller hands.

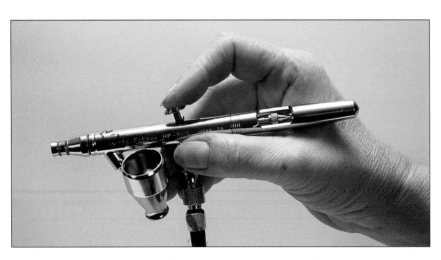

The basic airbrush grip.

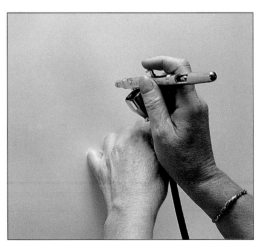

Two-handed airbrush grip.

disconnect fittings make air line connections quick and easy. Teflon tape eliminates air leakage in air line connections. Use Teflon tape (available where plumbing supplies are sold) on all air line connections with the exception of where the airbrush's hose connects to the airbrush.

3. If you are using a CO_2 tank, open the main air valve. Be sure to open the valve only a small crack. If you open it too much, the volume of gas expanding inside of the body of the valve will cause the regulator to ice up. Opening the valve too much also exposes the regulator's diaphragm to possible damage from the extreme air pressure contained in the tank. If you are using an electric compressor, turn it on. Check for air leaks at all air line connections.

4. Use an airbrush and the regulator to set the working air pressure. For most paints, 30 psi is a good setting to start at. (More viscous paints require more air pressure to atomize the paint properly.)

5. Put paint in the airbrush's paint container. When using a siphon-feed airbrush, attach the paint cup or bottle to the opening on the bottom of the airbrush by pushing it in until it fits snugly. With a gravity-feed airbrush, paint is put in the paint cup attached to the top of the airbrush. With a side-feed airbrush, insert the paint cup or paint bottle's siphon tube into the side of the airbrush until it fits snugly.

SPRAY PATTERNS AND OVERSPRAY

The distance from the airbrush to the painting surface and the volume of paint being sprayed will determine how much area the paint covers. To paint fine details, bring the airbrush closer to the surface and reduce the volume of paint. To airbrush large areas and larger details, hold the airbrush farther away from the surface and adjust the airbrush to spray greater volumes of paint. With practice, you will learn what distance-volume combination will give you the effects you want.

The term *overspray* refers to airbrushed paint that sprays onto an area where it is not wanted. Overspray is of course created when you are spraying paint onto a painting surface. It is also created when you are emptying the airbrush to make a color change, or cleaning the airbrush. Commercial overspray eliminators are available, but almost any container will work. For example, put some paper towels in a small bucket or empty coffee can and empty the airbrush into it. The towels will capture most of the overspray mist. After a color change, blast paint through the airbrush into the overspray container until the new color has flushed out any water left over from cleaning and any leftover pigment of the previously used color.

Place a clean sheet of paper near your painting area. Use it to test the spray characteristics of your airbrush before you start painting, before attempting to airbrush fine detail, and after any color change.

You will need to master four basic patterns to use your airbrush effectively: dots, lines, dagger strokes, and gradations. All airbrush painting is based on these patterns.

Setting air pressure. Push down on the trigger of the airbrush to release air. As the air continues spraying out of the airbrush, adjust the air pressure regulator by turning its control knob clockwise or counterclockwise to the desired pressure.

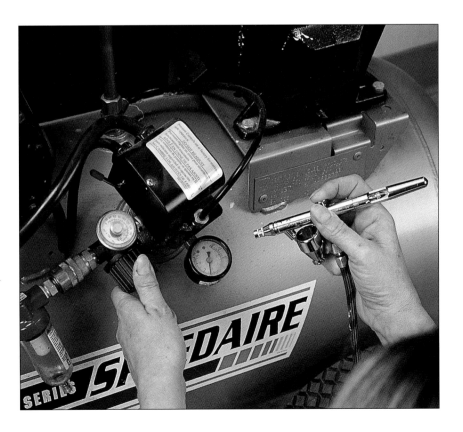

Single-Action Airbrush Exercises

What You Will Need

Easel with a cardboard or other rigid backing panel

Pad of white newsprint or copy paper

Black opaque or transparent acrylic airbrush paint

An electric air compressor, or CO_2 canister, regulated to 30 psi

Airbrush

The following step-by-step exercises take you through the creation of dots, lines, and gradations for single-action airbrushes and dots, dagger stokes, and gradations for dual-action airbrushes.

For the basic principles of operation of single-action airbrushes, refer to Chapter 1, page 17. As discussed in Chapter 1, the control knob on the rear of the single-action airbrush adjusts the paint volume sprayed when the trigger on the airbrush is pushed down. It does this by moving the paint needle forward and backward inside of the paint orifice. Turning the knob clockwise moves the paint needle forward to block a greater portion of the paint orifice, which decreases the volume of paint exiting the airbrush. Turning the knob counterclockwise increases the paint volume by backing the paint needle out of the paint orifice. Once you learn to set the controls and manage the distance from your painting surface, you can accurately preset a single-action airbrush to deliver the proper amount of pigment for the area that you are painting.

Begin by standing the pad of paper (or illustration board, which is used for the demonstrations beginning on page 43) upright on an easel to facilitate easy spraying. If you are using a single sheet of paper, tape it to the backing panel. Attach your airbrush to the air supply and put the paint in the color reservoir of the airbrush.

SAFETY TIPS

- If you are using a CO_2 tank, make sure it cannot topple or roll. You can strap the canister to a permanent solid fixture or put it in an enclosed area that leaves no space for movement. If the tank topples and the valve on the top of the tank is damaged, it is possible for the tank to become a torpedo propelled by the pressurized CO_2 escaping from the end of the tank.

- Always wear some level of respiratory protection when airbrushing. Even if a paint's label says that the paint is nontoxic, the overspray is not healthy to breathe. Paper masks are sufficient protection against dust and water-based paint spray. Two-stage masks have cotton or paper prefilters and an active charcoal filter approved by OSHA to protect the painter from the hazardous vapors of solvent-based paints. These masks are available in many designs. Consult your paint supplier for the type and style of mask best suited for the paint you are using. Make sure the mask fits snugly around both the nose and mouth areas.

- Paint sprayed with a large airgun makes considerable overspray that settles as dust. After spraying large volumes of any paint, clean your work area thoroughly.

- Never heat your workspace with any appliance that has an open flame if you are working with or storing flammable sign or automotive paints and reducers. These types of paints create dangerous vapors that can be ignited by any open flame.

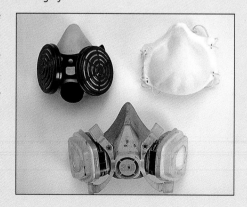

Clockwise from top left: small-size two-stage respirator with replaceable cotton prefilter and replaceable charcoal filter; cotton filter for use with water-based paints; large-size two-stage cotton/charcoal respirator with replaceable filter elements

DOTS

Before beginning, adjust the needle setting to spray a small volume of paint.

1. Hold the airbrush approximately $1/4$ inch from the paper surface at a 90-degree angle. Push the trigger down. Release the trigger as soon as you see a dot on the paper. Move to paint the next dot. Maintain a $1/4$-inch distance as you paint dots across the page.

2. Hold the airbrush $1/2$ inch from the paper and adjust the control knob to spray more paint. Repeat the trigger action you used in step 1 to render a larger dot.

3. To create larger dots, hold the airbrush slightly farther away from the surface. Practice painting dots of various sizes by holding the airbrush at different distances from the paper and adjusting the paint volume as needed to spray nice solid dots.

LINES

The line is the most difficult skill to master with the single-action airbrush because the paint flow cannot be feathered on and off at the end of each line. For thin lines, as for small dots, adjust the paint flow for less paint and hold the airbrush very close to the painting surface. To airbrush larger lines, increase paint flow with the control knob and hold the airbrush farther away from the surface.

1. Hold the airbrush $1/4$ inch above the paper and turn the paint control knob slightly to back the needle out of the paint nozzle slightly. To begin, start the airbrush moving in the direction you want to paint your line and depress the trigger. Once the airbrush is in motion, continue holding the trigger down. Maintain the $1/4$-inch distance from the paper as you move the airbrush along the line.

2. When the line is the length you want, let up on the trigger to stop the paint flow, *but continue to move your hand along the extended path of the line.* If you stop moving your hand, your lines will have barbell shapes at the ends.

3. Practice painting lines from right to left, left to right, up and down, and diagonally until you can paint a barbell-free-line everytime.

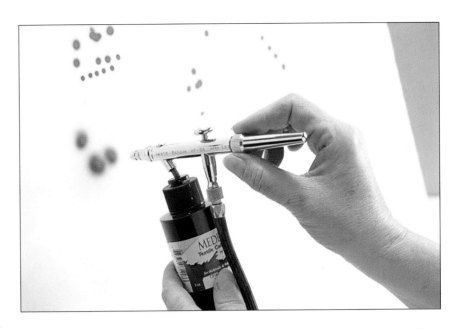

Adjusting the paint volume on a single-action airbrush. To spray a small volume of paint, turn the control knob clockwise fully, then counterclockwise $1/4$ turn.

From top to bottom: dots created by holding the airbrush $1/4$, $1/2$, and 1 inch from the surface.

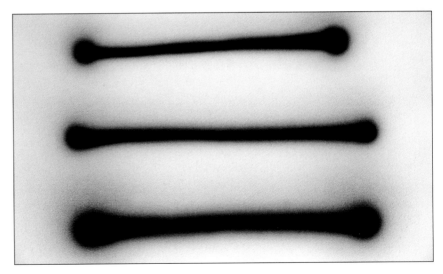

A barbell shape at the end of a line, like the ones shown here, will result if you fail to follow through with the stroke as you release the trigger.

GRADATIONS

The color gradation, or color fade, is used extensively both in freehand airbrushing and when filling in masks. Spraying a gradation with an airbrush is much like spraying a line with the airbrush, except the airbrush is held farther away from the surface and more paint is applied to cover the larger area being painted. The object is to use multiple overlapping passes to cover the surface with an evenly sprayed coat of paint, without any discernible blotches or lines, that fades smoothly and gradually from dark to light and has soft feathered edges. A gradation can be used to create a large background or to fill in a tiny masked area.

Airbrushing a color gradation with a single-action airbrush requires the same trigger control and airbrush movement that airbrushing a line does. The only difference is that the airbrush is held farther from the surface (4 to 12 inches) and greater volumes of paint are sprayed to cover the larger area. The basic technique for creating even color gradations with no dark streaks involves making multiple overlapping passes. The following exercise describes the procedure for a painting a gradation from dark to light color values, with the darkest values at the top of the page.

1. Hold the airbrush approximately 12 inches from the paper. To accommodate the increased distance from the paper, rotate the paint control knob to deliver the most paint possible. Maintain this distance throughout the exercise. Start the airbrush moving across the top of the paper in a horizontal pass.

2. Depress the trigger fully to initiate paint and airflow. Make a pass with the airbrush, taking care to maintain the 12-inch distance from the painting surface. If you get in too close with a paint pass, that pass will show up as a line instead of a nice even spray pattern.

3. When you have completed the first pass, let up on the trigger to stop spraying paint. As always, keep moving the airbrush along the path of the line or you will spray a barbell at the end of the pass.

4. Repeat the process in the opposite direction. The second pass should overlap the previous pass by one-half. Start the airbrush moving and depress the trigger. Hold the trigger down until you want to end the spray. When you reach the end of the second stroke, let up on the trigger while continuing to move the airbrush.

5. Repeat this process back and forth horizontally, overlapping each previous stroke by one-half, as you paint down the paper. Paint until the entire page has an even, light coat of paint.

6. Return to the top of the paper and repeat your back-and-forth passes to give the top half of the page another light coat of paint.

7. Return to the top of the page and repeat the process, but this time only repaint the top one-fourth of the page. If the paint is properly applied, you will see a soft, even blending of color that is darkest at the top of the page gradating to lighter values toward the bottom of the page.

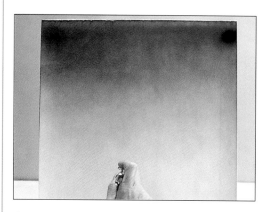

The surface after multiple light passes have been made.

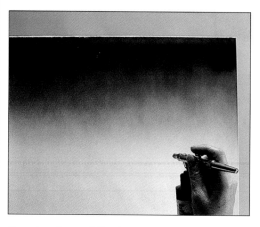

The surface after completing step 7.

Dual-Action Airbrush Operation

On a dual-action airbrush, the trigger is pushed down to allow "air only" to pass through the airbrush. Always hold the trigger down completely when painting. When the trigger is fully depressed, it is a simple matter to rock it backward and forward to move the paint needle in and out of the paint nozzle and deliver just the right amount of paint. Holding the trigger down at all times also results in a constant clean airflow across the needle, which prevents paint buildup on its tip.

Throughout this chapter, the correct trigger position for rendering the desired effect with a dual-action airbrush will be referred to by number, as shown.

The following step-by-step exercises take you through the creation of dots, dagger stokes, and gradations for dual-action airbrushes. You will need the same materials you used for the single-action exercises, and you should set up your materials (painting surface, easel, etc.) the same way.

DOTS

1. Grip the airbrush and hold the trigger down fully, releasing clean air out of the spray nozzle. While continuing to hold the trigger down, point the airbrush at a spot on the paper from a distance of approximately 1/4 inch. Ease the trigger back slightly to the 1 position by pulling it with your trigger finger, which is your index finger. Do not look at the tip of the airbrush to see if paint is being sprayed out. Instead, look at the spot on the paper where you are spraying. When the paint begins to exit the airbrush, you will see a round dot. Push the trigger forward to the 0 position to stop the paint flow. *Do not let up on the trigger between dots!*

2. Move your hand and paint the next dot by repeating step 1. Make a row of dots the same size across the paper. Remember to hold the airbrush the same distance from the painting surface as you paint and keep the trigger depressed between dots. Using your

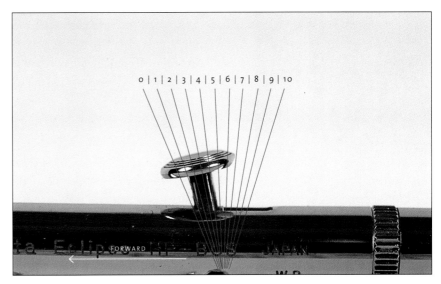

In this picture, the possible trigger positions are numbered from 0 to 10. At the zero position, there is no paint flow. As the trigger is pulled back from the zero position, more paint is released.

off hand as a bridge will help you to maintain a constant distance from the paper.

3. Holding the airbrush 1/2 inch from the surface, and with the trigger at position 2, make a row of larger dots across the paper.

4. Practice painting dots of different sizes by holding the airbrush at various distances from the paper, pulling the trigger to the higher numbers as you increase the distance of the airbrush from the surface.

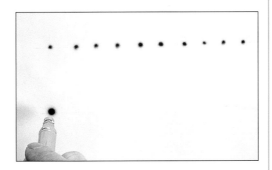

The row of dots shown here was painted by using the 0–1–0 trigger position. The larger dot was painted by using a 0–3–0 sequence.

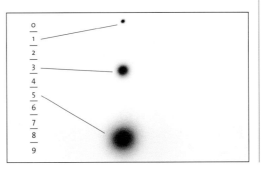

Three dots of different sizes matched to the trigger position that was used to paint them.

LINES

The basic principles of creating lines with a dual-action airbrush are the same as for a single-action airbrush. The weight of the line will be determined by how much paint is being released and how far from the paper you are holding the airbrush. As always, your goal is to be able to create perfect lines—lines with tapered ends—every time.

1. Hold the airbrush $1/4$ inch from the surface. Push the trigger down to deliver clean air. Start moving the airbrush horizontally from left to right. Gradually pull the trigger back to the 2 position as you move the airbrush along the path of the line until a solid line appears. Once the line is solid, *hold the trigger in that position and continue to move the airbrush along the path of the line.*

2. To end the line, simply push the trigger all of the way forward to stop the paint flow while continuing to move the airbrush along the extended path of the line.

3. Repeat the process, this time from right to left. Keep the trigger pressed down all the way between strokes. Keep practicing until you can create a perfect tapered line every time.

4. Holding the airbrush $1/2$ inch from the paper, start moving the airbrush along a line from right to left. As you move the airbrush along, taking care to maintain a constant $1/2$-inch

distance from the paper, gradually pull the trigger backward to the 3 position. Push the trigger completely forward to stop the paint flow at the end of the stroke while continuing to move the airbrush along the extended path of the line. As always, keep the trigger pressed all the way down. Hold the airbrush 1 inch from the surface and repeat the previous procedure while pulling the trigger backward to the 5 position.

5. Practice making lines holding the airbrush at varying distances—$1/10$ inch to 3 inches—from the paper, adjusting the paint flow accordingly by pulling the trigger backward to the appropriate position and returning it to the zero position. Paint lines back and forth, up and down until you have filled the paper.

DAGGER STROKES

A dagger stroke is a line with finely tapered ends and a thick middle section. Painting good dagger strokes is more difficult than painting uniform lines, but as this stroke has limitless applications, it is well worth the effort it takes to master it. The dagger, the most common stroke in freehand airbrushing (airbrushing without the aid of stencils or masks), is the only airbrush stroke that will render effects such as hair, fur, letters, and foliage without leaving barbell ends. The dagger stroke is also useful when painting with masks and shields. The painter can fill in a small masked area with

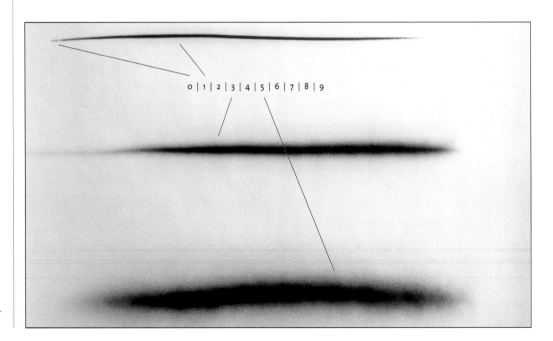

Three lines matched to the trigger position that was used to paint them. From top to bottom, the lines were painted at $1/4$, $1/2$, and 1 inch from the paper.

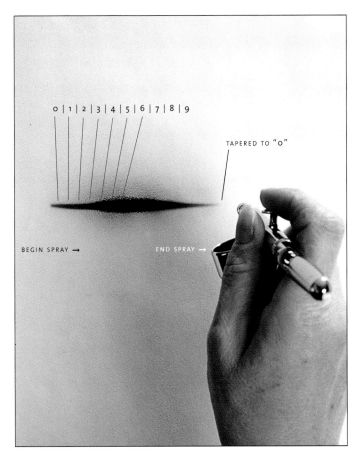

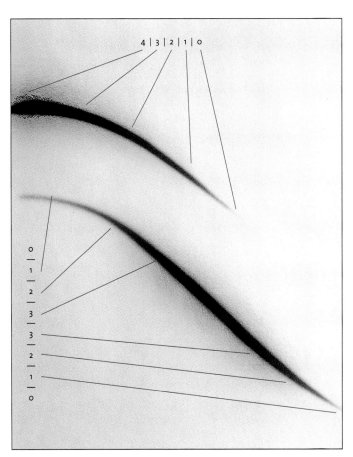

A single, short dagger stroke created by changing the trigger position incrementally from 0 to 6 and back to 0.

Two different strokes with the various parts of the line matched to the corresponding positions on the trigger-position chart.

multiple mini-dagger strokes to ensure that no paint buildup occurs against the raised edge of the mask or in the area surrounding the mask.

Airbrushing a dagger stroke is similar to airbrushing a uniform line, except you do not maintain the same trigger position.

1. Hold the airbrush ½ inch from the paper. Push the trigger down to deliver clean air. Start moving the airbrush horizontally from left to right. As you move the airbrush along the path of the line, gradually pull the trigger back to the 6 position.

2. Once you have reached the 6 position, immediately begin to push the trigger forward. Keeping pushing the trigger forward slowly, reducing the flow of paint. When the trigger has been pushed completely forward, paint flow will stop. As with all dual-action airbrush strokes, keep the trigger fully depressed between strokes. Taking care to maintain a constant 1-inch distance from the paper, practice until you can create exactly the effect you want.

GRADATIONS

Refer to page 40 for basic information on gradations. With a dual-action airbrush, not only can you achieve the dark to light effects that you get with a single-action airbrush, you can also create softly feathered edges. For the following exercise, you will need all the materials listed on page 38, plus Claybord or illustration board, plus ¾-inch 3M masking tape.

1. Tape around the edge of the Claybord or illustration board to create a ¾-inch border.

2. Hold the airbrush 9 inches from the surface. Depress the trigger fully to initiate airflow. Throughout the exercise, keep the trigger fully depressed.

3. Start the airbrush moving across the top of the paper in a horizontal pass from left to right. As the airbrush is moving, pull back on the trigger (0–10–0) as you begin spraying within the bounds of the masked area. Spray a wide paint pattern with the airbrush, taking care to maintain the 9-inch distance

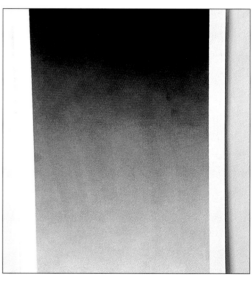

When spraying gradations with masks of any type, it is important not to build paint up against the edge of the mask, or it will have a high edge or "profile" once the masking tape is removed. To keep from building a high profile do not spray directly over the masking; instead, direct the spray slightly inside of the masking border and let the overspray color the area directly adjacent to the mask.

1

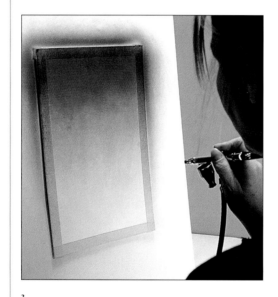

2 3

from the painting surface. If the airbrush is held too close to the surface for any given pass, you will create a line rather than a nice even coverage over the area you want to cover. Push the trigger forward (10–0) to stop the paint spray at the end of the pass just before painting over the taped border. This will ensure that you do not build up a high paint profile. Make multiple paint passes over the top one quarter of the page to gradually build color value from dark to light (photo 1).

4. Slowly work your way down the page, making fewer overlapping paint passes as you go, to gradually lighten the color values on the lower portions of the area. Stop painting 1 inch before you reach the tape border on the bottom (photo 2).

5. Remove the masking tape borders. The result should be a color value gradation from dark to light with a crisp border surrounding it (photo 3).

Working with Masks

All airbrush work requires that the artist know how to use masking materials to create the different images that will be seen in the finished piece. The three demonstrations that follow all involve the use of masks and/or stencils. They are designed for beginners, with the first being the most basic.

THE JIGSAW PUZZLE APPROACH

There are other approaches to masking when airbrushing complex designs, but the one shown here—which is rather like creating a jig-saw puzzle, then selectively removing pieces of the puzzle to airbrush the different parts of your design, then putting them back in place—is one of the most common. For the following exercise, you can use either frisket film or Mylar. If you use Mylar, you will also need 3M artist's repositionable adhesive. You'll also need three (or four; see step 1) different colors of airbrush paint, illustration board, and a #11 X-Acto knife.

Sun and Rays

1. Decide how large you want your finished design to be, then photocopy the design shown in photo 1 and enlarge to fit the dimensions you have decided on. Transfer the design to the frisket film or Mylar, using one of the methods described on page 63 or in the desert scene demonstration below. For the purposes of the demonstration, the "pieces" of the puzzle are shown already colored, but both frisket film and Mylar are transparent, and you will not see colors until you spray them on. Photo 1 has four distinct areas: 1, the background (which is colored blue here); 2, the rays of the sun (orange in the photo); 3, the sun itself (yellow); and 4, the area surrounding the sun and blue background.

2. Affix the design to your painting surface. Note that area 4, which is also masked, is not painted in this demonstration. If you like, you can choose a fourth color and paint that also.

3. Separate area 1 from areas 2 and 4 by cutting along their borders with a #11 X-Acto knife. For the 1–4 borders, you can use a cutting rail or some other straightedge.

4. Remove the masking from area 1.

5. Paint the background (shown in blue here). Let the paint dry thoroughly.

6. Replace the area 1 piece exactly where it was before. Remove the masking from area 2. Areas 1, 3, and 4 are covered with masking.

7. Airbrush the sun's rays (shown orange here), let the paint dry, and replace the masking over area 2.

8. Remove the masking from area 3 (areas 1, 2, and 4 are still masked), and paint it. If you would like to color area 4, replace the area 3 masking, remove the masking from area 4, and paint it. When all paint is thoroughly dry, remove the masking. Photo 8 shows the painted design.

3

4

5

6

7

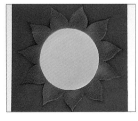

8

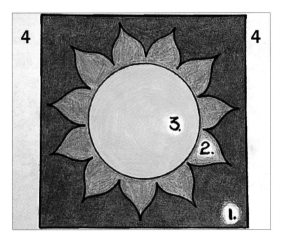

1

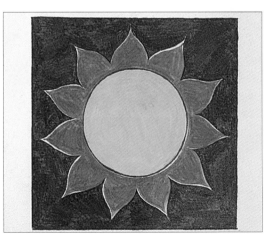

2

Desert Landscape

PAMELA SHANTEAU

In this exercise, I used masks to render both hard-edged foreground objects and soft background details. I also distinguished between background and foreground objects by varying the intensity of the color. (To keep the project simple, I used only one color.) I painted on 9- by 12-inch Claybord. I could have used illustration board, but paper was not an option because I would be using masking material with an adhesive backing. I also made my own homemade transfer sheet.

1. I drew the desert scene on inexpensive, lightweight copy paper, then put the scene, printed side down, on a clean white surface. I covered the visible lines of the entire back side of the design with a soft graphite pencil (6B). I used the side of my pencil lead to make broad strokes of graphite *to cover the main lines of the design only.*

2. I flipped the design over and affixed it to the top edge of the Claybord, graphite side down, using masking tape for hinges. I then used pencil to trace over the main lines of the scene, thereby transferring the graphite to the Claybord. To make sure the entire design had been transferred, I checked by lifting the sheet up.

3. I covered the entire painting surface edge to edge with transparent adhesive backed repositionable masking film, sticky side down. (Adhesive-backed masking film can be purchased in rolls or in precut sheets to specified dimensions.)

4. I used a #11 X-Acto knife to cut along the top ridge of the mountain range, then removed the frisk film covering the sky portion of the design. I put black paint in the airbrush and positioned the airbrush 6 inches from the surface at a 90-degree angle. I started moving the airbrush horizontally left to right, pulled the trigger to the 6 position, and held it there as I painted across the top edge of the exposed sky section, overlapping the top edge. When I reached the edge of the paper, I pushed the trigger forward to the

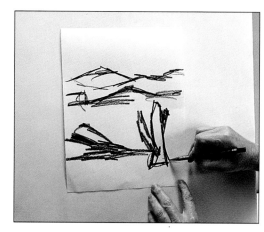

1. Applying the graphite application on the reverse side of my transfer sheet.

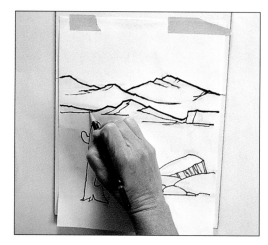

2. Transferring the graphite to the painting surface.

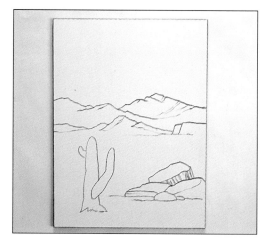

3. The transferred design covered with masking film.

zero position to cease paint flow, and kept the trigger pushed down to continue releasing air. I repeated the process holding the airbrush 7 inches from the surface, going from right to left and overlapping the previous first pass by

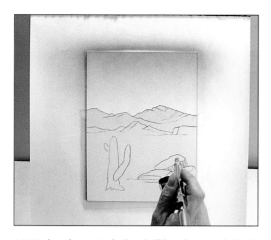

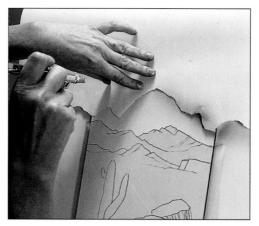

4. Notice how the paint is feathered off the substrate on both sides of the painting. This indicates where the trigger was pulled back to initiate paint flow and pushed forward to curtail paint flow.

5. Notice that the spray pattern appears on both the shield and the painting surface.

one-half. With every pass, I held the airbrush 1 inch farther from the surface than I had for the previous pass. I worked my way down the page, overlapping each previous pass by one-half. The final pass was made at a distance of about 11 inches from the surface, and the overspray covered the top edge of the mountain range with a light misting of paint.

5. I tore a piece of paper to resemble a mountain range, creating a type of hand-held shield, which I needed to render a distant mountain range in the extreme background of the image. I held the shield over the sky portion of the design, just above the top edge of the mountain range, which was still masked. Positioning the airbrush about 5 inches from the surface, and using the same trigger technique that I used in step 4, I painted over the edge of the hand-held shield (photo 5).

6. Holding the airbrush at a constant 6-inch distance from the surface, I started moving the airbrush horizontally left to right. I pulled the trigger backward to the 6 position and held it there to make a paint pass over and across the top edge of the masked mountains in the foreground. The spray pattern covered both the masked section in the foreground and the bottom edge of the middle mountain range. I gradated the paint from dark to light upward from the masked mountains in the foreground, each time pushing the trigger forward all the way (zero position) with my index finger when I reached the edge of the page.

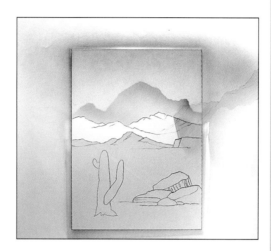

6. I used my #11 X-Acto knife to cut out and remove the thick strip of masking covering the middle-distance mountains. The soft, fuzzy appearance of the distant mountains is due to the fact that some underspray encroached under the shield, an effect that would not be possible if masking film had been used.

7. With the X-Acto knife, I cut the perimeter of the cactus and rocks in the foreground to separate them from the rest of the masked area and removed the remaining masking film from the mountain range in the foreground (photo 6) along with the "ground" in the foreground.

8. I painted the terrain around the rock and cactus with controlled paint-on, paint-off strokes to indicate shadows and terrain. The frisket film covering the cactus and rocks protected them from paint encroaching into their areas. Note the darker shadows close to the base of the cactus and rocks. They were rendered by concentrating multiple light paint-on, paint-off strokes (trigger position 0–2–0)

from a 1-inch distance. The terrain and shadows are a combination of soft fuzzy dagger-type strokes with small gradation strokes. Notice that all strokes are horizontal and feather off on the edges (see photos 7 and 8).

9. I created the barrel lines of the cactus by painting vertical lines of varying widths along the body and arm of the cactus (photo 9).

10. For the thorns, I airbrushed small dots along the length of the cactus (photo 10).

11. I held the airbrush $^1/_{10}$ inch from the surface to render some fine lines of uniform width on the rocks.

12. To paint the details in the two mountain ranges closest to the viewer, I started at the left edge of the middle mountain range and painted an airbrushed line over the graphite line to reinforce and define it. I continued to paint over all of the graphite lines in the front two mountain ranges (see photos 11, 12, and 13).

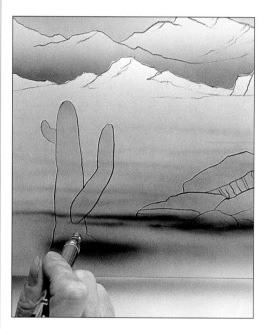

7. The overspray surrounding the substrate indicates where the paint spray was initiated and curtailed.

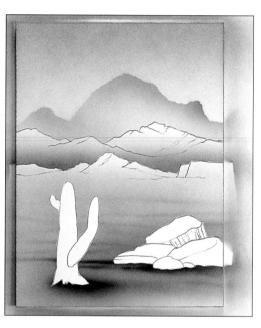

8. The foreground shadows and terrain are complete, and the frisket film has been removed from the cactus and rocks.

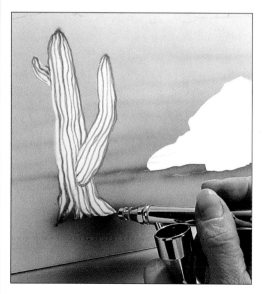

9. Creating the ridged effect of the cactus.

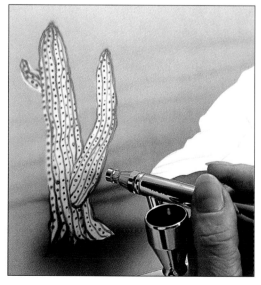

10. Airbrushing the thorns.

11. Outlining the rocks.

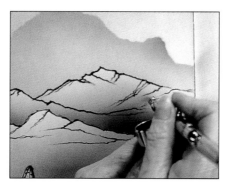
12. Reinforcing the lines in the middle mountain range.

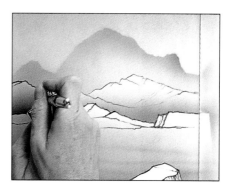
13. Reinforcing the lines in the foreground ranges.

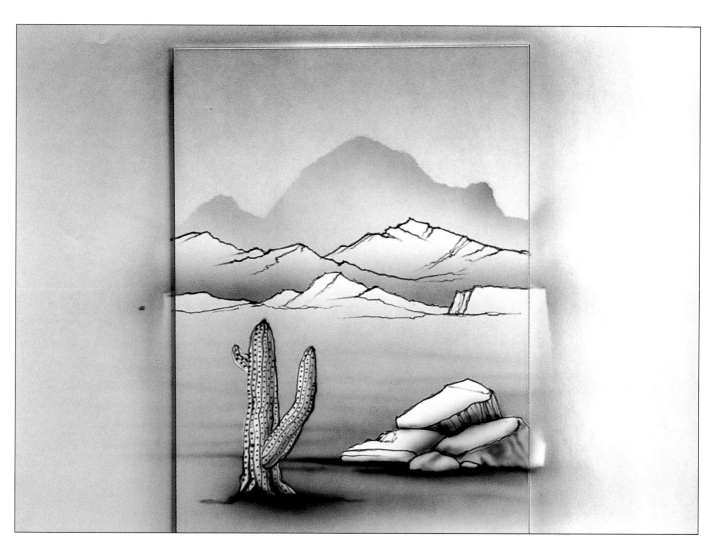
14. The finished desert scene. Notice how far off the painting surface the overspray reached. This indicates the points at which the trigger was pulled on or pushed off to start and stop paint flow

Working with Blended Color

The effects created by blending different colors of paint on a surface with an airbrush vary greatly depending on the characteristics of the paint being sprayed. Oils, acrylics, enamels, watercolors, and inks all have distinctive properties that can be modified by changing reduction levels and application rates. An opaque paint can be modified to transparent if it is thinned sufficiently with reducer or other appropriate medium and is sprayed in light coats. Because every brand of paint or ink has a unique chemistry, there is no absolute formula to determine mixing ratios of reducers or paints. Trial and error with the brand of paint or ink you desire is the only sure way to understand in advance what will happen when you spray it with an airbrush.

Opaque paint covers whatever it is painted over when applied in sufficient quantities. Multiple light coats of opaque paint are applied until the color value builds up enough to obscure the underlying surface. Once the opaque color reaches its maximum saturation, its color value will remain constant. No matter how many additional coats are sprayed, it will get no darker. Opaque paints build solid color value quickly, which makes them great for signs and other jobs that require quick coverage with a solid color.

Airbrushing transparent paint can produces rich tones by blending with whatever color is underneath them. The color will intensify with each added layer of transparent paint. If not skillfully applied, the transparent color will combine with the underlying color to make dark, muddy colors. Transparent mediums blend easily to create seamless transitions of one hue to the next.

Apple

PAMELA SHANTEAU

If you want to follow this demonstration step by step, start by photocopying the apple (photo 1) and enlarging it to the desired size.

I used Claybord as my painting surface. You will need all the materials that were used for the desert scene, except black paint. You will also need transparent red, green, brown, orange, and yellow acrylic airbrush paint. *Between each color change, you must evacuate the color you were using from the airbrush, flush the airbrush thoroughly with water, and spray all residual water from the airbrush before adding the next color.*

1. Following the same procedure that was used for the desert scene, I drew the apple on copy paper, flipped the paper over, used the side of a 9B graphite pencil to scribble graphite over the entire design, and attached the paper, graphite side down, to the Claybord. Once the design was completely transferred (I checked by lifting up the transfer sheet at the bottom), I removed the transfer sheet from the illustration board (photo 2).

2. I removed the backing from the repositionable adhesive-backed masking film, positioned it, sticky side down, over the illustration board, and smoothed out any bubbles by working them from the middle to the edges. I used the #11 X-Acto knife to cut out the outline of the apple, stem, and leaf, and pulled up the center design, leaving the surrounding area protected by the mask (photos 3 and 4).

3. Holding the airbrush 4 to 6 inches from the surface, and using the same paint-on, paint-off trigger technique demonstrated in the color gradation exercises earlier in this chapter (0–6–0), I sprayed sprayed a light coat of yellow over the apple, stem, and leaf. So that I would be able to create a highlight later, I left a small area at the upper left side of the apple unpainted. Because linear horizontal or vertical paint lines would destroy the rounded effect of the apple, I sprayed just inside of the frisket film border, following the contour of the apple. Overspray from the airbrush "filled" the small area directly adjacent to the masking film with pigment without

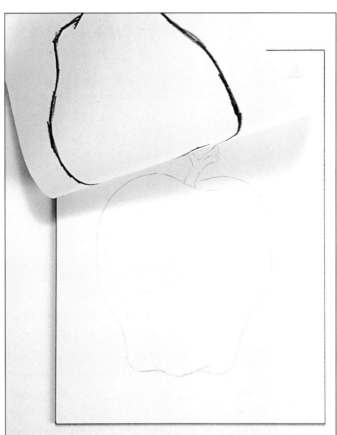

1

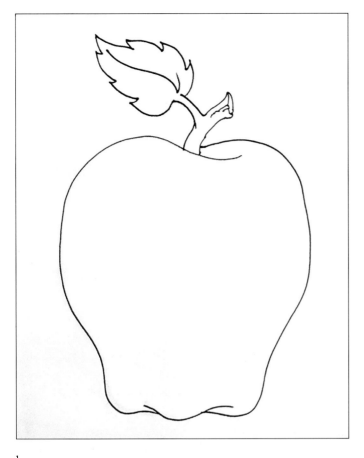

2

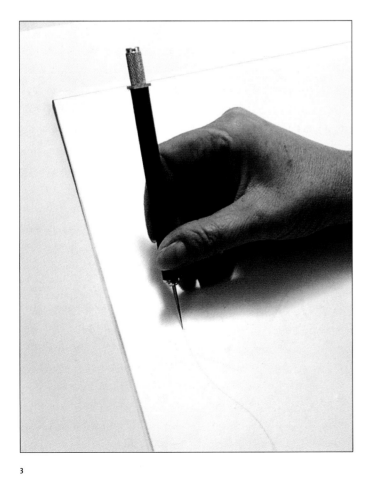

3

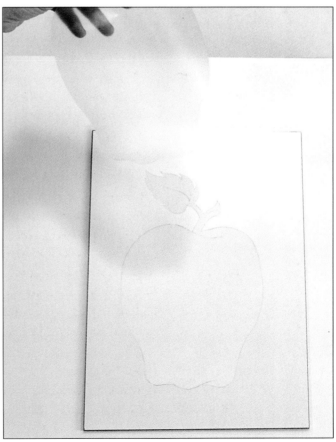

4

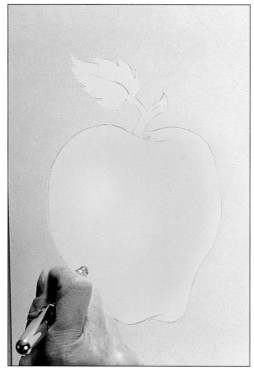

5

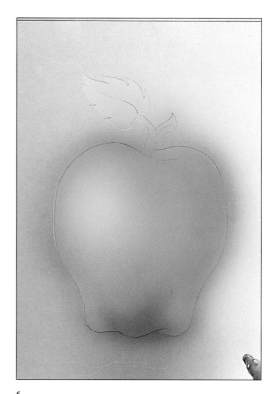

6

building a high paint profile. Visual evidence of the overspray appears on the masking that surrounds the yellow field. (See photo 5.)

4. I put orange paint in the airbrush. Since this project has the light shining on the apple from the viewer's upper left, I began airbrushing orange paint from the extreme lower right side of the apple. I gradated (blended) it upward and into the yellow area with light paint passes. I painted the inside contour of the apple shape completely, then made more paint passes over the lower areas of the apple to build up color. The value changes in the airbrushed orange paint were not created by changing color, but by making additional passes in the darker areas. Again, I followed the contour of the apple, never making side-to-side linear strokes. These slight variations were essential to create a three-dimensional effect. I did not spray orange paint directly on the highlight area. (See photo 6.)

5. With red paint, I defined the shapes and shadows by painting small color gradations with paint-on, paint-off strokes in the appropriate areas. I overlapped the gradations so that the right side was darkest, gradating

to lighter values toward the left side. I tried to keep the overspray into the highlight area to a minimum. I used about 75 percent of the red paint for this step (photo 7).

5. With brown paint, and holding the airbrush about $1/4$ inch from the surface, I used mini-dagger strokes to fill the stem area with very light wisps of brown paint. To paint the small ridges in the stem, I moved the airbrush so that it was about $1/10$ inch from the surface and sprayed lines of various widths and lengths. Because the background brown was painted lightly, the ridges stand out prominently (photo 8).

6. With green paint, I made small gradation passes along the length of the leaf from a $1/2$-inch distance from the surface, gradating from darker color on the right to lighter color on the left. I did not spray colors evenly over the surface of the leaf, but used more paint in some areas than others to help define the leaf's shape and contour. The trigger movement was in the 0–2–0 range. To make a highlight, I left some yellow on the upper left of the leaf. I airbrushed dagger strokes of various lengths to paint the veining in the leaves. (See photos 9 and 10.)

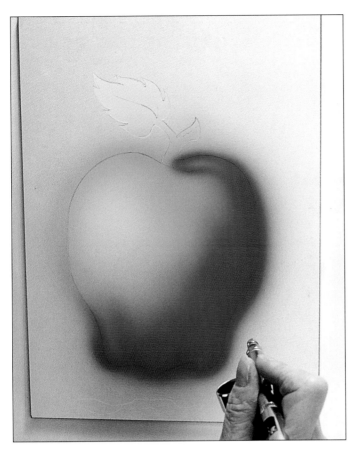

7

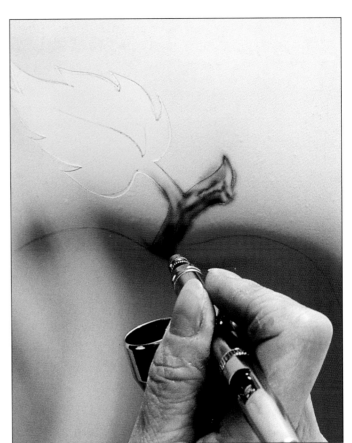

8

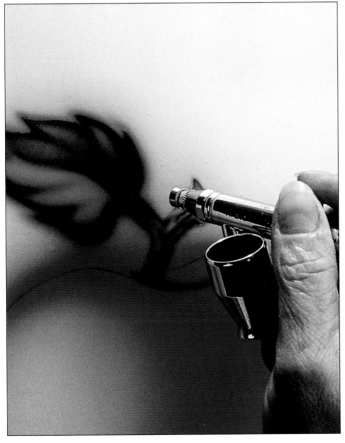

9

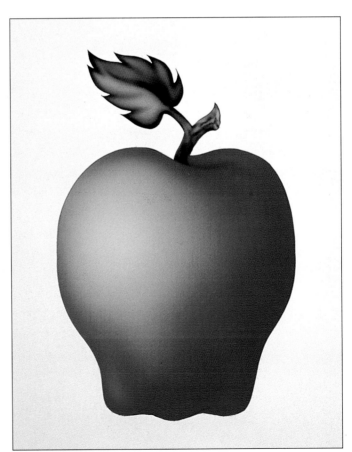

10

Cleaning Your Airbrush

After using your airbrush, you must clean it thoroughly, including all components of the needle-nozzle assembly, using these steps:

1. The paint nozzle, which is the most fragile component of the airbrush, is seated under the head assembly and to clean the nozzle you must remove the head assembly. Sometimes the head assembly can be removed by hand; sometimes you will need a wrench. If the nozzle is not threaded to the airbrush's body, you must keep the airbrush pointed upward as you remove the head assembly so the nozzle will not fall out of its seat. Check your airbrush's parts manual for information about how your paint nozzle attaches to the airbrush.

2. Remove the nozzle by unscrewing it or grasping it with your fingers and wiggling it out of its seat. If you damage the nozzle in any way, you will have to replace it.

3. Use water or the appropriate solvent for your paint to flush the paint nozzle. Pay particular attention to the point where the paint needle seals against the inside of the nozzle. If there is dried paint on the needle, it cannot seat firmly and cleanly against the inside of the nozzle. You can use squirt bottles for water and an old paintbrush for automotive solvents and reducers. Check for blockages inside of the nozzle using the needle from the airbrush. Scrape the inside of the nozzle and work out any paint that might have dried inside of it. Never enlarge or change the shape

of the orifice at the tip of the nozzle. If you do, it will have to be replaced.

4. Remove the tailpiece of the airbrush and loosen the needle's locknut by turning it counterclockwise one and one-half turns.

5. Remove the needle from the airbrush. With some models, the needle can be removed from the front of the airbrush after the head and nozzle have been removed and the locknut loosened. With others, you remove the needle from the rear of the airbrush after loosening the locknut. Check the manual for the model you own to see how the needle comes out. Clean the needle completely with water or the appropriate solvent.

6. Clean any dried paint from the inside of the needle guard, which attaches to the end of the airbrush's head assembly. An X-Acto knife, old toothbrush, or cotton swab with the appropriate solvent works well.

7. Flush the path the paint follows as it passes through the airbrush using a squirt bottle filled with warm water or airbrush cleaner.

8. Flush the airbrush body with water or the appropriate solvent, using a squirt bottle to force the cleaner through the airbrush's body. The hole in the needle-chucking guide at the rear of the airbrush is perfect to squirt the cleaner into. Once the airbrush is clean, evacuate the remaining cleaner from the body of the airbrush by spraying clean air and shaking the airbrush upside down. Dry the airbrush thoroughly with a clean cloth. If

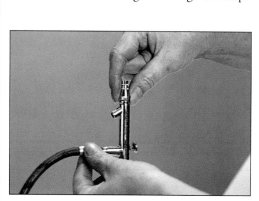

The head assembly being turned counterclockwise to loosen it.

Removing the paint nozzle from the body of the airbrush.

Flushing the paint nozzle with water from a squeeze bottle.

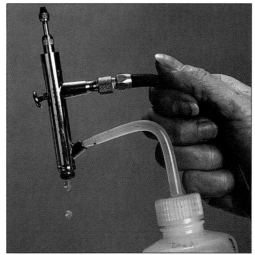

The squirt bottle forces water into the intake orifice on the underside of the airbrush; the water exits through the hole that the paint nozzle seats into.

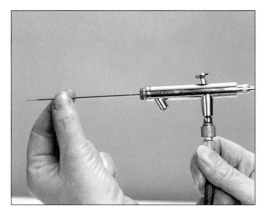

Needle being drawn from the the front end of the airbrush.

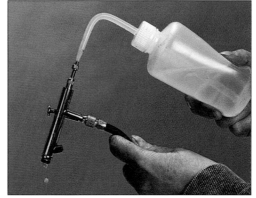

Flush the paint from the paint nozzle using a plastic squeeze bottle with a long neck and a tiny opening that directs the water exactly where it is needed.

water is left in the airbrush after cleaning, the metal alloys of the paint nozzle and needle may bond, so the needle cannot be removed from the airbrush easily.

9. Lubricate the needle before reassembly. Apply petroleum jelly, light grease, or a lubrication product made especially for cleaning airbrushes to the needle and chucking assembly. This will keep the metal parts in the needle-nozzle assembly from bonding when the airbrush is not in use.

REASSEMBLING THE AIRBRUSH

1. Start with the paint nozzle. Hold the airbrush so it is pointing up. Place the paint nozzle in its seat or screw it in.

2. Screw the head assembly on, being careful not to damage the nozzle as it slides into the head assembly. Tighten the head to the airbrush body. Usually, the apppropriate tightness can be achieved without a wrench.

Push the needle into the airbrush. Starting at the rear of the airbrush carriage, push the needle into the chucking guide and through the airbrush just until it seats snugly against the inside of the paint nozzle. If you force the needle once it has stopped, you may damage the paint nozzle.

4. Tighten the locknut on the end of the carriage. Make sure the locknut is tight or the needle will not respond properly when the trigger is pulled back.

5. Screw the tailpiece onto the back of the airbrush.

Using an Airgun

For general information on airguns, see Chapter 1, pages 20 to 21. Operating an airgun is relatively simple compared with operating an airbrush. Normal operation of an airgun does not require as much finger control or fine detail work as the airbrush does. The main goal when using an airgun is to spray an even coat of paint on a surface with no drips or sags in the paint.

Large airguns combine elements of single-action and dual-action airbrushes. The paint spray pattern and paint volume are adjusted with control knobs on the airgun, as they are with single-action airbrushes. Airgun triggers resemble dual-action airbrush triggers in that they have two "stops"; pulling the trigger to the first one initiates the flow of clean air and pulling the trigger to the second one initiates the flow of paint.

1. Put paint in the color cup.

2. Hook the airgun up to an air source. (A large air compressor with a regulated air line and moisture trap is recommended.)

3. Set the air pressure to 40 psi for a standard airgun or 10 psi for an HVLP model. Pull the trigger back and initiate the airflow to set the working psi.

4. Set the pattern and paint controls to the halfway marks. Test the spray pattern and paint volume by pulling the trigger back all the way, spraying a test pattern, and looking at the result. Adjust the controls until you can produce an oval spray pattern of uniform coverage.

5. Holding the airgun approximately 24 inches from the surface, pull the trigger back to the first setting, which starts the air flow, and begin to move across the painting surface horizontally. To introduce paint into the airflow, pull the trigger back until it stops. Maintain the 24-inch distance to the surface as you make your paint passes. At the end of each stroke, push the trigger back to the first stop, which will stop the the paint from spraying, but be sure to keep the airflow going.

6. Repeat the process in the opposite direction, overlapping the previous paint pass by one-half. Continue back and forth until you have covered the entire area or object you are painting with an even coat of color.

7. If a deep color is desired, build the color by applying multiple light coats of paint instead of one or two heavy coats. Applying heavy coats will result in runs in the paint.

CLEANING YOUR AIRGUN

It is essential to clean your airgun thoroughly after every use. If paint is ever allowed to dry inside of an airgun, you will need to replace the affected parts.

After you have disposed of any surplus paint in your paint cup, wipe it out with a paper towel. Put an appropriate solvent into the color cup and use an old paintbrush to scour the inside of the receptacle until no pigment can be seen. Refill the paint jar with clean solvent and spray it through the airgun. Disassemble the paint head and wash the parts with an appropriate solvent. An old paintbrush or toothbrush does an adequate job of cleaning the spray head and paint orifices. Wipe the parts dry before reassembling the airgun.

Troubleshooting

Problem: The paint is not spraying in a continuous, steady stream, but is spitting or skipping.

1. Paint nozzle blocked.	1. Remove the paint nozzle from the airbrush and clean with appropriate solvent.
2. Paint has built up on the paint needle, increasing its diameter.	2. Remove and clean the paint needle.
3. The breather hole in the paint reservoir is clogged.	3. Clear breather hole located in the cap of the paint reservoir with an old airbrush paint needle or other sharp object
4. The paint path is clogged.	4. Flush the entire paint path. Start with the tube in the paint reservoir and continue to the airbrush's body. Finally, flush the paint nozzle.
5. The paint reservoir is nearly empty.	5. Add paint to the reservoir.

Problem: You cannot make fine lines with the airbrush.

1. The paint nozzle is damaged or worn.	1. Replace the paint nozzle.
2. Paint has built up on the needle, increasing its diameter.	2. Remove and clean the paint needle.
3. Air pressure is too low.	3. Increase air pressure by adjusting the air regulator.
4. The airbrush is being held too far from the surface.	4. Hold the airbrush's tip as close as possible to the surface as you spray.

Problem: The paint is splattering or running

1. The consistency of the paint is too thin.	1. Make sure the paint has not been excessively thinned and is shaken vigorously before use.
2. Too much paint is being sprayed for the distance the airbrush is being held from the surface.	2. Adjust the distance from the airbrush to the surface.
3. Paint has not been thoroughly mixed.	3. Shake the paint bottle vigorously before putting it in the paint reservoir.

Problem: Bubbles are appearing in the paint reservoir or color cup.

1. The head assembly is not sealed to the airbrush body.	1. Tighten the connection of the head assembly against the airbrush's body with a wrench.
2. The tip of the airbrush is blocked.	2. Clean the needle guard and head assembly where the paint exits the airbrush.

Problem: Paint sprays before the trigger has been pulled backward.

1. The locknut at the rear of the needle is loose.	1. Tighten the locknut.
2. The paint nozzle orifice is damaged.	2. Replace the paint nozzle.
3. The paint needle is not sealed against the inside of the paint nozzle.	3. Disassemble and clean the needle and paint nozzle.

Problem: The needle cannot be removed from the airbrush.

1. Paint has dried in the airbrush body or paint nozzle.	1. Soak the airbrush parts in appropriate solvent and attempt to remove the needle once the paint has emulsified. Be prepared to replace parts.
2. The needle's locknut has not been loosened.	2. Loosen the locknut in the rear of the airbrush.

Problem: The needle will not pass through the airbrush when reassembling after cleaning

1. The trigger of the airbrush has been installed sideways.	1. Reinstall the trigger correctly.

Problem: Trigger movement backward and forward does not affect paint flow.

1. The needle locknut is loose.	1. Tighten the locknut.

Problem: Nothing happens when the trigger is pushed down.

1. The air supply is blocked or restricted.	1. Make sure all air valves are open and the regulator is adjusted to spray to the correct psi setting for your project.
2. The air compressor is not on.	2. Turn on the air compressor.
3. The trigger is improperly installed.	3. Make sure the bottom of the trigger is engaging the air valve in the neck of the airbrush. (Your owner's manual will show the correct way to install the rigger so that it engages the air valve.)

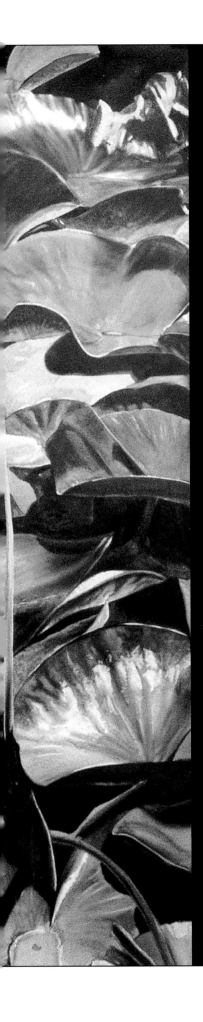

DEVELOPING
IMAGES

There is more to becoming a competent airbrusher than knowing how to operate the airbrush and mastering basic techniques. The most successful artists have a healthy store of images—called *references*—they can call upon to provide the inspiration for a given piece. Airbrushers who are masters of freehand drawing will often simply use a reference image as a guide as they lay out their designs with graphite pencils, colored pencils, or other drawing implements. Others will use one of the standard transfer tools, which include projectors, photocopiers, and the classic graphing (grid) method. This chapter discusses both how to go about collecting references, with an emphasis on 35mm and digital photography, and how to reduce and enlarge, and transfer, the chosen image to the painting surface.

Reference Materials

Most artists, including airbrush artists, maintain a collection of images that often is referred to as a *reference morgue*. The contents of the morgue are used to develop paintings or stimulate new ideas for paintings. The images in this collection can be gleaned from almost any source. Slides and photographs (35mm and digital) are excellent reference sources, and avoid any problems connected with using other artists' work. Often, artists take reference photos specifically for an assignment. A wildlife painting might require a trip to a zoo to take photos. A fantasy painting might require photographing a model and then adding wings and other details to the image during the projection process.

The Shanteaus' personal morgue consists of file cabinets containing both reference pictures from other artists or photographers and thousands of photos and slides, as well as a large collection of digital images, which can be housed in a fraction of the space needed for film prints and slides. Digital images can be stored on the hard drive of a computer, and backed up on zip disks, until they are needed—for printing to use as a reference or to be published on the Internet. When you have a healthy stock of reference materials, no matter what project you are pursuing—for example, to develop a new character for a game—you can browse through your reference morgue looking for an existing photo that might be altered to suit your needs.

Pictures from magazines, newspapers, and books are a very common source of reference. Books by master fantasy painters (Pamela says that Boris Valejo, Frank Frazzetta, Roger Dean, Hajime Sorayama, and Olivia are personal favorites) are staples in most reference morgues.

Publications such as *National Geographic* offer a plethora of top-quality images across a wide range of subjects. Other sources of qual-ity reference include wildlife magazines, fashion magazines, science and space publications, and, of course, the Internet.

A NOTE ON FAIR USE

Fair use refers to the use of a copyrighted image that is permissible under copyright law. The copyright law states that use of a copyrighted work for purposes such as "criticism, comment, news reporting, teaching (including multiple copies for classroom use), scholarship, or research is not an infringement of copyright." Taken into account when deciding whether a particular copy is an example of fair use is the purpose and character of the work (any commercial use is definitely illegal), the nature of the copyrighted work, what portion of the work in relation to the whole has been copied, and the effect of the use on the potential market for and value of the copyrighted work. Any work *not* protected by copyright can be copied, even if it is for commercial purposes. For more information on what works are and are not protected by copyright, go to the Copyright Office Web site: www.loc.gov/copyright.

If in doubt, *don't copy someone else's work*. Architectural works created after 1990, for example, are protected by copyright, which means that you could copy a photograph of Notre Dame Cathedral and use it for T-shirts that you plan to sell, but you could not legally copy a photograph of, say, Zaha Hadid's Vitra Fire Station, which was built in 1993, to use commercially. Many airbrush artists, including A. D. Cook (see Chapter 8, page 118), prefer to work entirely from reference material they have created themselves, thus avoiding all copyright issues.

You should never do an exact copy of any reference that you did not develop yourself. If you use another artist's photo or artwork as reference, be sure to add, subtract, or change enough elements in the design so that you can truly call the work your own. For example, when Pamela Shanteau was asked by a game developer to paint an angry army of Asian peasants armed with primitive weapons, she used a photograph depicting a modern-day political protest in China to work out the basic perspectives and proportions for the game scene. Changing the signs and banners into wooden spears and flags was a simple matter, as was adapting the clothing style to reflect the era that the game was set in. She projected the scene onto her painting surface, traced the people who made up the angry mob characters, eliminated the details in the scene that did not apply, and added details as necessary to improve the composition.

Anyone planning to use an image that has been sculpted, drawn, painted, or photographed by someone else as reference must keep in mind that such images are the property of the artist, photographer, and/or publisher. Any unauthorized reproduction of someone else's art or photos for profit is illegal. (See Box: A Note on Fair Use.)

Students and airbrush novices who have yet to accumulate a reference morgue are advised to begin compiling one as soon as possible. Remember that quality reference materials are available everywhere, but the best source for originality is your own camera or sketchpad.

TAKING PHOTOGRAPHS

Whether you are using a 35mm camera or a digital camera, get the best system you can afford.

- Any camera equipped with a quality lens is suitable for taking photographs for reference. Different lenses have different capabilities, depending on the focal length.
- Any lens with a focal length of 28mm or less is considered a wide-angle lens. A wide-angle lens will capture the entire profile of an object like an automobile from a relatively short distance. Wide-angle lenses are useful when shooting photos in confined areas. Be aware that if you use focal lengths below 28mm, a fish-eye effect will be evident. The lower the focal length of the lens the more pronounced the fish-eye effect will be.
- Fixed lenses with a 50mm focal length are preferred for portrait photography because they emulate the human eye.
- Zoom lenses have a range of focal lengths, for example from 28 to 80mm, 70 to 200mm, and 100 to 300mm. A lens with a 300mm focal length will fill the frame with an object from a distance. This type of lens is useful for outdoor and wildlife photography.
- If a detachable camera lens does not have macro capabilities, a macro adapter might be available for it. This accessory attaches between the lens and the camera body to enable the lens to focus on an object from mere inches away.
- An accurate light meter, whether hand-held or built in, is a must.

From left to right, 35mm camera with Tamerac brand 28 to 200mm zoom lens, macro focusing teleconverter (Vivitar), Sekonic L718 light meter, 35mm camera with Tokina brand 28 to 105mm zoom lens.

Digital Cameras

Digital cameras offer unparalleled convenience and economy when matched with a quality color printer. Top-shelf digital cameras rival their 35mm cousins for picture quality.

High-end professional digital cameras are still much more expensive than comparable 35mm cameras, but this is changing rapidly. In mid-2001, professional-quality digital cameras manufactured by Canon or Nikon that are capable of taking images up to 6.0 megabytes were priced in the $3000 to $5000 range. Two years ago, the same camera would have cost in excess of $20,000. As prices continue to drop on digital cameras, they are fast becoming the first choice for photographers. If you wish to print a digital photo on a computer printer, you will want to shoot and save it in the largest file size possible. The denser the pixels, the better the print will be. If the digital photo is intended for use on the Internet, maximum file size is not needed since the Internet only supports 72 dots per inch (dpi).

With digital work, missed photo opportunities due to inaccurate camera settings that aren't discovered until after the film has been processed are a thing of the past. Digital images can be displayed, reviewed, or printed instantly to check for proper composition and exposure. This feature is very handy when photographing reflective surfaces. An unwanted "hot spot" from a reflection or flash unit can ruin an otherwise good photograph. As digital images can be viewed immediately after taking them, such flaws can be spotted right away and the image reshot if necessary. The ability to take hundreds of digital photos in one day, without purchasing film or paying and waiting for film processing, makes it simple and economical to become an experienced photographer in a very short time.

Digital images can be published on the Internet with minimal effort. A Web page or Web site is a great way to gain exposure to a wide range of potential customers. Anyone investing in a new camera system, especially artists and illustrators, should seriously consider digital imaging.

DIGITAL TIPS FROM DONN SHANTEAU

I shoot my digital images with an Olympus C-2020 Z digital camera, which I bought in 1999 for over $800. Today the same camera costs $500 or less. It captures and saves images up to 2.1 megabytes (1600 dpi x 1200 dpi) and has macro capabilities for extreme close-up photography. The 2.1-megabyte file size is adequate for creating quality 8- by 10-inch prints on any decent color printer for use as reference or display purposes at events, shows, and conventions. A one-megabyte file size will produce a quality print up to 3 by 5 inches. If the 1-megabyte image is printed in a format larger than that, the image will appear grainy due to insufficient pixels to fill the larger area.

An Olympus 2020 digital zoom camera

Transferring Images

After you have decided what image you are going to use, you must transfer it to the painting surface or to masking material such as drafting film, paper, or acetate. You can transfer images using the classic graphing technique, using a slide projector, or using an opaque projector. You can also use white copy paper and graphite to transfer a design; this technique is explained in Chapter 2 in the Desert Scene demonstration beginning on page 46.

OPAQUE PROJECTORS. Opaque projectors are used extensively by airbrush painters and artists alike. They facilitate design enlargement or reduction in a fraction of the time it takes to graph an image manually. A drawing or photograph is placed in the projector and the image is projected onto a surface. The surface can be the substrate you will be painting on or it can be masking material such as drafting film, paper, or acetate. Use the projected image as a guide to trace the outline and pertinent shading onto the substrate or the stencil material with graphite. Once that is done, the design is ready to paint or the masking material is ready to be cut apart and used as stencils.

SLIDE PROJECTORS. A slide projector makes a great layout transfer tool. Simply photograph your subject with slide film and project the image to scale onto your substrate or masking material. Adjust the scale of the projected image by moving the unit closer to or farther from the surface. As with the opaque projector, draw in the outline and details on the painting surface or masking material with a graphite pencil.

PHOTOCOPIERS. Photocopiers are invaluable for enlarging or reduce a drawing or photo in an instant. Multiple copies of the same design can be cut into sections with an X-Acto knife and used as hand-held shields.

GRAPHING. The oldest method for transferring an image to a painting surface is called graphing. Using this time-tested method, you can transfer a design to the painting surface or masking material with only a pencil and a ruler.

1

2

3

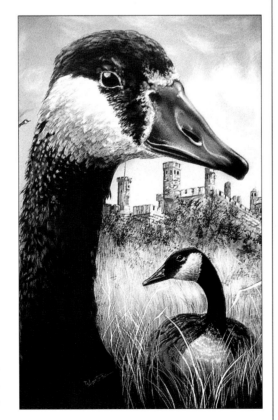

4

Transfer by Graphing
PAMELA SHANTEAU

1. I chose a suitable source image: a 4- by 6-inch photograph of a goose from my personal reference morgue (photo 1).

2. On Mylar film, I created a grid with eight ½-inch squares horizontally and twelve ½-inch squares vertically, numbered each square along the top and left sides, and placed the film over the source photo (photo 2).

3. I wanted to airbrush a painting that was twice the size of the source photo, so I doubled the size of the Mylar grid, making 1-inch squares instead of ½-inch squares, on a 9- by 12-inch Claybord surface, then numbered the squares. (Because the Claybord was 1 inch wider than the Mylar film, the extreme right column was not numbered. I used this space as a border area for the goose's bill.)

4. I laid the original Mylar-covered source photo next to the Claybord surface with the 1-inch grid and copied the lines of each square in the ½-inch grid onto the square with matching numbers on the Claybord surface (photo 3).

5. After I had transferred the entire goose design onto the painting surface, I erased the grid. To complete the painting, I add a castle in the background, some foliage, and a companion goose (photo 4). I sprayed a clear fixative over the finished artwork as a protective coating.

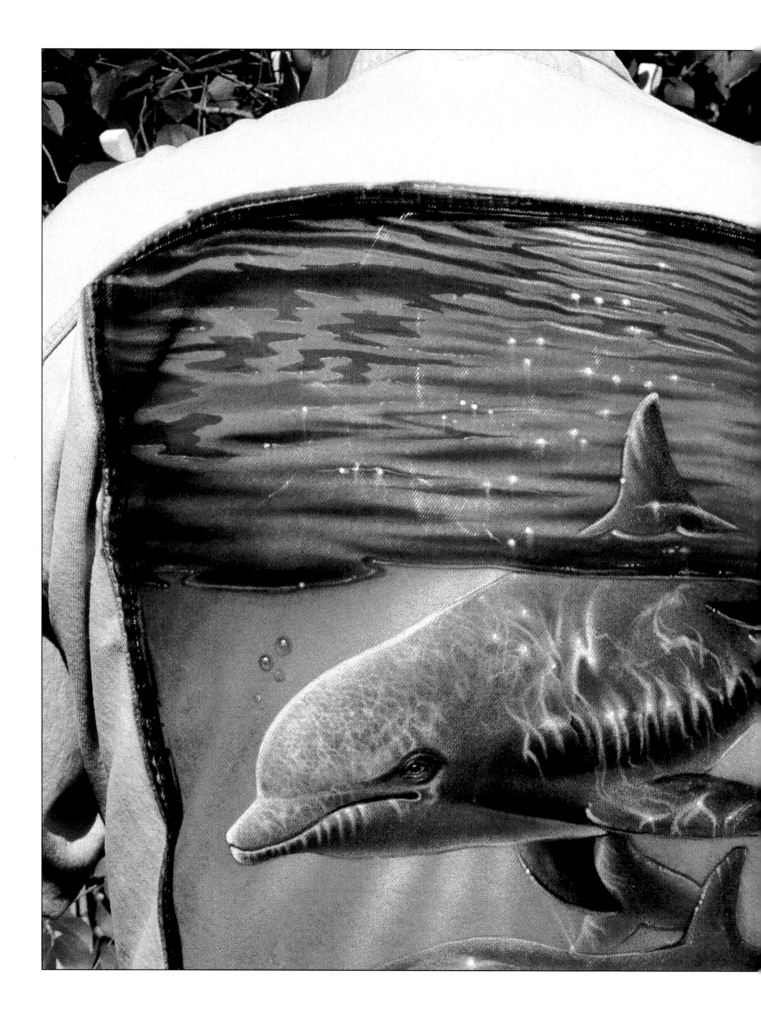

TEXTILES

Airbrushing on textiles is the most common way to make money with the airbrush. Airbrushers set up shop at fairs, conventions, concerts, and shopping malls to paint T-shirts, sweatshirts, jeans, leather articles, hats, and bags. Textile airbrushing is a good jumping-off point for anyone who wants to make a career with the airbrush because airbrushed clothing and accessories appeal to such a wide range of potential customers.

The Basics

Getting started is easy—and it does not require major investments in equipment and materials. All you need is an air system that will maintain over 40 psi while you are spraying, an airbrush with a 0.5-mm paint nozzle, textile airbrush paints, and an article of clothing or a bag to paint on. To start with, it's a good idea to choose a natural-fiber item. Natural fibers absorb paint at a high rate, a property that helps mask some deficiencies in technique. It's also wise to start small. If you do make an error that requires starting over, replacing a T-shirt or hat is not an expensive proposition.

Cardboard is widely used for backing when airbrushing on textiles. It is inexpensive, and can be cut to any size. Once the cardboard has been cut, it can be inserted into or placed behind a fabric, so that the article will easily stand on an easel for painting. The cardboard backing will absorb any paint that comes through the fabric. A rigid board (such as $^1/_4$-inch compositeboard) that is cut to proper dimensions can also be used as a stable backing when airbrushing on fabric. Many artists use a combination of hardboard and cardboard. The cardboard is placed between the fabric and the hardboard to absorb any paint that passes through the fabric.

TEXTILE AIRBRUSH PAINTS

Paints that are formulated and premixed for airbrushing on textiles are acrylic-based. Once acrylic textile paint has dried and been heat-set, it develops a plastic outer coating that bonds to the fabric and is waterproof. Textile paint that is not heat-set will fade when laundered. When properly applied, in multiple light coats of paint rather than thick coats, acrylic textile paint dries quickly, minimizing downtime while waiting for wet paint to dry.

TRANSPARENT. Transparent airbrush paints are for use on white and light-colored surfaces only. You can add an opaque medium for more opacity or to create pastel colors. You can also create custom colors by mixing paints.

OPAQUE. Opaque airbrush paints work well on both light- and dark-colored surfaces. Add an airbrush extender medium (see "Textile Airbrush Mediums," opposite page) to opaque paints to increase their transparency and create lighter values. Any opaque airbrush color can be mixed with other opaque or transparent colors.

FLUORESCENT. Fluorescent airbrush colors work best when painted over a white or light-colored surface. If you are painting over a dark surface, base-coat the surface with an opaque white airbrush paint. Any fluorescent color can be mixed with transparent colors, pearlescent colors, or other fluorescent colors.

PEARLESCENT (PEARL). Pearlescent airbrush paints, which create a light-reflective, shimmering finish, work well on both light- and dark-colored surfaces. They can be mixed with pearlescent, transparent, fluorescent, iridescent, and chameleon paints.

CHAMELEON. Chameleon airbrush paints can be used on both light- and dark-colored surfaces. Surfaces painted with a chameleon color have a slightly metallic look until light hits them. When light hits the surface, a shimmering effect is produced, which changes as the angle of the light source changes. Chameleon paints can be mixed with iridescent, pearl, transparent, and fluorescent colors.

IRIDESCENT. These paints have a shimmering appearance, which changes depending on the angle of light. They can be mixed with other iridescent, pearl, transparent, or fluorescent colors to create custom hues. When using these paints on a dark surface, you will get the best effects if you first spray a white basecoat (or two) over the painting surface.

TEXTILE AIRBRUSH MEDIUMS

EXTENDER. Airbrush paint extenders increase the transparency of any color they are added to. How much you need for a given paint to get the consistency you want will depend on the viscosity of the paint. Add extender a little at a time until you get the effect you want.

OPAQUE AIRBRUSH MEDIUM. The ultimate equalizer, opaque medium modifies paint properties and creates a middle ground between transparent and opaque paints. Opaque medium adds pigment to transparent airbrush colors to make them more opaque and it thins opaque colors so they become more more transparent.

CATALYST. Catalyst can be added to airbrush colors to assist in the heat-setting process. Paint to which a catalyst has been added will become set, or permanent, at lower temperatures. Add the catalyst according to the directions on the label. Paint to which a catalyst has been added should be used within three days.

BONDING AGENT. Bonding agents are added to airbrush colors to increase their adhesion to synthetic fibers, denim, or leather. Use according to label instructions. Paint to which a bonding agent has been added should be used within three days.

FINISHES

Clear textile paint can be applied over a finished painting on fabric or leather. The coatings generally brighten the colors a bit, and offer protection against ultraviolet (UV) light. Clear-coating over textile paint is not a necessity, but it does lengthen the life of the artwork.

Clearcoat

A clearcoat is a protective topcoat that dries to a clear matte finish. Spray the clearcoat over your finished airbrush design when it is dry. Clearcoats are permanent on most surfaces, including fabric, paper, wood, metal, plaster, canvas, and leather. Before using, read the instructions on the label.

Gloss Coat

A gloss coat is a protective topcoat that dries to a clear gloss finish. Spray the gloss coat over the completed airbrush design when it is dry. Gloss coats can be airbrushed on fabric, paper, wood, metal, plaster, canvas, and leather. Before using, read the instructions on the label.

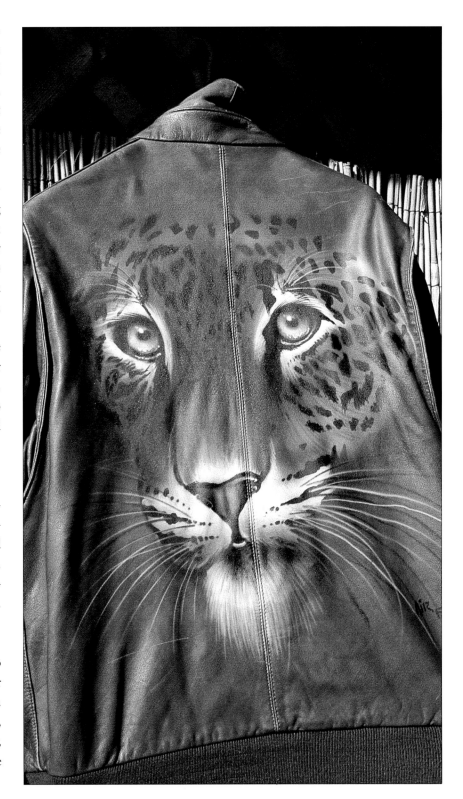

Airbrushing Textiles and Leather

Airbrushing Leather

- For best results, lightly mist a basecoat of opaque white on areas to be sprayed.
- Apply color, avoiding over-saturation and excessive paint layering.
- Allow colors to dry thoroughly before heat-setting.
- Iron for 30 minutes at a medium heat setting using a protective cloth, or use a hot airgun at the highest heat setting for five minutes.

Mark "The Shark" Rush operates one of the world's largest air-brushing businesses, in Panama City Beach, Florida: 364 days a year, Mark and his crew of eight master artists create custom designs on T-shirts, hats, coats, and tote bags. Rush lived in Hawaii for 8 years, where, he says, most nights he painted sunsets from his balcony, learning firsthand about the variable effects of light on landscapes. Mark's Web site is bigairbrush.com.

Textiles, or fabric, suitable for airbrushing include 100 percent cotton, cotton blends. denim, and natural fibers, such as silk, linen, and wool. No matter what fabric you are using, the following basic information is applicable. To airbrush leather, follow the steps shown at left.

- Before you start painting, wash the item to remove sizing and mill finishes, which will keep the fabric from absorbing the paint. Place an appropriate backing material inside of or behind the fabric. (See above, "the Basics."). When airbrushing textiles or canvas, it is particularly important to avoid thick paint buildup and excessive paint layering.
- When you have finished the design, allow the colors to dry thoroughly. Drying times vary depending on the fabric, the paint mix used, and how wet the paint was sprayed. You may use a heat gun to accelerate drying time.
- When the paint on fabrics is dry, heat-set the design using an iron or clothes dryer. If you are using an iron, 2 minutes at the maximum heat setting should be sufficient. Use a protective cloth between the iron and fabric and keep the iron moving. If you are using a clothes dryer, turn the article inside out and dry for 40 minutes at the highest heat.

Canvas Tote Bag: Beach Scene at Sunset

MARK RUSH

For backing board, I used a compositeboard cut slightly larger than the size the final painting will be. Making sure to the keep the area painting centered, I gathered the loose material around to the rear of the backing board, stretching it smooth, and used masking tape to hold it in place, then put the stretched canvas and board on an easel. I set out the Createx textile colors that I would need for the sunset: black, dark blue, hot pink, hot yellow, and hot green. (For my sunset tropical scenes, which are in great demand, I have made a reusable Mylar drafting film mask/stencil, created using a computer system, that is cut into the shape of palm trees.)

1. To begin, I sprayed Clearco spray mist 600 adhesive (it has just the right amount of tack) on the back of the stencil and affixed it to the bag. I used a roller to make sure that the edges were bonded to the fabric to eliminate underspray. I fanned black paint into the cut-out trunk and palm frond areas with gradation strokes until the desired darkness was achieved (photo 1).

2. I used a hair dryer to dry the paint on the stencil. (If a stencil is wet, you run a high risk of the paint smearing.) When the paint was dry, I removed the stencil (photo 2).

3. Using a straightedge, I lined up the island for a horizon line. Using a hand-held mask, I painted the top of the water line a dark blue with side-to-side dagger strokes of varying lengths and thickness, which created an interesting horizon (photo 3).

4. With the same blue color from the previous step, I wisped in cloud shapes by painting softly blended gradation strokes. Moving the airbrush closer to the bag, I darkened the center portion of the clouds using back-and-forth dagger-type strokes. Still using the same blue paint, and starting at the bottom, I rendered the wave in the foreground using gradation strokes. The result is a gradation from darkest at the bottom to light blue at the top of the wave. I highlighted the top of the wave with white paint. I added purple clouds to the sky section by blending soft, circular gradation strokes and then darkening the middle section of the purple clouds with mini-dagger strokes. See photo 4.

5. To create the sun, I used a round shampoo bottle cap as a shield. I pressed the cap into the fabric and airbrushed hot pink paint around it. I also added some of the pink to the upper wave tips and surrounding clouds as reflected highlights (photo 5).

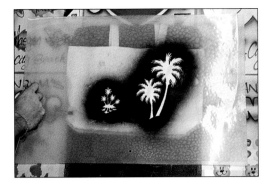

1

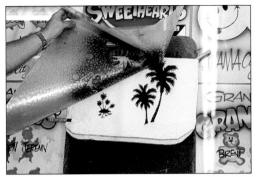

2

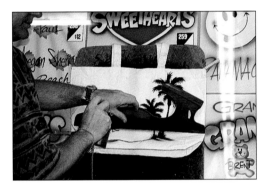

3

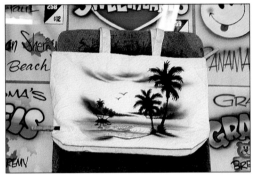

4

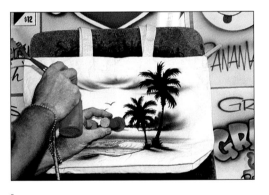

5

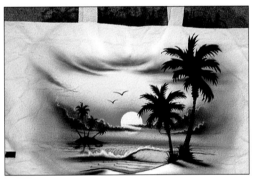

6

Tip

For creating masks, using a computer system that scans an image, enlarges or reduces it to the desired dimensions, and cuts the lines of the design into Mylar drafting film saves hours of manual work. For more information on making masks using a computer see Chapter 5, page 86.

An automobile design that has been laid out and cut on Mylar by a computer. Each of the individual elements can be removed separately.

6. To represent the colors of the sky reflecting in the water, I added hot yellow and hot green to the water with horizontal strokes, then added hot yellow to the sky in soft gradations (photo 6).

7. I added the customer's name in the upper left of the design using freehand dagger strokes. When the paint was dry, I put the bag in a commercial dryer to heat-set the paints. (You could also do this with a heat gun or hair dryer. Check your paint label for the heat-setting directions for the brand of paint you are using.) Photo 7 shows the finished bag.

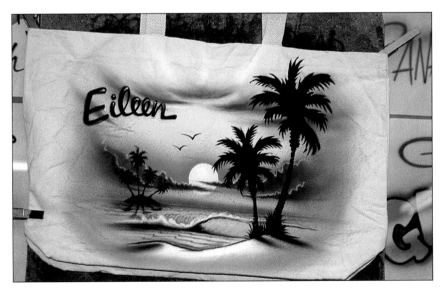

7

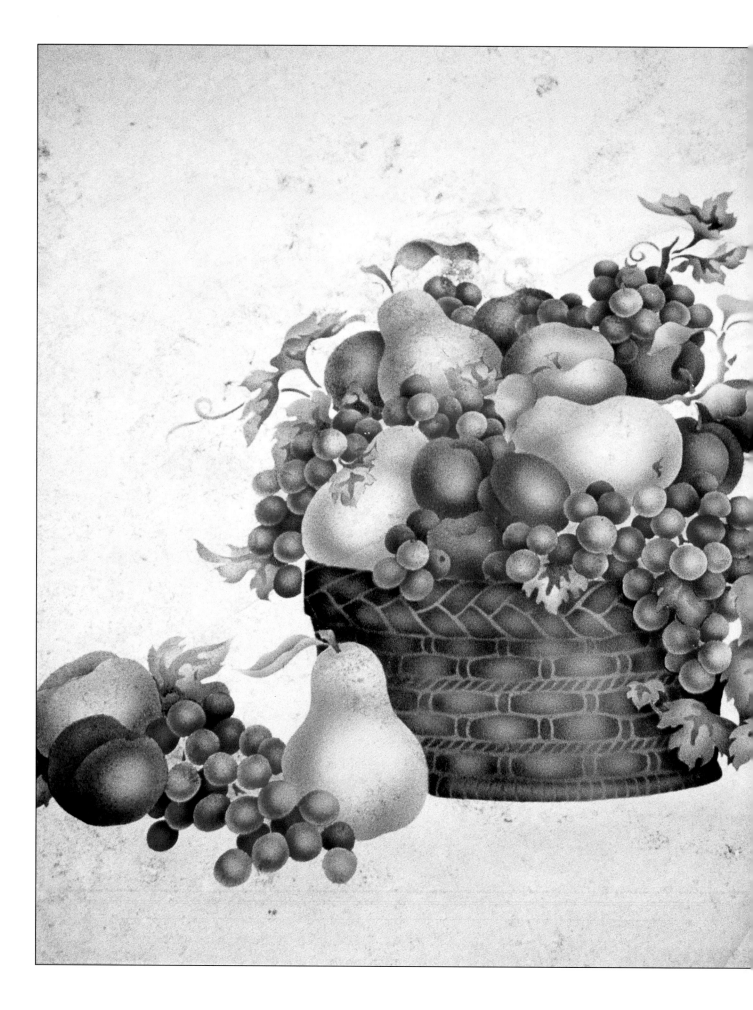

MURALS
&
SIGNS

Projects such as painting on walls and painting large signs are tailor-made for airbrushing. The airbrush's ability to blend color over large areas not only renders fantastic effects, but does so with a minimum of effort. After exposure to the airbrush, mural and sign painters who may have used paintbrushes exclusively in the past usually realize what a terrific time-saving tool the airbrush can be.

Airbrushing Interiors

Decorative painting techniques have gained popularity in recent years as homeowners discovered there are endless ways to customize and personalize their environments. Nothing can match the dimensional effects, subtle shading, and color blending possible with the airbrush, which is a real advantage when designing for interiors.

Whether used alone or combined with other painting techniques, the versatility of the airbrush makes it an indispensable tool that can be used for faux and fantasy wall finishes, murals, borders, stenciled motifs, and whimsical trompe l'oeil. Although walls are the most common "canvas," given the right products, you can airbrush on virtually any surface, including hardwood floors, ceramic tile, fabric, concrete, and limestone. The beautiful fruit basket on the opening page of this chapter was painted on limestone, whose porosity makes it a wonderful surface for airbrushing. It was designed for the stove-top backsplash in a custom home.

SURFACE PREPARATION

Proper surface preparation is crucial, since your artwork will last only as long as the paint you used to create it.

- If you are painting on a surface from which wallpaper has been removed, be sure it is free of glue and dirt. Before painting, prime the wall with a white primer.
- Once the primer has dried, spray on a flat white basecoat. Any color in the basecoat will affect the airbrushed colors.
- You can stencil or airbrush freehand over a basecoat that has dried to the touch as long as it doesn't feel damp or cool, but if you are using frisket film with an adhesive backing, allow the basecoat two weeks' curing time before you work on it.
- After painting, the artwork needs to be protected from handprints, smoke, and abrasions incurred during cleaning. Normally,

one coat of polyurethane is sufficient protection. If the art is to be in a high-use area such as a day care center, apply at least two protective coats of polyurethane.
- In kitchens and bathrooms, additional protective coats are unnecessary unless the painting is in an area that requires constant scrubbing, such as a stove or sink backsplash.

ESSENTIAL EQUIPMENT

When airbrushing interiors, the proper equipment will not only save you time, but wear and tear on your body.

Scaffolds vs. Ladders

Use a portable scaffold instead of a ladder whenever possible. It gives you a secure, flat surface to stand on and more room to work. The platform is adjustable in height and is easier to move than a ladder, as it is equipped with locking wheels. You can clamp your airbrush holders to a shelf off to one side so there is less chance of an accident. When working with the scaffold adjusted at its highest level, extend the corner posts with PVC pipe sized to a comfortable reaching height and drop the post of your airbrush holder into the PVC so you don't have to bend down frequently. Affix a magnet to the shelf to keep your cleaning needle handy.

Even if you do have a scaffold, you will want to have ladders and stools of various heights. Normally the scaffold is set up so the painter is able to reach as much of the work area as possible without moving the scaffolding. Ladders and step-stools allow artists to access areas they cannot reach from the scaffold.

Airbrushes

Because there are so many aspects involved in airbrushing interiors, it is necessary to have a variety of airbrush types. The choice of airbrush will depend on how large the painting or mural will be, and whether it will be air-

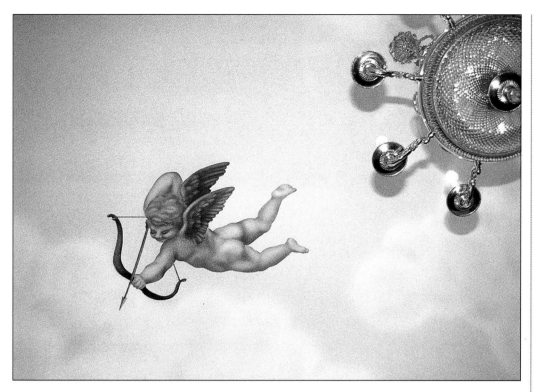

This cherub by Sheri Hoeger, part of a ceiling mural, was rendered with a combination of stenciling and freehand airbrushing.

brushed on a wall or a ceiling.

For painting a wall mural that will require high-volume spraying, most interior airbrushers choose a siphon-feed airbrush, with a large paint orifice and paint reservoir (e.g., 0.5-mm orifice with a 4- to 8-ounce paint reservoir).

Gravity-feed airbrushes with smaller orifices (e.g., 0.35 mm) work well for spraying details on wall paintings, but since they have a limited paint cup size, they require refills more often than siphon-feed models

Side-feed airbrushes can also be used for wall murals, and because their color cups can be rotated 360 degrees without spilling paint, they are invaluable for airbrushing ceilings.

Airbrushes with large paint orifices, such as the Iwata Eclipse HP-BCS or Paasche VL (both with 0.5-mm orifices), are a good choice when painting on a large scale. Both of these airbrushes spray enough paint to cover an area quickly but still offer the painter the ability to airbrush fine details. Airguns such as the Iwata LPH-100, which have 1.3-mm orifices and can spray patterns up to 8 inches wide, are perfect for spraying background colors and sky effects.

Because most interior work involves using many different colors, the most efficient way to airbrush interior designs is to have an airbrush for every color you will need. This requires attaching an air manifold to the compressor's air line with outlets for each airbrush being used. Four colors are usually enough for a stenciled design or small trompe l'oeil piece. For murals, you will probably need 6 to 10 colors. If you cannot afford multiple airbrushes, you can use one or two siphon-feed models.

Tip

If you do not have an airbrush for every color you will be spraying, before beginning to paint, you can mix the colors you intend to use in paint bottles which attach to the bottom of the airbrush with a siphon cap. The bottles vary in size from small ($^1/_2$ to 3 ounces) to large (4 to 8 ounces), and when you want to change colors, you can can simply switch to another bottle.

One-person scaffold capable of providing a stable 4-foot-high work platform.

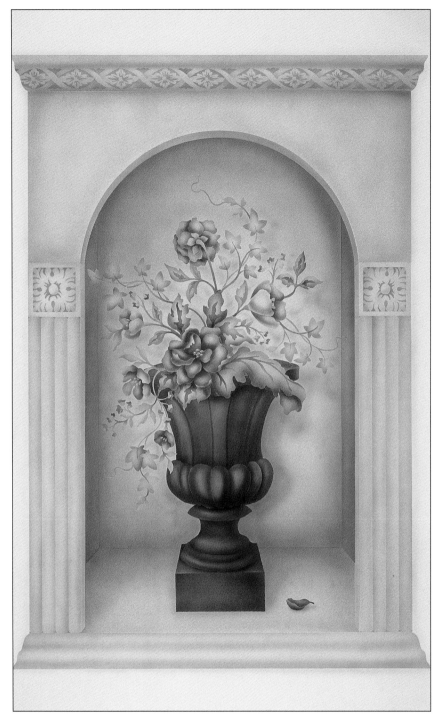

Sheri Hoeger painted the urn and flowers shown here by combining three separate multiple-overlay theorem stencil designs. The design elements were painted from front to back, beginning with the floral elements, which were masked off with frisket film when necessary before painting the next layer.

ceilings full of clouds, etc., purchase a standard compressor with a large air storage tank (20 gallon minimum).

Other Equipment

All of the standard accessories for a mobile medium-size shop (see Chapter 2) apply to interior stenciling or murals. In addition to the standard masking tapes, breather masks, stencil-making materials, and measuring tools, you will require portable scaffolding and or ladders and step-stools.

WORKING WITH STENCILS

Stencils for decorative painting can be bridged or bridgeless. Templates, contouring templates, and theorem designs are all bridgeless.

Bridged stencils consist of one or more overlays. Positive shapes cut into the stencil, called windows, are separated by strips of the stencil material, so that all the shapes are permanently connected. The shapes on bridgeless stencils are not permanently connected. With templates, all the pieces, positive and negative, called dropouts, are cut separately and must be manually positioned. Contouring templates have additional details cut into the dropouts, so that you do not have to use a separate overlay for those details. A theorem design is created from a series of stencil overlays. Adjacent windows are cut from separate pieces of stencil material, and the artist adds registration marks so that when all overlays are stenciled, the finished design will be seamless. A given design may be created using any one of these types alone, or a combination of them.

Commercial Stencils

Current laser technology has made a tremendous array of commercial stencil designs available. Dozens of companies offer beautiful, versatile stencils in a wide variety of styles and sizes. There are more theorem designs on the market than ever before; these give the final print a seamless appearance. Flowing contemporary designs allow users to arrange stencils in various ways to uniquely embellish individual rooms.

Compressors

For interior work, a silent compressor, such as the Silentaire 50-TC or 50-10-S compressor, is absolutely worth the investment. Look for one that is easily portable and includes a holding tank. Some models are available with wheels. If you plan to do large-scale murals,

Airbrushed embellishments are a wonderful complement to popular faux finishing or wall-glazing techniques. Commercial trompe l'oeil mural components abound, giving us "tools for creativity" by allowing us to use separate elements to develop our own compositions.

The Internet is a great resource for stencils, as many companies have their catalogs available online. The Stencil Artisan's League, Inc. (SALI) is an international teaching and trade organization dedicated to the promotion of excellence and education in stenciling and related decorative arts. The Annual SALI Convention and Exposition features several days of classes in stenciling, faux finishing, murals, perspective and theory, and airbrush, and offers the opportunity to see the latest in stenciling and related products. Attending the SALI convention is a wonderful opportunity to network with others interested in interior decorative painting.

Original Stencil Designs

When deciding how to break down your overlays, consider how you are going to use the design. Is it going to be repeated many times, for example, for a border, or repeated just a few times in strategic locations in the room? Do you plan to use it for an accessory item, and, if so, will you be painting just one, or multiple copies for a craft show? A heavier stencil material may be easier for use on a floor; a lighter one for use on a ceiling. Will you need the paint application to go fast? If so, minimize the number of overlays you use. Often, a one- or two-overlay bridged stencil will suffice.

Even though theorem style is most popular for contemporary and traditional décor, some designs are most effective when the bridges define the shapes, especially if they are to be viewed from a distance. Lyn le Grice (a famous English stenciler and author of *The Art of Stenciling* and *The Stenciled House*) uses bridges as an integral part of her designs. The negative space, whether that is bridges or the spaces around your forms, are as important as the positive space—the painted area of your

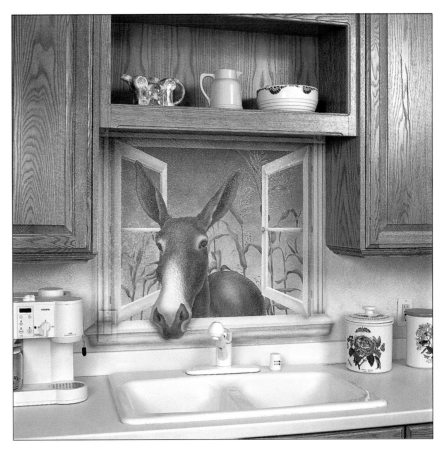

In this trompe l'oeil window mural by Sheri Hoeger the donkey appears to be nosing into the kitchen. Note that the switch plate was primed and painted right into the mural. Bridgeless stencils were used to develop the image. Contouring templates were cut out of the bridgeless stencil and used to add details and highlights.

design. If you are using colors close in value to each other for your design, bridges may work best. Some stencils in this style may be cut from one piece, such as leaves and stems separated by bridges. Additional overlays will be necessary if you are going to add detail, such as veins in the leaves.

Successful bridgeless stenciling requires contrast to define the shapes. This takes more work to achieve. If you are cutting a bridgeless design, each "window" with a common line must be isolated from the adjacent shape by cutting from separate overlays. As a general rule, cut large foreground areas that don't touch each other on the first overlay, cut detail within those shapes from the second overlay, and so on.

Contouring templates are also useful for interior works. For more information on contouring templates, see the demonstration on page 82.

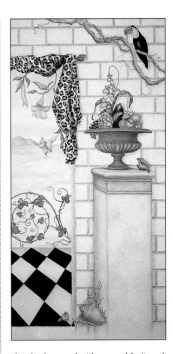

This display panel with urn and fruit, and leopard curtain, were airbrushed using stencils designed by Sheri Hoeger. Many layers of stencil masks were used to create the urn and flowers; the swag and leopard spots required only two.

Stencil Materials

Though most commercial stencils are cut from 5-mil Mylar-type material, there is a range of choices for hand-cut stencils. You may find a type of material that you use exclusively, or you may use different materials depending on the specific circumstances of your project. A good choice for hand-cut stencils is a 3.5-mil product that is matte on both sides. Some advantages of this material are:

- It is relatively light in weight.
- It is extremely durable and holds its shape well.
- It is available in a variety of sizes, in both sheets and rolls.
- It is very flexible, conforming easily to corners.
- It accepts pencil marks on either side.
- It is available with a printed grid for designs where it is necessary to maintain a specific size.
- It cuts more cleanly with a stencil burner than some of the thicker films, with a minimum of "curl" from the heat.

Cutting Stencils and Masks

STENCIL BURNERS. Stencil burners cut the stencil material by melting it. The melting process burns away a portion of the stencil or mask material it is melting, leaving a void that is the same diameter as the stencil burner's melting tip. Once melted, stencil edges will not remate accurately. Do not use a stencil burner to cut out technical designs with fine details; the melted edges work much better for rendering natural items such as fur, foliage, hair, fire, or water.

It is best to burn stencils and masks on a piece of dark-colored glass, so that you can see exactly what has been cut and how clean the cuts are. Start your cutting along with the comfortable arc of your arm, moving steadily and swiftly with your burner. It may help to stand to get more leverage. When your arm or hand muscles begin to feel awkward, lift up rather than stopping with the tool still on the film. If you hesitate while cutting, you will get an uneven edge or warping of the material. Shift the pattern or stencil with your noncut-ting hand and resume cutting with your cutting hand. For a smoother cut, focus your eyes slightly ahead of where you are actually cutting, as you focus on the road ahead when you are driving a car.

X-ACTO KNIFE. If you need a sharp, clean line, an X-Acto knife is the proper tool to use. The knife does not remove any material as it slices through masking or stencil material. Surfaces cut apart with the knife can be rebutted together cleanly to protect adjacent areas from overspray. When you want a straight line, guide the knife with a ruler or straightedge. For best control, pull the knife toward you as you cut. For cleanly cut corners, rotate the material as you cut. Have plenty of new blades on hand. If you feel the blade start to drag, replace it.

Sheaf of Corn

SHERI HOEGER

Sheri Hoeger's biography is on page 81.

1. Using the graphite transfer technique demonstrated in Chapter 2, page 46, I transferred the corn drawing to frisket film and placed it on the wall. Using a #11 X-Acto knife, I first exposed the large background section (photo 1).

2. I painted from the background shapes to the foreground shapes, using yellow, orange, green, and a custom-mixed "muddy" purple mix of pyrolle red, anthi blue, raw umber, and white (photo 2). (The stippled bits on the masking in photos 2 and 3 show where I test-sprayed my colors.)

3. I continued the process by cutting, pulling, and painting the remaining layers one by one, moving from the background layers out (photo 3).

4. I pulled the film from the sections in the extreme foreground last.

5. All the frisket film has been removed (photo 4).

6. I used a paintbrush to paint in the grain cascades (photo 5).

7. Photo 6 is the finished painting; the shadows were airbrushed freehand.

1

2

3

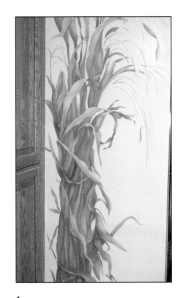

4

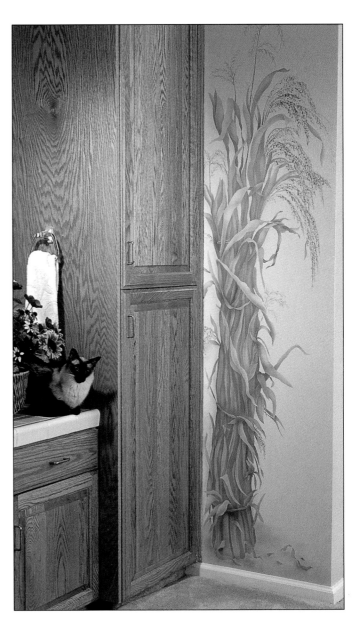

5

6

COLOR

For interiors, you achieve a pleasing continuity by blending colors borrowed from the room pallet. When choosing or mixing the colors you will use in a room, keep samples of fabric, furniture, etc., close at hand to use for reference. Even if you (or a client) have an aversion to a certain color, it does not necessarily mean that color should be eliminated from the pallet. It is likely that you need the effects of that color in the mix, even if it will not be dominant. It can help to have an artist's color wheel, which is available at art supply stores.

Practice creating as many effects as possible using just three colors: red, yellow, and blue. Warm colors seem to come toward the viewer. If an orange tone (created by mixing or layering red and yellow) is a little too bright, you can lightly shade with green, which will mute it to some extent. You might also shade the deepest shadow areas with blue; this will result in purple tones where it is layered over red. Cool colors seem to recede. You will get green tones if you layer blue over yellow, and you will get teal tones if you layer blue over green. Layering blue over orange will result in brown tones.

Sheri Hoeger's Tips on Color

We react emotionally to color. This is especially important to remember when designing artwork for interiors. Your awareness of the psychology of color will help you in guiding your client. For example, if the client is interested in a cheery kitchen, or wants to bring some pizzazz to an area, bright or warm colors should be dominant. On the other hand, if you are commissioned to paint a mural for a client whose overall interior scheme shows a clear preference for muted, subtle tones, you should probably choose cool colors, and avoid sharp contrasts.

Always mix your colors in the room where you are planning to paint, so you can consider all the colors in that area, and not the just the swatches for, say, a rug or sofa. Include a color that is close to the wood tones of the paneling or flooring, for example. The result will be a finished piece that is truly in harmony with its surroundings.

Layering cool colors over warm colors or vice-versa will result in more muted tones, so if you want to match a fabric, you should start out with colors that are a little brighter than the fabric color to allow for that effect. Remember that complementary colors (colors opposite one another on the color wheel) look wonderful next to each other, but they will "cancel each other out," or turn to muddy grays and browns, when mixed together or layered over each other when airbrushing. A good way to "knock down" a color is to mix it with a color that is half-way between its complement on the color wheel. For an example of this principle applied to airbrushing a leaf, see step 4, page 82.

If you are matching a very dark-colored fabric, you need to use a lighter and/or brighter version of the fabric color for the wall painting. If you don't, the color will appear black, and will not show subtleties of shading. As long as the tone is right, the eye will not perceive that the color is not as dark as the color it is meant to match. The relationships of the colors in your design are more important than the individual colors. Just make sure that the color is dark enough to have a good deal of contrast from the other colors used in the design. That will give the effect of a "match," while retaining the desired intensity of hue (chroma) for the individual colors.

When painting a mural with a background, you are working with color to create atmospheric perspective and a sense of realism. None of the colors in the background should be as bright, warm, or dark as those in the foreground. This does not mean there would be no warmth at all in the background colors—just not to the same degree as foreground objects. There should be less detail and less contrast in the background area. Objects in light will be warmer. Objects in shadow will be cooler.

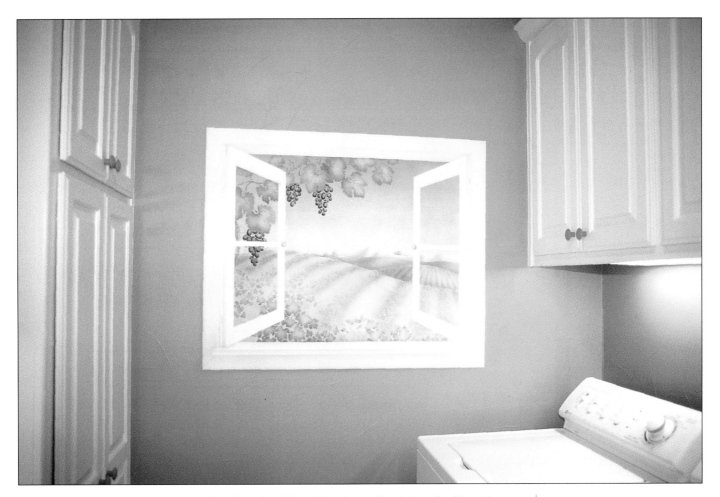

Here Ms. Hoeger mixed a lavender color with the colors violet, pink, and blue. The lavender was airbrushed over the white window frame to indicate shading. The same lavender was used for the shadow that the window frame casts on the orange wall. The orange background changed the tone of the lavender significantly, but did not effect the color harmony of the image.

This trompe l-oeil rooster, the window on which he is perched, and the surrounding wood were painted by Sheri Hoeger in the stall area of a bathroom. The landscape seen through the window was hand-painted and a graining tool was used to achieve the old-wood effect of the walls and window frame. The rooster was airbrushed using a stencil, which provided the contrast of both line and color that makes him the focal point of the painting.

COMPOSITION

In airbrushing for interiors, the term *composition* refers both to the composition of the artwork itself and how the piece, and its placement, affect the décor of the room it is in. A good composition balances color, value, and mass. Here are a few general guidelines

- Choose a focal point. Sometimes the choice of focal point will be obvious—for example, an important architectural feature—and sometimes you will have to create one.

- Remember that the colors and values you use will affect composition. Warm colors and high contrast draw the viewer's eye to them, and can be effective when used near or at the center of a composition. Using a bright or dark color near the edges of a composition may throw it off balance.

- Counterbalancing a bright focal point with smaller, well-spaced bright or dark elements can keep the viewer's eye moving through the space.

- Vary the size of the elements of your composition. If your focal point is large, other elements should be smaller. They should draw you to the focal point, and balance elements of the room.

- Odd-numbered placements will balance best, especially three.

- Vary the height and angles of the elements, so that the viewer's eye is led around the space.

- If you are painting a free-form image, such as a garland, it will seem more grounded, or anchored, if it is placed so that it follows the line of an architectural feature, such as a doorway.

- Never let the end point of a free-form design "point" to an unsightly object such as a vent cover or switch plate. A slight turn in the design away from these will avert the viewer's eye from them.

- A shape that has a sharp corner or point will draw the eye more readily than a rounded shape.

- The composition should provide a dimensional feeling, so that the foreground seems to be inside the room. Animals or birds should also face into the room.

- If airbrushing a free-form design, do not follow a straight horizontal or vertical line.

- Sometimes the hardest part is to know when to stop. Remember that negative space in any composition is as important as "filled" or positive space.

Flowing free-form garlands of fruit and florals designed by Sheri Hoeger, soften the window and lend character to the room.

CREATING SHADOWS

If you are painting a trompe l'oeil (fool the eye) effect, it is especially important to choose a light source, real or imaginary, and shade the entire design consistently with that light source. The cast shadows are very important for achieving a three-dimensional look. You can either airbrush a drop shadow by shifting the stencil slightly to the opposite direction of the light source and spraying a crisp shadow, or freehand a soft shadow. Shadow colors are not necessarily gray. They should generally be cool colors, and will look more natural if they are in "the mix" of the object that has been painted. The shadow color should be a darker value of the color it is on top of.

MASKING

At the 35- to 40-psi pressure recommended for interiors, you have good control, and a minimum amount of overspray is produced. At this level, you need only mask off approximately 2 to 3 inches from the edge of an opening, or a bit more if the window is large and you are spraying from a distance of greater than 3 inches or so.

When airbrushing near the ceiling and the juncture between ceiling and wall, however, mask those areas with 6-inch masking paper, as overspray tends to collect in corners. A useful tool for this is a hand masker, which affixes masking tape half on and half off the paper as it is pulled off the roll. If you are stenciling on a textured wall, it is likely that some spray will get under the stencil, even if you use stencil adhesive spray. If the overspray is visible, touch it up with the wall color. If you are painting a large-scale mural, mask baseboards, moldings, carpet, light fixtures, and furniture.

A Trompe l'Oeil Geranium

SHERI HOEGER

The trompe l'oeil effect is one of the more common themes in interior stenciling. The three-dimensional illusion for this piece was created by overlapping three distinct stencil layers, thus building a sense of depth, and establishing a light source (in this case, I decided that the light would be originating from over the left shoulder of the viewer) to determine where highlights and shadows would be.

1. For this project, I used two stencil sheets with leaves and blossoms on them

Sheri Hoeger, "The Mad Stencilist," has worked in the decorative painting field since 1988, and her work is widely recognized throughout the United States and Canada. Her pioneering stencil designs have been featured in numerous trade journals. In 1993, she created her own line of stencils, Embellishments Stencils, which features over 200 original designs. Ms. Hoeger teaches in workshops all over the country and at the annual SALI conventions. For more information about Sheri Hoeger and her work, visit her Web site: www.madstencilist.com.

When I am airbrushing a piece that does not require a ladder or scaffold, like this one, I set my work area up with a 5-gallon bucket fitted with a tool holder—available from home improvement stores—and clamp my airbrush holders to the rim of the bucket.

designed so that one overlaps the other. I taped (with red tape) both stencil sheets to a sheet of cardboard and cut the outlines out by hand using a #11 X-Acto blade (photo 1).

2. I cut the outline of the geranium pot from a sheet of Mylar. I sprayed the back side of the dropout of the pot (the part in the middle) with repositionable artist's adhesive and positioned it on the wall, exactly where it would appear in the finished piece, as a guide for placing the floral stencils in later steps.

3. I sprayed the back of the leaf blossom stencil and its dropouts with artist's repositionable adhesive and positioned the leaf/blossom stencil so that the leaves appeared to spill over the top lip of the pot (photo 2). I then made pencil marks indicating where the pot should be, removed the pot dropout, and positioned the dropouts for the leaves and blossoms in their appropriate places.

4. With the leaf stencil in place on the wall, I removed the centers (dropouts) of the leaf and blossom shapes that would be farthest from the viewer (I will refer to this part of the stencil as layer 1). Only the negative outlines of the leaves and blossoms remained on the wall. I painted a test leaf as follows: I started with a yellow that had to be brighter than the yellow of the wall the piece was being paintd on (yellow oxide mixed with titanium white), shaded lightly at the center and more intensely toward the edges of both the leaf and blossom to get the desired effect. Next, I used green, which toned down the yellow, and reinforced the contours of the leaf. The yellow-green blend gave a much more interesting effect than would have been possible with green alone. Each consecutive color covered slightly less area than the color it was sprayed over, so that I got the full benefit of the blend between them. I next used red (red oxide, lightened slightly with titanium white), which muted the green, concentrating on areas that were receding from the

picture and areas that I wanted to be shadowed. I then sprayed the red shadowed areas with a light misting of blue, which created purple tones. Layering red over the green shadowed areas created slightly teal tones. Once my test leaf was sprayed and I was satisfied with the results, I colored all of the leaves in layer 1.

To paint the blossoms in layer 1, I started with the same yellow base color used for the leaves and layered red oxide over it to create the general color of the blossom. I airbrushed blue at the base of each petal to help contrast the individual petals of the blossom. Photo 3 shows the finished test leaf and blossom in layer 1.

5. I fashioned a contour stencil by trimming away $^1/_4$ inch of the outer edge of each leaf dropout. When it was replaced within the center of the negative outline of the leaf, a small ring ($^1/_4$-inch) section around the dropout remained exposed between the dropout and the outline. Painting within the exposed ring on each leaf gave them their distinctive coloring. (Fashioning a contour shield that is cut with the exact curve you need for a particular leaf creates remarkably lifelike effects.) Painting in the exposed ring between the dropout and the negative outline (photo 4) added definition to the leaf. Photo 5 shows the completed leaves and blossoms in layer 1.

6. After finishing the layer 1 leaves and blossoms, I did not remove the masking, but removed the remainder of the frisket film dropouts covering the leaves and blossoms, exposing layer 2, the remaining leaves and blossoms on the Mylar sheet. I painted the layer 2 leaves and blossoms in the same way that I painted layer 1, but as painted, I overpainted the edges of the adjacent layer 1 leaves to create a layered, dimensional effect. Photo 6 shows layers 1 and 2 of the leaves and blossoms once they have been painted onto the wall and the stencils removed.

Tip

By using contour templates, you can minimize the number of bridgeless overlays needed for a particular project. A contouring template has features, or contours, cut into the dropout area of the stencil, rather like a jigsaw puzzle. Unlike hand-held, all-purpose shields, contour templates can be cut with the exact curve you need for a particular element.

1

2

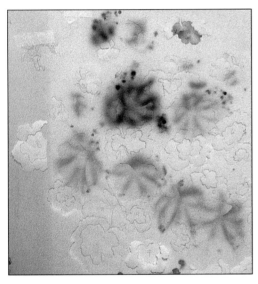

3

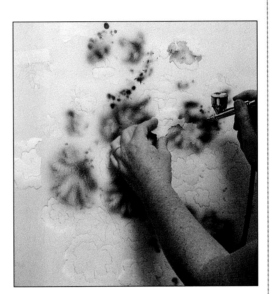

4

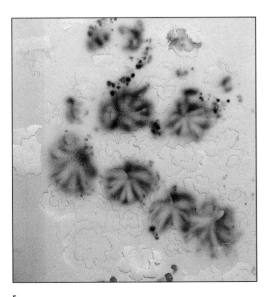

5

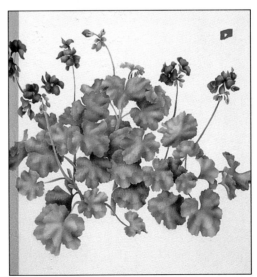

6

7. I drew and cut a third stencil for layer 3 of the leaves and blossoms and placed it over the finished layers 1 and 2. Some of the elements in the design extended upward while others were draped over the pot. Once layer 3 was painted, I removed the negative masking. Photo 7 shows layer 3 leaves and blossoms before the masking was removed.

8. I used the adhesive-backed dropouts from layers 1, 2, and 3 to protect the leaves and blossoms from the overspray that painting adjacent areas would create by putting them in place and pressing them onto the surface. I placed the geranium pot dropout (the positive, or interior area, of the pot) where it belonged, using the pencil marks I had made in step 4, then arranged the pot's outline (negative) around the interior dropout of the pot. Photo 8 shows the negative outline of the pot properly positioned on the wall. All the leaves and blossoms are covered with stencil material. The masking on the interior area of the pot has been removed to show the areas yet to be painted.

9. I extended the negative masking around the pot and flowers with brown masking paper to protect adjacent areas from paint overspray. I positioned the dropout section of the vase so its upper edge could be used as a stencil to define the foreground lip of the pot. To define the lip of the pot, I sprayed a darker layer against the edge of the masking. The colors used for the lip were the same as those used for the pot: a yellow base with red, green, muddy purple, and blue layered over one another to create the perfect brown tone. I also dabbed a sponge dipped in a mixture of these colors to give the pot some texture. For the shadowing I mixed muddy purple and blue. Photo 9 shows masking in place before painting the the lip of the pot.

10. Once the pot lip details were rendered, I removed the dropout covering the pot.

I began painting the pot by gradating the brown color from dark to light, starting at the outer edge and blending inward to a lighter value. Keeping in mind my light source, I left a lightly painted area on the curve of the pot to indicate a highlight and help define the curvature of the pot (photo 10). After the paint had dried completely, I replaced the pot dropout to protect it from overspray.

11. To paint the dirt edge against the inside of the pot's lip, I used paper torn in an arc that roughly matched the arc of the pot's lip, taping it in place with fine-line blue masking tape (photo 11). I used the torn paper as a stencil to airbrush the uneven surface of the dirt against the inside lip of the pot. I painted multiple light coatings of dirt-colored paint until I was satisfied with the result.

12. I dabbed a sponge dipped in brown paint over the pot to create a weathered effect. I lightly gradated brown paint over the sponged area, following the contours of the pot and making sure not to obliterate the highlight. I softened the dab marks by lightly gradating paint over them so as to maximize the round dimensionality of the pot, taking care not to obliterate the highlight (photo 12).

13. I put the negative stencil for layer 3 in place, but adjusted it $1/8$ inch off to the right and $1/8$ inch down (photo 13). I held the airbrush about $1/8$ to $1/4$ inch from the surface to minimize overspray and airbrushed a dark brown color lightly against the offset area of the stencil edge to make a shadow.

14. I offset stencil layers 1 and 2 in the same way that I offset layer 3, and airbrushed the shadows.

15. I removed all stencils, and airbrushed a freehand shadow, gradating the edges lightly, on to the wall to the right of the pot, providing the final touch to the trompe l'oeil effect. Photo 14 shows the finished painting.

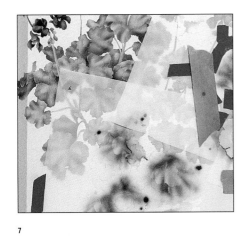

7

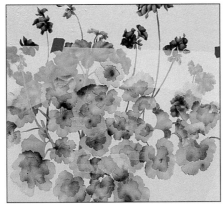

8

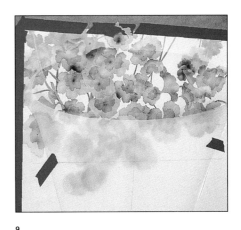

9

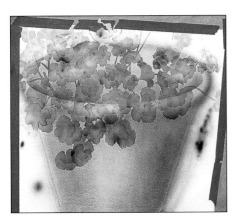

10

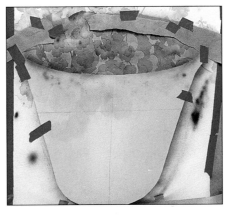

11

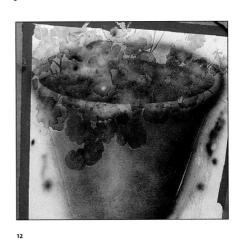

12

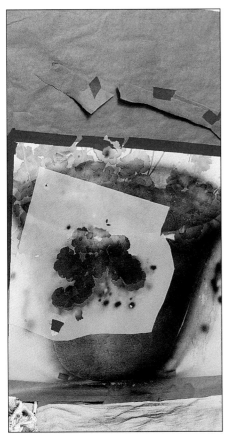

13

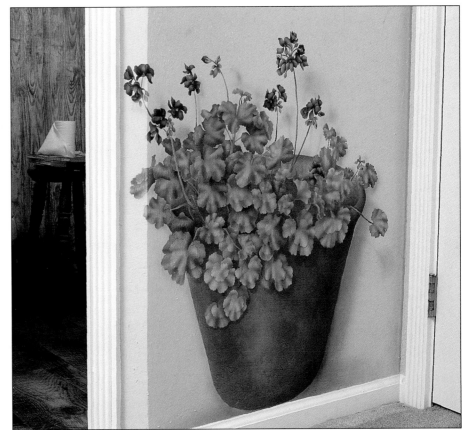

14

Special Effects for Signs & Other Uses

Tip

When you are using vinyl as your painting surface, remember that it is not absorbent, so if you apply too much paint on one pass, the paint is likely to puddle and will take a long time to dry. Instead, spray multiple light coats until you have created the effect you want.

Computer-generated vinyl letters and graphics have taken the sign world by storm. With computer vinyl systems, any image can be scanned into or designed on the computer, plotted out on an adhesive-backed vinyl material, and cut out with absolute precision. Once cut, the vinyl letter is removed from its adhesive backing and can be immediately transferred to a banner, sign, or vehicle. The entire process takes only a few minutes from start to finish. These systems are, however, extremely expensive, costing anywhere from $10,000 to $20,000. Fortunately, amazing effects can be achieved using lower-end plotting and cutting systems and an airbrush. The neat thing about airbrushing on vinyl is that no masking of the area surrounding the painted area is needed to contain overspray. All overspray is eliminated when the letters or graphics are *weeded,* that is, when the unused portions of vinyl are removed from the backing paper. The following step-by-steps show how to paint special surface effects without the aid of expensive computer systems.

All you need is Deka Sign Air paint, an X-Acto knife with a #11 blade, white enamel-receptive vinyl letter material, vinyl transfer tape, a vinyl tape squeegee, enamel paints, an airbrush—and the right software and hardware. (For information on the less expensive sign-making products, see the Source Directory, page 157.) The following demonstrations were done by Pamela Shanteau with an Iwata Eclipse airbrush. *For all of them, remember to flush your airbrush before each change of color.*

Sky

1. To get started, design, plot, and cut the word SKY on plain white vinyl. Do not remove the excess vinyl material surrounding the letters. Put a light blue paint (mix blue and white to your desired shade) in the airbrush and hold it 10 to 12 inches from the vinyl.

Starting at the bottom, at an air pressure of 30 psi, gradate from dark to light as you paint upward. Paint with gradation strokes (0–10 –0) across the vinyl with the plotted and cut letters (note that the cuts around the letters are not visible in the picture). Gradate from dark to light from the bottom of the vinyl up, two-thirds of the way up the letters.

2. Mix a darker blue than the color used for step 1 (mix less white into the blue than you did in the first step). Holding the airbrush 10 to 12 inches from the surface, gradate dark to light (trigger position 0–10–0), starting at the top of the letters and ending in the middle area of the letters. Spray light coats of paint and allow each coat to dry adequately before spraying the next one.

3. Put white paint into the airbrush and spray cloud wisps with light dagger strokes at various distances from the surface: $1/2$ inch to 2 inches (trigger position 0–2–0). To enhance the effect, swirl the tips of the clouds.

4. Weed the letters by removing all of the vinyl material that surrounds them, using an X-Acto knife, if necessary, to cut off any stray pieces of vinyl material.

5. Apply transfer tape over the painted letters with a squeegee to bond it to the letters. The transfer tape will not stick to the portion of the backing paper that has been weeded and is therefore devoid of vinyl.

6. Once the transfer tape has been squeeged (pressed) over the letters, separate the paper backing from the transfer tape. The letters will adhere to the transfer tape and will lift off from the paper backing while remaining perfectly aligned.

7. Position the letters and the transfer tape on the sign surface sticky side down. Firmly rub the squeegee over the top of the transfer tape to transfer the letters onto the sign surface.

8. Pull the transfer tape from the sign surface.

1 White vinyl with blue color blended (gradated) upward dark to light from the bottom edge.

2 The darker blue has been blended (gradated) dark to light from the top downward, overlapping the application from step 1.

3 The ends of each paint pass are blended softly into the blue background.

4 The letters after weeding.

5 Painted vinyl letters with transfer tape in position.

6 Lifting the vinyl letters from the paper backing.

7 Transferring the letters onto the sign surface.

8 The completed transfer.

The shadowed letters with granite-like dot pattern.

The "cracked" GRANITE.

Granite

1. Begin by plotting and cutting the word GRANITE on white vinyl with your computer system. Holding the airbrush 4 inches from the surface, use black paint to spray around the outlines of the letters with paint-on, paint-off strokes (trigger position 0–5–0) to keep from overapplying the paint. (The coats should be light enough so that the black appears grey.) Decide where the light source is, and reinforce the shadowed side of the letters with more layers of the black paint to build them to a darker value. Next, set your airbrush pressure at 5 psi; at this low pressure, you will create a pattern of large dots rather than a fine mist. The dots must be completely dry before starting the next step, and you can shorten the drying time by spraying air-only on the letters. Do not worry about keeping the paint within the confines of the letters; any overspray will be eliminated during the weeding process.

2. Reset the airbrush pressure to 30 psi. Hold the airbrush $^1/_{10}$ inch from the surface and pull the trigger back slightly (0–1–0) to airbrush very fine black lines that indicate the "cracks" throughout the granite. Cover the letters with cracks of various widths.

3. Following steps 5 through 7 for the SKY exercise, transfer the letters to the surface of the sign. For the completed lettering, see the illustration on the next page.

Hot

For this exercise, you will need Artool Flame-meister hand-held shields.

1. Begin by plotting and cutting the word HOT on white vinyl. Airbrush an even coating of yellow over the unweeded vinyl. Flush the airbrush.

2. Using orange paint and the Flame-meister hand-held shield, airbrush in the flame shapes. Flush the airbrush and put red paint in the paint holder.

3. Airbrush in the red paint, graduating from dark to light starting at the bottom of the letters and moving upward.

4. After the vinyl has been weeded and the word transferred to the sign surface, use some more red paint to outline the letters and add little flame licks.

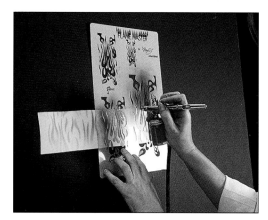

1

2

3

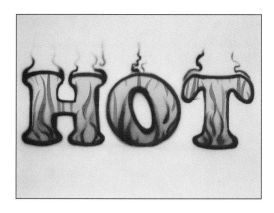

4

✐Scary

For this exercise, you will need Artool Skullmeister hand-held shields.

1. Begin by plotting and cutting the word SCARY. Using red paint and starting at the bottom, airbrush a gradation, going from dark to light. Stop painting once you have covered the bottom half of the letters (photo 1).

2. Holding the Skullmeister stencil against the surface over the letters, spray black paint through the skull and bones designs that are cut into the stencil. Start at the top and fade the color as you paint downward. The red and black paint should meet somewhere near the middle of the letters (photos 2 and 3).

3. Mist a light gradation of red paint over the entire surface, then reinforce the areas near the edges of the letters with more red paint. Weed the letters and transfer them to the sign. The photograph at the bottom of this page shows the finished lettering. Some red was added to the top of the letters to make them stand out better.

1

2

3

The possibilities for creating special effects lettering for signs are endless. Shown here are the three effects demonstrated above, as well as two additional creations: COSMIC and WOOD. The basic materials, and cutting and transfer techniques, were the same. For COSMIC, a circular template was used to create planet shapes, and the stars and galaxies were sprayed with white paint, then lightly shaded with blue. For WOOD, after spraying the basic yellow, the airbrush was held closer to the surface to intensify the yellow value, with the shadowed sides of the letters receiving the most paint. To simulate wood grain, brown was mixed with the yellow and horizontal lines were sprayed at varying distances (1/10 to 1 inch) from the surface, so the lines would not be of uniform width.

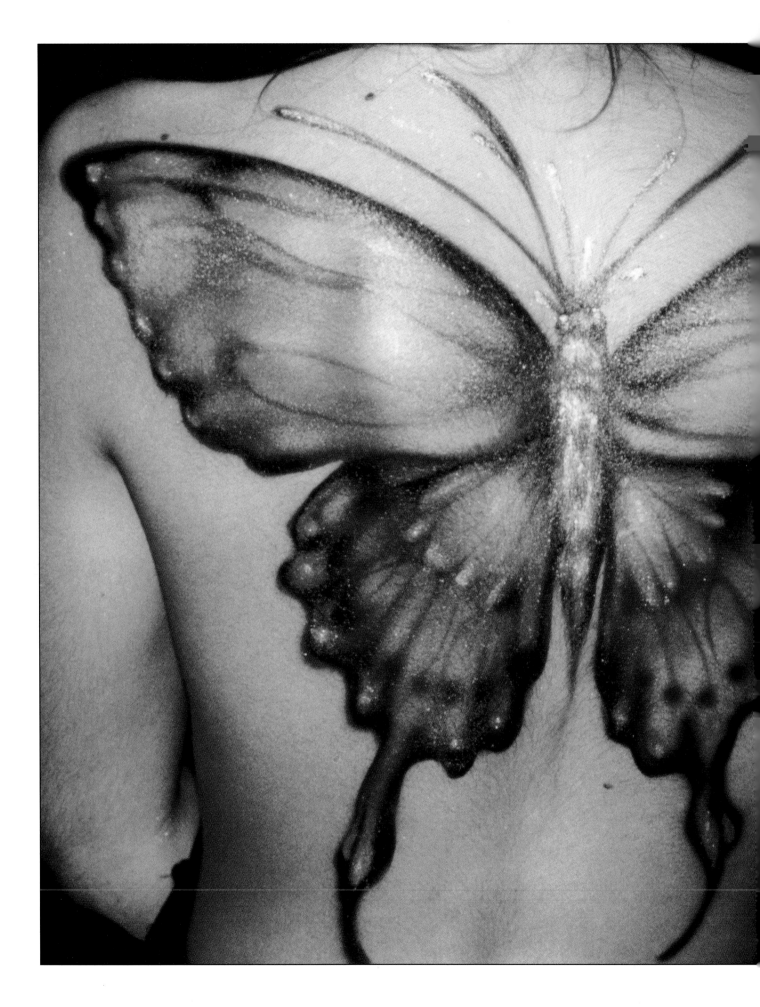

BODY
&
FINGERNAIL ART

All body art makes a statement. Whether its purpose is religious, social, or personal, it communicates its message in a fundamentally dramatic way. Body painting is probably the oldest form of art still practiced today, predating even the famous prehistoric wall drawings discovered in the caves of southern France. Natural pigments smeared over strategic body parts camouflaged hunters and indicated both a person's tribe and that person's status within the tribe. Over time, body painting assumed a ritual significance in many cultures.

Body Art

Tip

Most sales of airbrush equipment are final, meaning that retailers will accept returns only if there is a manufacturer's defect. However, most manufacturers will repair or exchange defective equipment within the first year, so save your receipt and be sure to send in the warranty card if there is one.

Over 5000 years ago, the evolution of body art led to an art form known as mehndi. The earliest use for mehndi, which involves applying a paste made from ground henna plant to the human body, was probably medicinal, as henna is a natural coolant. The desert inhabitants of Egypt and the Middle East found that applying henna stain to their skins, which lasts for weeks after an initial 24-hour curing period, kept their bodies cooler. It is not known exactly how and when mehndi evolved into a decorative art, but mehndi designs today vary widely depending on the country and on local traditions. In India intricate mehndi designs on the head, hands, and feet are said to provide magical protection from misfortune and ensure a prosperous life.

In the United States, the body art movement gained momentum in New York City in the early 1990s with an East Greenwich Village gallery showing of photographs depicting mehndi designs. The show was a huge success, and New Yorkers began wearing mehndi as a fashion statement. Articles in fashion and art publications brought mehndi to mainstream America, as many saw the temporary nature of henna stains as a viable alternative to the permanent inks used in tattoo parlors. Mehndi—and for that matter any temporary body art—is neither painful nor permanent.

TEMPORARY TATTOOS

There are basically two types of temporary tattoos, those that are airbrushed and those that are applied using transfers. Airbrush-style tattoos can be applied by spraying body art pigments through commercial or homemade stencils or by spraying on the body art paints freehand.

Transfer-style tattoos, as the name suggests, are transferred to the skin from special tissue-thin transfer paper. With either stencil or transfer designs, additional colors and fine design elements can be airbrushed or painted on with a paintbrush.

ESSENTIAL SUPPLIES
Paints

For body painting, you will need a full range of paintbrush colors and a full range of airbrush paint colors. Body paints are either alcohol-based or water-based.

Water-based body art paints are easy to apply with the airbrush or paintbrush, and are recommended for face painting and for

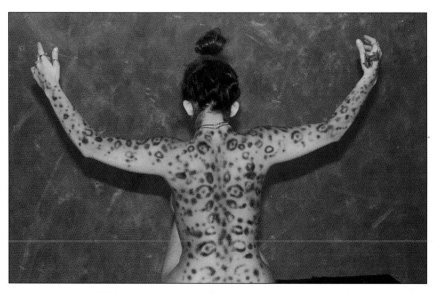

Leopard girl was airbrushed freehand.

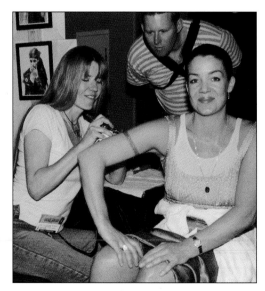

Pamela Shanteau airbrushing color on a temporary Celtic Knot armband tattoo for film and television star Claudia Christian.

designs that need to last only a few hours (e.g., for parties). Water-based paints are more commonly used than alcohol-based paints because they are cheaper, and easier to apply and remove, than alcohol-based paints. However, they smear easily and run if exposed to moisture and last at most one day only.

Today, alcohol-based paints are widely available at arts and craft stores. With proper care, designs that have been painted with alcohol-based paints will last, on average, for three to five days. These pigments paint on easily, are waterproof, and stand up to rigorous dance routines and showers without running and streaking. However, natural body oils and emulsifiers such as baby oil, aloe, suntan lotion, and isopropyl alcohol will break down alcohol-based paints. Areas of the body that are particularly oily—the neck, head, and creases in the knees and elbows—are the least desirable spots to apply either water-based or alcohol-based paints.

Airbrush System

A minimum of four high-quality double-action airbrushes, preferably with a 0.35-mm nozzle, are recommended for body art. The air source can be any of the ones described in Chapter 1, pages 13 to 15. *All airbrush body art must be sprayed at 18 to 20 psi in order to prevent air bubbles from forming in the blood vessels of the skin.*

Paintbrushes

The small paintbrushes shown on page 30 are perfect for painting fine details or touching up temporary tattoo designs.

Other Supplies

- **Isopropyl rubbing alcohol.** Use 70% isopropyl alcohol for cleaning the area of skin on which paint will be applied and 99% strength isopropyl alcohol for cleaning the tools and removing the tattoos from the skin. If the skin is not properly cleaned prior to painting, the tattoo will have a very short life span.
- **Lint-free cotton pads.** The pads you use to

apply the rubbing alcohol to the skin must be lint-free. They are are available from beauty and cosmetic stores.

- **Setting powder.** Once the design is finished, you will need setting powder to set the paint so that it will last longer. The powder dries and wicks away the skin oils that can affect the tattoo. You can use setting powder specifically designed for body art paints, or you can use baby powder. If you use baby powder, make sure it contains no lotions or aloes.
- **Baking parchment paper.** Tattoo stencils are reusable, but you cannot put the original backing back. A good way to store your stencils between uses is to lay the stencil sticky side down on parchment paper so that it adheres lightly. This will preserve the adhesive and keep any debris from contaminating the stencil.

STENCIL-STYLE TATTOOS

Stenciling is a common technique in the airbrushing world, for interior decorating, modeling, automotive airbrushing, T-shirt painting, and fine art and commercial work. Airbrushers who do body art, temporary tattoos, and nail art also make extensive use of stencils. Stencils can be original hand-cut designs or precut commercial stencils. Some commercial stencils that are used for body art have an adhesive backing of the same type used for medical tapes so that they will not irritate the skin. Others will require an adhesive to be added or will need to be held in place by hand during the airbrushing process.

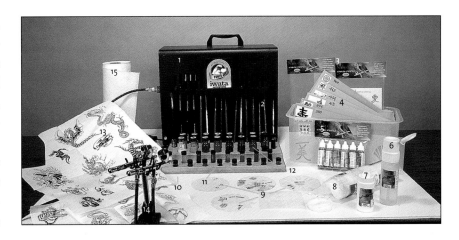

A basic set of supplies for body painting. 1, Iwata power jet compressor; 2, detail brushes (sizes 000 to 5); 3, commercial stencils; 4, a file of original and commercial designs; 5, Artool Body-Of-Art airbrush colors; 6, rubbing alcohol in pump bottle; 7, Artool Body-Of-Art setting power; 8, lint-free cotton pads; 9, nail art stencils; 10, handmade paint/brush station; 11 and 12, body art colors in various size bottles; 13, transfer images; 14, gravity-feed Iwata Eclipse airbrushes mounted on airbrush holder; 15, roll of paper towels.

Reusable stencils for temporary airbrush tattoos.

Butterfly Stencil

PAMELA SHANTEAU

1. Clean all dirt and body oils from the the area to be painted by swabbing it with a lint-free cotton pad that has been soaked in isopropyl rubbing alcohol.

2. Dry the area to be painted with clean air from the airbrush so the stencil will adhere to the skin.

3. Peel the backing from the stencil to expose the adhesive side and place the stencil on the skin. Make sure that the edges of the design and any small points are firmly stuck to the skin.

4. Add a small amount of yellow tattoo ink into the cup of the airbrush. With air pressure at 18 psi, hold the airbrush 3 to 4 inches from the skin and spray a base color of yellow evenly over the exposed skin inside of the stencil.

5. With orange paint, recolor the outer edges of the butterfly wings. Notice how the yellow and orange transparent colors blend into a third color.

6. Add additional red ink to the remaining color in the airbrush. Blend it around the wings in the same manner as the orange. Build the red slowly with multiple light coats. Flush the ink from the airbrush with 99% rubbing alcohol.

7. Add black to the color cup and paint in the butterfly's body, head, and antennae. Make one very light pass around the outside edges of the wing area so they will be clearly defined once the stencil is pulled. Flush the airbrush.

8. Pull up the stencil (photo 8), and powder the tattoo. Tell your client to repowder the design before and after bedtime, and after showering or bathing.

1

2

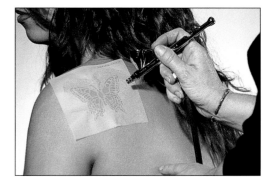

3

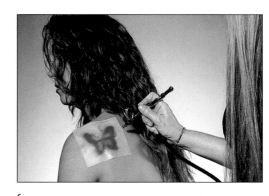

4

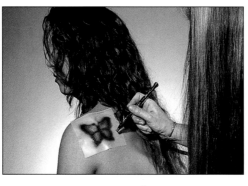

5

6

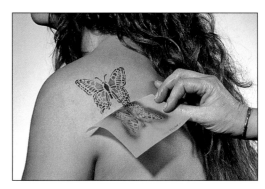

7

8

TRANSFER-STYLE TATTOOS

Transfer-style tattoo designs, which are printed onto sheets of tissue paper, are a one-use-only item. You can purchase sheets with multiple designs or one repeated design. You can cut apart the sheets and file the designs by number, putting each numbered design into its own envelope that will fit into a portable plastic file box. If you have a studio, you can set up a numbered display showing all the tattoo designs you offer. Then, when a customer asks for a design, it is easy to locate the desired transfer by number.

Tribal Design Transfer Tattoo
PAMELA SHANTEAU

1. After choosing the design you will use and cutting it from the transfer sheet, use a lint-free cotton pad to clean the area to be tattooed with 70% rubbing alcohol. Leave the skin area very wet with the alcohol.

2. Before the alcohol has evaporated, place the transfer on the wet skin, ink side down.

3. Press the design onto the skin with even pressure using the cotton pad and your fingers. Try to apply even pressure over the entire design. Do not rub the wet transfer paper or it will tear.

4. While the transfer paper is still very wet, pull it up gently from the skin. If the alcohol on the paper has evaporated, rewet it before pulling the transfer up.

5. Blow the skin dry with a fan or air-only airbrush setting. If any part of the tattoo did not transfer fully, you can touch up the design by hand (photo 5). Use a lint-free pad to apply setting powder (or aloe-free baby powder) to the design.

6. The finished design. Notice that no trace of the powder can be seen; it has all been absorbed into the skin.

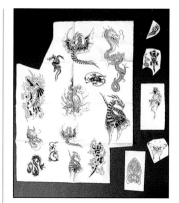

Some of the thousands of temporary transfer designs available.

1

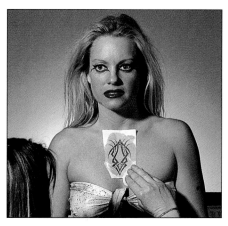

2

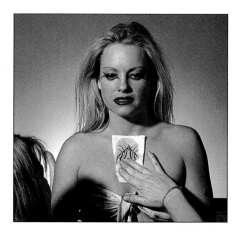

3

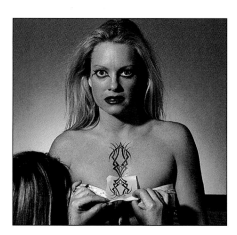

4

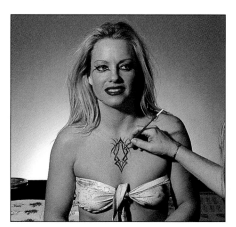

5

6

1

2

3a

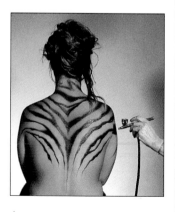

3b

FREEHAND BODY ART

Freehand body art allows the artist the greatest range of expression; the only boundaries are the artist's creative limits. Applying body art without a transfer requires careful planning if the design is at all complex. Usually, you will need to draw renditions in colored pencil of the theme you will be painting.

Tiger Girl

PAMELA SHANTEAU

This client wanted a full-body tiger design. Before I began painting, I did a thumbnail sketch of the model with tiger markings. The sketch aided me in mapping out where to apply each color. The following three steps describe the basic technique used.

1. Use a lint-free cotton pad to clean the area to be painted with 70% rubbing alcohol, then dry with the clean air stream from the airbrush. Put white paint into the airbrush and paint in the white face details (photo 1). Flush the airbrush with 99% rubbing alcohol.

2. Add orange to the airbrush and paint the face, neck, shoulders, back, and arms, building up the color showly until you have the shade you want (photo 2). Flush the airbrush with 99% alcohol.

3. Add black to the airbrush and paint in the stripe pattern on the face, shoulders, and back (photos 3a, 3b). Holding the airbrush 2 to 3 inches from the skin, use the paint-on, paint-off trigger technique (0–5–0). You'll need to make multiple passes for each stripe; as a single pass would result in stripes that would be much too thin.

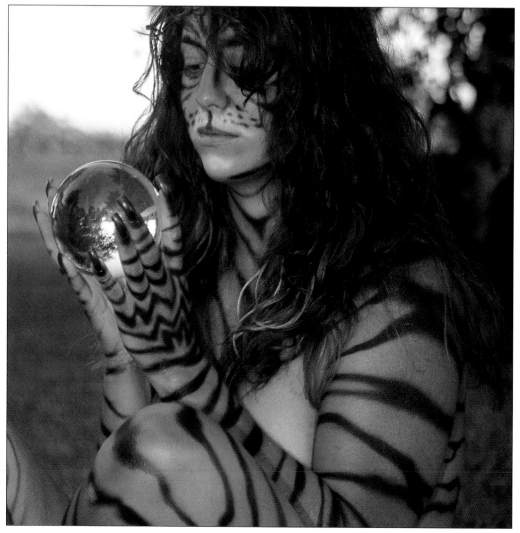

Tiger girl with all her stripes.

Nail Art

Nails with airbrushed designs are really mini-artworks on tiny canvases, and their popularity has grown by leaps and bounds over the last decade. Industry statistics show that airbrushing was the fastest-growing salon service in 1997, 1998, and 1999, second only to reflexology in 2000, and back to number one in 2001. Customers for airbrushed nails are fashion-conscious consumers who want the best designs out there, whether they are interested in classic looks or the latest novelty. Whether you are purely a recreational airbrusher or have aspirations to become a professional, nail airbrushing can be a very satisfying outlet for creativity. If you do have aspirations to be a professional, be sure to read "Tips for Professionals," at the end of this chapter.

CHOOSING THE RIGHT EQUIPMENT

Most companies that market to the professional beauty industry offer a nail airbrush system sold as a unit, or a grouping of compatible products. Even if you intend to airbrush nails only for yourself or your friends, purchase of a professional system may be a smart way to go, as the less expensive systems available at craft stores are not nearly as versatile as those designed for professionals. The best of the professional systems cost from $500 to $700 dollars. For $325 to $400 you can get a decent system, but anything that costs under about $300 is purely for the recreational user and is likely to be missing some important components.

The Airbrush System

For basic information on airbrushes, compressors, hoses, etc., see Chapter 1, pages 12 to 19. For nail art, an internal-mix type is the model of choice. You can use a single-action or dual-action airbrush, but dual-action models are best for all precision work. Single-action types, although less expensive, have two serious drawbacks for use with nail art.

- **Paint flow.** To adjust the paint flow, you will have to stop painting to make the necessary adjustments. If you are doing stencil work this will mean letting go of the stencil, making the adjustment, and replacing the stencil in the exact location on the nail that it was before continuing to paint. Although this can be done with some stencils, it is not easy, particularly in the unsteady hands of beginners. When a stencil is awkwardly bent around the curved nail plate, and with ultra-curved nails, it will be impossible even for the experienced professional to get the stencil in exactly the same position, and in those cases it will be essential to finish the stencil design in one spray.
- **Spray pattern**. Single-action airbrushes typically have a somewhat speckled spray pattern, which is not generally desirable for nail art. In contrast, the spray pattern of dual-action airbrushs, in the hands of an experienced user, is even and fine.

Whatever airbrush you are using, a nozzle size of 0.2 mm is ideal for most nail work. Although larger size nozzles may be used for nails, they are not a good choice for fine details.

If you are doing salon work, it is definitely worth the money to buy one of the "silent" compressors. Some bargain compressors sound like chain saws when they are turned on. The ideal pressure setting for nail art is between 18 and 25 psi. You can buy a unit that is preset to stay within those parameters or you can invest in a pressure regulator and gauge so that you can set your own psi level. (See Chapter 1, page 13.)

MEDIUMS AND SUPPLIES
Paint

Virtually all paints intended for nail airbrushing are water-based acrylics, but actual drying time, consistency, and ease of cleaning (for

both skin and airbrush) will vary according to brand and color. For example, some brands are difficult to remove from the skin and require that an adhesive-backed paper shield be placed around the cuticle and down the sides of the nail to prevent overspray from reaching the cuticle; other brands wash off easily with soap and water after the nail is sealed, eliminating the need for shielding. Follow the manufacturer's recommendations for the brand of paint you are using and follow the suggested method of application and cleaning. It is a good idea to avoid brands or colors that do not dry quickly or tend to cause undue clogging, no matter how appealing you find the color. If you are getting poor results, but believe the problem is your lack of familiarity with the product, keep using it in your practice time, but when working with clients, stick to the ones you feel absolutely comfortable with. As you gain experience, you will be able to add new colors to your palate.

Cleaning Overspray

When using shields around the nails, some of the paint may run underneath the shield and dry on the skin. The excess paint can be removed by wetting a pointed cotton swab with airbrush cleaner or nail polish remover and gently wiping away the paint, being careful not to come in contact with the nails. If you are using a paint that does not require shielding, you should first complete the design and properly seal the nail. (See "Basecoats, Varnishes, and Topcoats," below). Using soap and water or the manufacturer-recommended cleaner, gently wash hands and nails under warm water to remove paint from the skin and pat dry.

Basecoats, Varnishes, and Topcoats

All nail art requires that an enamel basecoat be applied before painting the design. Nail airbrush basecoats are all very similar in formulation and function but vary from clear to lightly pearled to heavily frosted. Color is a matter of preference; however, airbrush paint does not adhere well to clear basecoats, and therefore they are not recommended.

If you are airbrushing on nails that do not have a smooth surface (e.g., ridged nails), you may purchase one of the many ridge-filling products available at local drugstores and beauty counters. Paint one coat of the ridge-filling product on clean nails to improve smoothness, let dry, then paint on one coat of the recommended airbrush basecoat. Enamel basecoats need to air-dry, but using a fan will help shorten the drying time to less than 5 minutes. Apply basecoat thinly to all areas which you want paint to adhere to; apply it close to the cuticle and wrap it around the free sides and top of the nail. After waiting 3 to 5 minutes, proceed with the airbrush design.

Most professional nail artists recommend that after the nail design is finished, a varnish coat be applied before the topcoat is added; the varnish coat makes it easier to apply the topcoat with out leaving brushstrokes. To be effective, the varnish coat should be applied lightly. Heavily applied varnish will cause the paint to crackle or smear when the topcoat is applied. To make sure you are getting the right spray, first direct the spray to the top of your nonpainting hand; once you are sure you are spraying the light mist you want, without moving your finger on the trigger position, move directly to the nails and go over them lightly, one by one. At no time should the varnish appear wet or shiny. If it does, you are applying too much. If necessary, retest on your hand before moving on.

Whether or not you have applied a varnish coat, applying two topcoats over the airbrushed design is absolutely essential for both appearance (the topcoat provides a high gloss shine) and longevity of design. Although topcoats formulated for use with nail airbrush paints are not water-based, if applied correctly they will not "melt" the design colors. For the first topcoat, use the brand recommended by the paint manufacturer. Start by dipping your brush into the topcoat container so that the brush is holding a generous amount of the top-

coat. To make sure the tip of the brush does not dig into the painted design, hold your brush at no more than a 45-degree angle to the nail. Use the three-stroke method developed by professionals: begin at the cuticle—as close to the cuticle as possible without getting the topcoat on the skin—and gently brush the topcoat down the left side of the nail, followed immediately by the right side, then down the center of the nail. For the second topcoat, you may use the same brand you used for the first coat, or you can apply a specialty topcoat, such as an ultraviolet (UV) or gel coat, both of which are formulated for maximum shine and durability.

Stencils and Masks

Either stencils or masks—commercial or custom-designed by the artist—can be used to create an infinite number of designs. Stencils, which are made from paper or plastic, typically Mylar, and are not adhesive-backed, are used to create positive design elements (see Chapter 5, pages 74 to 75). You hold them up to the nail and spray the paint through the cut-out shapes or along the edges to create various effects. Stencils can be reused many times if cleaned properly (with the recommended airbrush cleaner or warm soap and water) and stored so that the delicate edges are not bent.

Masks are made of a pliable, adhesive-backed material such as plastic or frisket film. When the film is removed from the backing, the design element is placed directly on the nail, to which it will lightly adhere. Masks are available in sheets with a variety of precut designs. (There are literally thousands of terrific designs on the market.) You can also purchase blank masking sheets and cut your own designs using a fine-point razor knife. If you choose not to use precut shapes, make sure you have the requisite skills to design and cut your own; otherwise, the result will look amateurish. Like stencils, masks can be used to create positive design elements; they can also be used to shield an already painted positive image, exposing the background for painting and detailing. As a particular design evolves and new areas need to be shielded, masks can be layered to achieve the desired effect.

AIRBRUSHING NAILS

To create the perfect airbrushed nail, you need to have the requisite technical skills—and you need a good design, whether you are going to use precut commercial products or make your own. One way to go is to first draw your ideas on paper. When you have a general idea of what you would like to do, use practice nail tips to work through the design and try out color schemes. It may take you several tries to get the effect you want.

You can also start without making a drawing first, or even having a specific idea of what your overall design will look like, and instead simply experiment. In other words, let your imagination take you for a ride and see what you end up with. Of course, working like this may not lead you down the most efficient path, so if you like what you have done, consider whether you could have achieved the same effect using a more direct route. Either way, jot down the steps that were taken to create any successful design, and keep an index of all the designs you have created so that you can reproduce them at any time.

Sunset

LAURA MORGAN-GLASS

When finished with each color, run cleaner through the airbrush and use a small cleaning brush inside the well or cup to clear it of color, if necessary. In order to keep colors true, the well or cup needs to be free of residual paint so that the colors will not mix, particularly if you are going from dark to light. Repeat this procedure with every color change.

1. Apply an enamel basecoat. Allow it to air-dry for two minutes, then mist on an undercoating of white airbrush paint. After the white paint is thoroughly dry, put yellow paint in your airbrush, hold the airbrush at a 90-degree angle to the nail and mist a soft yellow

Laura Morgan-Glass is an internationally recognized airbrusher whose work has been featured in national trade and local fashion publications. Currently she is National Sales Manager of Medea Beauty Products Division for Iwata-Medea Inc. in Portland, Oregon, where she is reponsible for product development, promotions and events organization, and education programs. Since 1983, she has operated a highly successful salon business in Portland, Oregon.

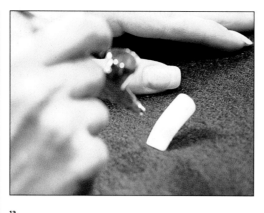

1a

1b

2

3

line horizontally across the nail (photo 1a). Spray the yellow line about two-thirds of the way down from the top of the nail. Layer the yellow on slowly until the color is the intensity that you're looking for (photo 1b).

2. After flushing out your airbrush and paint cup, put orange paint in your airbrush and layer the orange on slowly, directly above the yellow, until you have the shade you want, then clean out the brush and cup and apply the next color—a neon pink—directly above the orange. Spray a grape color above the neon pink and a violet color above that, at the top of the nail design (photo 2). (If the nail isn't long enough to accommodate two additional colors, omit one of them.)

3. To create the ocean, spray mint green or aqua horizontally along the very bottom of the nail. If you are an intermediate-level airbrush nail artist, you may be able to easily apply the green color without the use of a shield. If you are a beginner and not yet able to control the diameter of your spray pattern,

it would be a good idea to hold the straight edge of a stencil or use masking to shield the horizon (photo 3), so you don't inadvertently spray green too far up onto the yellow.

4. To create the blue horizon, hold the straight edge of the stencil against the fingernail to shield the background. Spray blue along the edge of the template, trying not to overlap the green (photo 4).

5. Tear a corner off of a piece of paper towel and place on the nail, exposing only a small area of the lower left-hand corner of the design (photo 5). Spray black paint over the exposed area, creating the slightly fuzzy landform for the trees.

6. Use a palm tree stencil to create the images of the trees. Hold the stencil down firmly yet gently and spray black paint onto it from a 90° angle (photo 6a). (If you direct your spray at the stencil from a 45° angle, you may inadvertently spray paint under edges of the stencil, creating a blurred edge.) Photo 6b shows the finished palm trees.

4

5

6a

6b

7

8

𝒯𝒾𝓅

Creating a three-dimensional image—in this case the moon—using an already-sprayed background color as the image's primary color is not easy. Practice steps 7 and 8 on paper until you become adept at getting the effect you need before doing it on an actual design for a friend or client.

9

7. Use a round cut-out stencil to create the moon (photo 7). Carefully place it on the nail in the desired location and spray the lower edge of the lower half of the circle black. To do this successfully, you will need to spray a very small amount of paint. Spray the lower half of the stencil by moving your hand with the curve of the inside edge of the moon. Direct your spray on the stencil itself instead of the hole and just let the overspray do the work for you. When finished, gently remove the stencil from the nail.

8. Put a few drops of white paint in your airbrush and replace the stencil in the original position of the moon. Finish the upper half by spraying white along the inside curve of the stencil image, using the same technique as in the previous step (photo 8). As in step 7, direct your spray onto the stencil itself and allow the overspray to create the desired effect. Photo 9 shows the finished nail, after the topcoats have been applied.

Professional Tips from Laura Morgan-Glass

As a professional airbrush artist, you will have the unique opportunity to develop your creative potential as an artist by painting designs that your paying clients and future paying clients will actually enjoy wearing. As a business owner and airbrush artist with many years of experience in the business, I can offer the following tips to the recreational nail artist thinking of turning professional:

- Are you patient? Consider some of the challenges that are unique to this medium. The fingernail is a small, slick, nonabsorbent surface that can be very curved. Even on what is considered a larger nail bed, airbrushing nail art designs can be very delicate and tedious work. Living canvases, even under the best circumstances, wiggle quite often, adding to the degree of difficulty.
- Can you work rapidly? In a salon, you will have only 20 to 40 minutes to create your glorious mini-masterpieces. Because salon professionals and their clients are on very rigid schedules, speed is the name of the game here.
- Do you have strong powers of concentration? The salon environment is not a peaceful one: the conversations of co-workers and customers, phones ringing, and interruptions all add to the challenge.
- Have you thoroughly mastered the application process—and the secrets of optimum retention? If you try to airbrush nail art on customers before you are adept at every aspect of the application process, you are bound to become frustrated, and will appear inefficient in front of your clients. You also need to have a feel for how long airbrushing will wear on a particular person, what failures of technique will adversely effect retention, and what activities will cause the nails to show signs of wear and tear early on, so

you can properly guide your clients regarding home care.

If you can answer yes to all of those questions, you have a strong chance of succeeding as a professional.

Here a few tips for the person who owns or is working in a nail salon.

Learn how to mine the trade shows. Trade shows provide a good opportunity to observe different equipment in use and ask questions about the products. It also gives you the opportunity to take one for a test drive, so to speak. Even if a test hasn't been formally offered, establish yourself as a serious shopper by asking if you can try out the airbrush. If the demonstrator is in the middle of a choreographed show demonstration, make an appointment to come back when he or she is less busy. Ask if there are any show discounts offered.

Adopt a practice schedule. Like anything new, it is imperative that you be patient and allow yourself the time to develop your skills. Book time out of your schedule to practice on nail tips. Purchase display nail tips, like those by Medea, or make your own by attaching pins to the back of tips with a low-melt glue gun. Choose an hour a day, 2 hours three times a week, or whatever works best and stick to it. To learn all the ins and outs of actually wearing airbrushed art, you'll need to wear it yourself. Spray simple color fades on your own nails. It is a good way to test the wear of the art. If it doesn't wear well, contact the manufacturer for guidance.

Set up a dynamite display board. When you are completely satisfied with a design, put the finished practice tip on a display board in several color schemes. Clients will find it easier to choose a design if you have some popular color choices for them to look at. Make sure that you offer conservative color choices

on your display to attract those who may be less adventurous. Simple color fades and airbrushed French nails are elegant and offer choices to professional women who feel that bold designs may not be appropriate in their office environment. Airbrushed French nails are beautiful and feature white tips that are thin and do not streak, unlike traditional nail polish. Have an array of designs for each holiday and offer to prebook appointments early.

When a client sits down at your table, be ready to offer style recommendations and color options. Your client may be somewhat overwhelmed by the choices and take longer if you don't help out with the decision. Let your clients know that they can come in 15 minutes early or a few days before a scheduled appointment to look over the display boards and make a choice.

Pay top dollar for topcoats and clearcoats. When a client is paying extra for specialty art, it is wise to use the best topcoat you can buy. Also, make sure that the client has a top-qual-ity clearcoat to put on at home in between appointments, which will increase the longevity of any design.

Get a top-of-the-line "silent" compressor with an automatic shutoff feature. The louder compressors, although less expensive than the quiet models, are sure to alienate your coworkers and give you a headache in the bargain. The automatic shutoff turns the compressor off as soon as you stop spraying, which lengthens the life of the motor.

Stay on the cutting edge. In this highly competitive business, it is important to offer the latest nail fashions and methods of application. You may be comfortable with the services you currently offer; however, expanding your menu will keep steady customers from going elsewhere and will attract new customers. Perhaps more importantly, taking on new challenges will reenergize you, help to avoid the burnout that accompanies repetitive work, keep you motivated, and open the door to other opportunities.

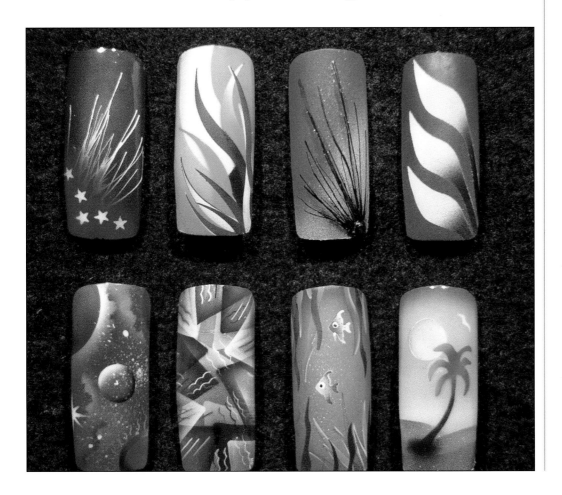

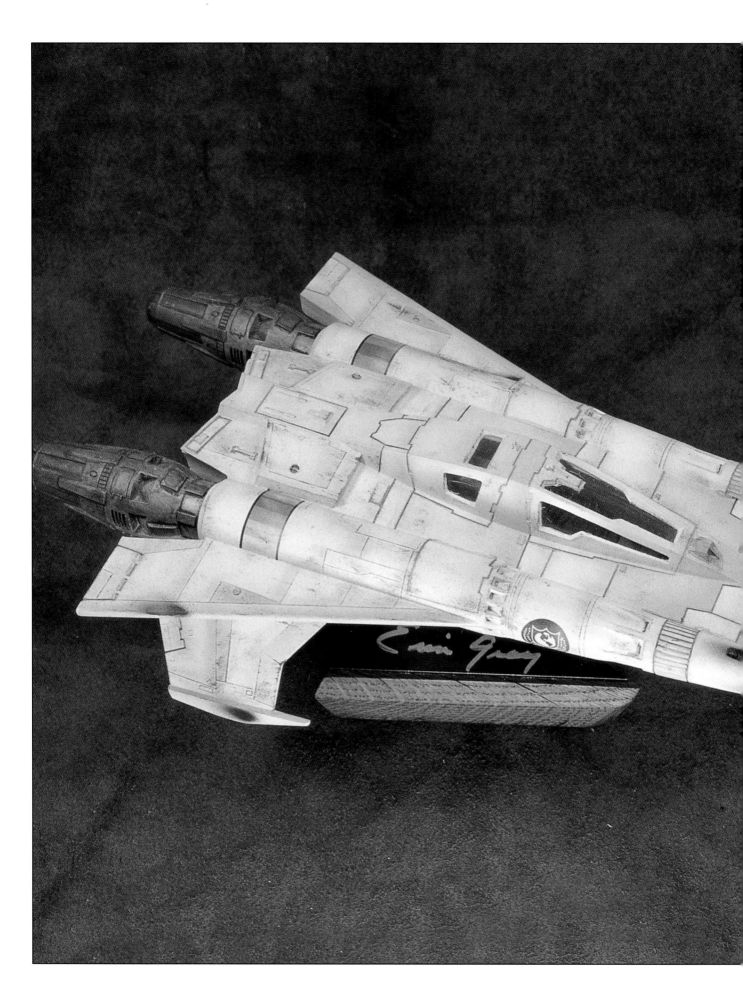

SCALE MODELS & CRAFTS

Two of the most popular uses of the airbrush are for painting model kits and unfinished craft pieces. For either application, a knowledge of specialized masking techniques is essential, as is a familiarity with the different types of paints used and the characteristics of the surfaces to be painted. In the following pages master model builder and airbrusher Tom Grossman and crafts master Lindy Brown share some of their professional secrets.

Scale Models

From Tom Grossman:

Your biggest stumbling block will be thinking that you don't know how to do something that you have never tried. I find the greatest rewards when I can overcome that hesitation and try something new. Ask questions when you need to. Watch modelers building subjects that you haven't tried yet. They will use different techniques that will probably be useful with your favorite kits. This means that every subject can be enjoyed, regardless of personal preference.

The Rule of Introduction.

Always test any new combination of products and materials before applying them to an affectionately built kit.

Extending the life of your paints

Small plastic paint pots like the ones that sometimes come with model kits can be purchased empty, in racks of eight or more, at most craft stores. Keeping paints in these small pots preserves the life of your paint as it cuts down on the number of times you have to open and close the original jar (see photo, page 110).

Models—kits from mainstream manufacturers or garage kits, static scale models or radio-controlled models—are created to be built and painted. Building them is fun and many books have been written about how to do it. But it's the painting that really sets a finished model off. Although the techniques described here pertain to airbrushing static scale models, they can easily be applied to many other types of models and you can use the following as a jumping-off point into your own little corner of the hobby.

Mainstream kits are made by injecting molten polystyrene into hot metal molds. Because of the great expense involved in this type of production, these kits are usually mass-produced by big companies. But a whole universe of less expensive alternatives to injection-plastic materials is available these days. Model kits also come in metal, vinyl, and resin, and don't require an assembly line to produce. In fact, one person working at home (maybe even in a real garage) can produce model kits.

Airbrushers working on scale models will find many more challenges than simple paint schemes. Car bodies and aircraft fuselages are wonderful canvases for the adventurous. Intricate or unusual camouflage schemes have a certain artistic appeal as well. Artists can spray with paints that will react differently depending on the light, or airbrush spacecraft surfaces that simulate the different effects of ionizing radiation. Airbrushing can be used to make built-up models more realistic by adding weathering. The challenge is to create a small-scale simulation as realistically as possible—with as much complex detail and as many colors as you need.

ESSENTIAL SUPPLIES

Paints

Modelers armed with airbrushes are blessed with a wonderful selection of paints to choose from, and an experienced modeler's toolbox will contain a variety of products. Paints used for models are either water-based or solvent-based (oil- or lacquer-based). In the past, solvent-based paints were the best choice for models because of their superior durability. The newer acrylics, however, are rapidly catching up. Most, when properly cured, will sand as well as solvent-based paints with wet-dry sanding products. Some of the model paint lines within the two main groups groups are airbrush-ready, some require thinning (see Box, "Getting the Right Consistency"), and some must be mixed with airbrush medium. For a general discussion of paint types, see Chapter 1, pages 26 to 29.

The safety precautions you need to take will depend on the kind of paint you are using and what you are painting. For example, some solvent-based paints are incompatible with the vinyls and resins used by manufacturers of garage kits, and some of the airbrush thinners have hazardous chemicals in them, even those for water-based paints. Be sure to read all safety literature and follow any suggested guidelines. This isn't the hobby to die for. (See "Safety Tips," page 38).

No single company offers a complete airbrush-ready paint line, one which includes all the manistream colors as well as a variety of metallics, skin tones, and clearcoats. The key for the airbrusher, as for all painters, is to experiment with different products from different manufacturers. (One very talented figure modeler uses artist out-of-the-tube watercolors thinned with distilled water. Because the mixture he is spraying is so thin, he is able to spray at an unusually low pressure and still get a fine, even spray, and erase mistakes with a damp cloth or cotton swab. He achieves the shades he wants by layering, and applying a solvent-based clearcoat between layers.)

Several of the gaming miniature companies also market lines of acrylic paints under their label. These paints have lots of interesting colors not found in the palettes of the mainstream manufacturers. They do, however,

require thinning. The Testor Corp, for example, has great lines of solvent-based and acrylic paints. Some are airbrush-ready. Many are blended to match the Federal Standard paint chips that so many military modelers swear by. Some of the other paint lines include skin tones, clearcoats, and metallics. Also available is an extensive line of automotive colors, including pearl and candy colors.

Its always a good idea to comparison-shop: you may find that you can get the effect you have achieved with an expensive combination using a lower-priced mix.

Masks

Unlike color applied with pencils and brushes, color applied with an airbrush doesn't always go where it is intended. It is possible to miss the target, particularly if the target is small. There is also the ever-present problem of over-spray. It is disheartening to suddenly notice that the color you have been spraying on one part of your model has bloomed on other parts, "downwind" of where you were aiming. *Masking*—in a variety of forms—keeps paint off the areas that are not supposed to be painted. It can also be used to create smooth, crisp edges at the boundaries of color patches.

There are two main types of masks: masks that have an adhesive backing and will adhere to the surface they are protecting and masks without an adhesive backing. The latter are also called no-tack masks, freehand masks, or floating masks. All adhesive masks have what is known as *tack,* which refers to the degree of stickiness of the adhesive. Ideally, an adhesive mask should have enough tack to hold it securely in place but not so much that it lifts up the paint it is protecting. No-tack masks are not actually bound to the surface being masked. They are held in place by the artist; if large enough, by gravity; or by tape. The unmasked area is painted and the mask is moved. Just about anything can be used as a freehand mask, including cardboard, paper, straight edges, French curves, cotton balls or pads, and plastic wrap. Plastic wrap is partic-

ularly useful for covering large surfaces.

Commonly used adhesive masking materials for model making are tape, frisket film (see Chapter 1, page 32), liquid masks, and Parafilm. Parafilm, a low-tack wax-based product which comes in rolls and which is resistant to most commonly used solvents, was originally designed for use in biological laboratories to seal containers but can be used in virtually any modeling application. (See below, "Using Parafilm.")

For modeling, frisket film is most useful for flat or cylindrical surfaces with little relief. Camouflage patterns with distinct edges can also be done with frisket film. Usually, the camouflage design is traced onto the film with a permanent pen. The backing is removed and the frisket film is positioned on the surface and cut with a sharp hobby knife. If using this technique, care must be taken to avoid damage to the surface while cutting. For simple designs, it may be easier to cut the film and then place it on the surface.

Tip

Frisket film is relatively high tack, and a good technique for reducing the tack is to place the sticky side of the frisket film on a hard surface and remove, then repeat this several times before using it on a model.

Some modelers use liquid masks, including latex mold maker, rubber cement, and liquid masking products. Liquid masks are typically applied with a paintbrush, but some can be thinned and airbrushed. Getting the layer thick enough so that it can be easily removed may take several coats. The advantages of these products are that they are relatively easy to apply and they conform to any shape on any surface. Disadvantages are that you have to wait for them to dry and that they can be difficult to remove. Some modelers use regular pencil erasers to dislodge liquid masks. They start from the outer edge of the mask, lifting up the masking material as they go, and work toward the center of the mask. In addition, liquid masks are often hard on equipment. A good habit to develop is to clean your brush often during use. Any time you notice buildup of liquid on the brush, stop and clean the brush thoroughly.

Using Parafilm

Cut a section from the roll and remove the backing paper. At this point, the film has a fibrous appearance. Grabbing both ends of the cut piece with thumbs and fingers, stretch the piece along the bias until all the fibrous-looking portions have vanished. Although package instructions say that the film can be stretched to five times its original size, pieces are usually ready to use when they are two or three times their length. The film develops maximum tack after a few seconds. Next, place the film over the area to be masked. Make sure that the surface is clean and oil-free. Parafilm is flexible enough to be wrapped around corners, curved edges, and any shape.

On the downside, it can be a challenge to get the film to stick to smooth surfaces. Warming the film with fingers or your breath can help improve the tack. Pressing with a damp paper towel works as well. The edges of Parafilm masks are also very fragile. Even a slight touch can cause the film to roll back onto itself, away from the desired boundary. These little errors are usually discovered when the film is being removed. It is also easy to miss

𝒯ip

You can use your fingers to press the Parafilm into place, or you can use clay shapers or a stiff-bristled brush. Clay shapers come in three sizes, and two styles, each of which has four differently shaped rubber tips. The smallest is the most useful. Moistening, not wetting, the fingers or tools, helps the film to adhere properly.

Parafilm tools. 1, parafilm—4-inch-wide and 2-inch-wide; 2, Fiskars locking scissors; 3, clay shapers (from top to bottom, #10, #6, #3);

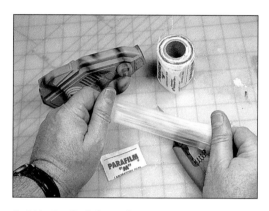

Stretching Parafilm before applying it to a small model part with many curves and indentations.

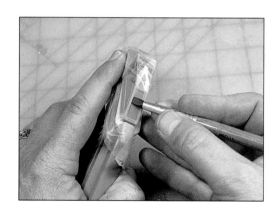

Using a #3 clay shaper to press the Parafilm into the area on the model part that needs to be masked. You can also use clay shapers to fold any excess film back over itself.

covering a spot with the film. This can be avoided by covering the large areas first and then applying the film to the smaller sections individually. Overlap the smaller film sections onto the larger main section.

Lifting the mask can be tricky, also. The pencil eraser technique described above also

works with Parafilm. Start at the edges of the mask, pulling or pushing the film toward the center, away from the edge. As with all masks, if the paint has been applied heavily, it's a good idea to use a new hobby blade and carefully cut around the mask before attempting to lift it.

Tapes

Tapes or tapelike materials that can be used for masking include vinyl tape for automotive striping, transparent tape, masking tape, Post-it notes with large adhesive areas, and Post-it tape. These products are best for relatively straight edges on flat or cylindrical surfaces with little or no relief. Be careful not to apply so much paint that it is drawn under the mask along the panel line. It may be necessary to reduce the tack of the tape by pressing it to a piece of cloth a few times before putting it in place. This causes the adhesive on the tape to pick up particles and fibers from the cloth, thereby making the tape less sticky. It is also a good idea to test the compatibility of the adhesive with your paint before applying it to the intended surface. Some solvent-based paints interact with tape adhesives. Post-Its are relatively low tack, and are easy to remove without lifting paint from the surface. Post-its can be pressed onto a surface to trace relief by embossing with a soft pencil. Once so marked, the Post-It is removed and cut to fit. Post-Its are also reusable. It is possible to cut several at once while they are stacked.

Sealers and Gloss Coats

Sealers are a necessity. They can be used to apply a particular luster to a finished paint job or to protect layers of work before adding the next. They are also needed to make decal carrier film disappear into the surface they are applied to. Several good sealers are available, both solvent- and water-based. Some of the craft paints include sealers in their lines. The major hobby lines have them in their palettes as well. Another product that is known to many is Future floor wax. It has the ability to hide minor surface flaws such as small scratches on clear parts. It can also be applied with a paintbrush or an airbrush. A thin coat gives a satin finish. A thicker one gives a great gloss finish.

Gloss paints are less forgiving of improper thinning or incorrect pressure than flat paints. For a final gloss finish, a good choice is paints that are thinner than usual and applied at air pressures as low as 15 psi. Cured gloss paint, acrylic or enamel, can be sanded with very fine grit wet-dry sanding products.

Decals

Building civilian themes frequently involves the application of decals over gloss finishes. Racing cars and airliners can be covered with decals. If you have ever applied decals to any surface, you know they are likely to wrinkle up, either while you are applying them or once they get wet. Decal setting solutions, which are available in several strengths, are designed to soften the glue on the decal just enough so that it will adhere firmly to gloss finishes smoothly and firmly, even over irregular surfaces. Decals are best applied to a gloss surface with a decal setting solution. Before using a setting solution, recall the Rule of Introduction (page 106). Water-based clearcoats and solvent-based clearcoats are both available, and decal setting solutions vary in strength and effect on depending on the type of clearcoat that has been used.

WHEN TO AIRBRUSH: BEFORE OR AFTER ASSEMBLY?

One extreme position is, "Paint all the parts; then assemble them." The other is, "Paint nothing until the entire piece is assembled." Most modelers work somewhere in the middle. The compromise depends on the demands of the kit and the modeler's skill and interest level. The availability of tools can be a factor as well. Assembling pieces first may avoid demanding touch-up but can result in uneven finishes in more difficult to reach areas created by assembly. It might be easier to get a smooth and uniform finish on a particular surface before assembling the parts. But painting the pieces or subassemblies first can require more involved touch-up work when the pieces are finally assembled. So, while studying the kit prior to building it, think about how you are going to paint it and what aspects of the project are most important to you. That, coupled with experience, will help you make the right choice.

Accessories

Two types of accessories that are essential for modelers are holders for the small parts you will be working with and good cleaning tools. "Found" objects that can be used by modelers include the following:

- Clothespins with the "business end" cut to a point work well for parts still on the trees or with tabs.
- Self-closing tweezers with teeth in the jaws also work well. Some have the jaws set above the handle so that you can set them on your bench top with the piece held safely above the surface.
- Hemostat scissors make excellent holders but be careful not to damage parts while closing them. Bamboo chopsticks also make great holding sticks. When cut in half, you get a stick with a point and a stick with a squared end. Drilling the right-sized hole in the end makes it easy to use them with parts of resin kits that have pins inserted.
- For very small pieces with no places to grab or no pins, use white glue to temporarily attach them to sticks or the back of clothespins. A piece of 2x4 with holes drilled into it at angles makes a nice stand for the sticks. Make sure the holes are large enough to hold the sticks you are using. Some of the tool companies also make free-standing devices that have alligator clips or self-closing tweezers mounted on them.
- Stiff-bristled stencil brushes are great for

Some useful accessories, shown on a generic rotary cutting mat. The blue mat in the foreground is an Excel Self-Healing mat. 1, model parts on chopsticks, and a styrofoam block on a stick, in a handmade wood block holder; 2, Crafter's Pick white glue; 3, plastic paint pots; 4, Monoject #412 syringe; 5, stencil brush; 6, curved hemostat scissors; 7, tweezers.

removing paint buildup from the end of the nozzle while working. They come in different sizes and can also be used for cleaning out paint cups.

- Syringes with long, curved tips can be used to blast cleaner into the cup on gravity-feed airbrushes or the stem on siphon-feed models. A spray bottle with cleaner in it works very well, too.

AIRBRUSH EFFECTS FOR SCALE MODELS
Vehicles and Military Hardware

These themes offer unlimited possibilities. The vehicle category is self-explanatory. By military hardware I mean anything connected with the military, past, present, or future, for land, sea, air, or space. There is a great diversity of techniques, too, and different interest groups may specialize in some more than others. Enthusiasts of civilian themes are practiced in applying gloss finishes. Military themes offer practice in camouflage. Railroad modelers are particularly adept at weathering effects. In addition, different scales call for different techniques. Finally, any kind of model is a candidate for the application of decals.

Painting military subjects, either sci-fi or historical, can involve camouflage, panels, and weathering. The best place to learn about the different aspects of building and painting military objects is in the company of military modelers. Not only can they offer pointers on rendering wear and tear and weathering, but they usually have excellent reference materials for different schemes as well. With the wealth of reference material available in movies and TV, sci-fi modelers can become as intense about accuracy as the builders of military vehicles.

Weathering refers to the often-subtle effects of wind, water, and sun on the surfaces of vehicles or weapons. One way to achieve a weathered look is to use different values of the same color. Darker values are used in the shadowed areas or those surfaces in the background. Lighter values are applied to the sur-

faces in the most extreme foreground, particularly on corners and edges. Adding white, gray, black or its opposite color from the color wheel can change a color's value. Each of these combinations produces different effects. Mixing dark colors with small amounts of metallics gives a more realistic effect. One common strategy is to base-coat the model in the darkest color, often black, and then add the rest of the colors on top of that. Good depth of color can be achieved by applying several light coats and building the color in layers. The end result is an uneven coat, suggestive of weathering and shadow.

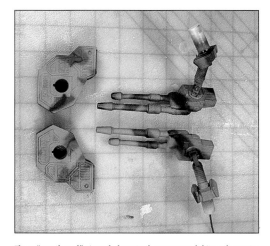

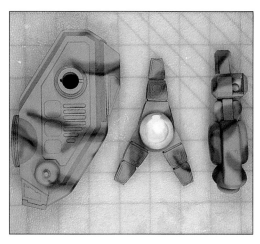

These "weathered" pieces belong to the same mech kit as the parts shown in the photographs on page 108. The model was painted and assembled by Tom Grossman (the finished piece is shown below, right). For the weathering effect , a base color was made from dark green, brick red, and black. This was added in different amounts to a mixture of gold and clear flat. Several layers of different darknesses were sprayed along the lower edges of panels and vents and over the undersurfaces. Run-off lines (the black lines) were added in downward directions from the corners of panels and other logical places. In places where different colors overlapped, the artist removed the top layers of paint by rubbing it away while it was still wet, giving a weathered look to the colors underneath.

For the camouflage pattern, random flame-shaped patches of dark green and burnt umber were applied to the upper surfaces of the vehicle. These were sharpened and shaped during several touch-up passes with each color. Finally, the flame-shaped patches were accented with black lines running along the borders where the green and umber patches touched.

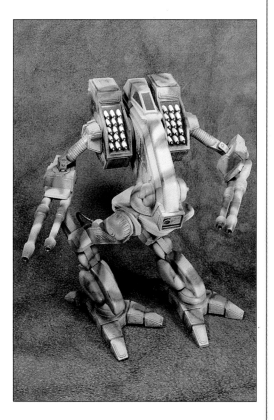

Mechs are anthropoid war machines of varying proportions. They include, but are by no means limited to, the Gundam kits that became popular in the late 1990s and the machines inspired by the Macross and BattleTech series that preceded them. They can be thought of as the armor of the future. This Vulture Battlemech, an Armorcast resin garage kit, is roughly on the same 1:48 scale used for mainstream armor kits. It was designed as a large gaming piece, and the joints were made to allow easy repositioning by removing or modifying the built-in stops.

Starting Over

Every now and then, a painting just doesn't come out the way you planned. When that happpens, you can either add more layers to cover up what you don't like, which sometimes destroys details, or you can strip the whole things and start over. Several popular stripping methods include soaking the kit for varying lengths of time in full-strength PineSol, Easy Off oven cleaner, Simple Green, Castrol Super Clean, or undiluted Formula 409. Automotive brake fluid is said to work well also. But all of the heavy-duty products present safety hazards. For example, Super Clean is an automotive degreaser and it interacts with lead compounds, like some of the metals used to cast model parts. Be sure to take proper safety precautions for fumes and skin contact as directed on the package. And remember the Rule of Introduction: Test the materials together first. Paint up a piece of spruce, let it cure, and drop it in. Start your tests with the least toxic products, the household cleaners like PineSol, Simple Green, and 409. If those don't work, up the ante. Be prepared to help the stripping with some elbow grease and a toothbrush.

Tom Grossman built his first
model when he was 5 years old,
and with a brief time out for col-
lege, courtship, and marriage,
has been building and painting
models ever since. In 1983, he
and his wife, Maxine, opened
their craft manufacturing busi-
ness, Humming Line Creative
Works, in Colorado Springs. In
the mid-1990s he left his 17-year
teaching career to become a
Hobby Industry Association
Certified Professional
Demonstrator and in 1998 began
teaching classes in airbrushing
and model building in Colorado
Springs and Denver. Over the last
few years, he has earned numer-
ous awards from model contests
all over the country. Tom is now,
among other pursuits, a manu-
facturer's representative for sev-
eral craft and hobby companies.
Visit the Grossman company
Web site at http://www.hum-
mingline.com.

Star Blazers Gamalon Battle Carrier (Bandai)

TOM GROSSMAN

The Battle Carrier is a styrene injection kit, at approximately a 1:1000 scale, inspired by the Japanese animation series Star Blazers. The detail is crisp, and the panel lines are recessed. The techniques described here could be applied to many other subjects, at many dif-ferent different scales.

1. I base-coated the kit with brick red many times during assembly. The basecoat

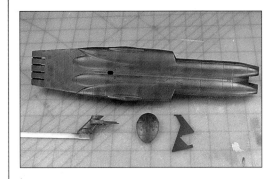

1

was used as an indicator for seams that need-ed to be hidden. The seams were sanded, filled, and repainted as needed. Once the construction as deemed acceptable, a final, uniform basecoat of brick red was applied. Dark green was then sprayed along panel lines and concave corners. Brick red mixed with gold was sprayed on the leading edges of all panels and concave edges. Brick red with copper was sprayed along all trailing edges.

2. I did the touch-up of the panels and the corners using Post-It tape and Post-it notes for masking.

3. I cut T shape stencils of the smallest panels out of Post-Its with a #11 blade X-Acto knife.

4. The finished piece, clear-coated with flat acrylic, was assembled and mounted on the stand that comes supplied with the kit. The base for the attack carrier was splattered with white paint to resemble stars.

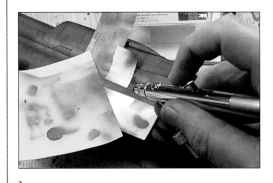

2

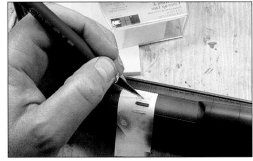

3

Tip

Taking figure drawing classes
can help develop an understand-
ing of the shadowing and mus-
culature of the human form. It
provides a chance to study the
subtleties of skin color, shading,
and detail on different bodies in
different lighting conditions. It is
also a great jumping-off point
for those who decide to start
sculpting their own figures.

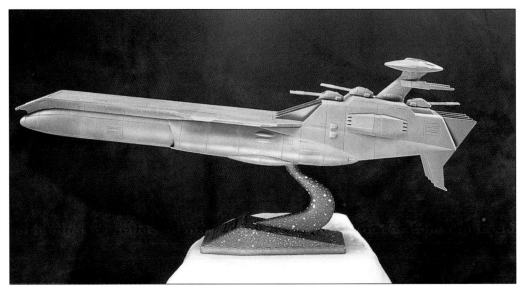

4

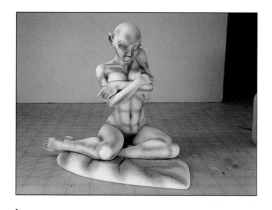

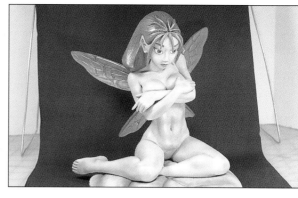

1 2 3

Figures

More common to figures than the other themes are fabric, flesh, and hair, at least for most of the human subjects. Clothing can be metal, armor, or fabric with metal decorations. Dinosaurs and some monsters are covered with scales. Monsters can have dead flesh in muted colors, while girl kits need to have vibrant, lustrous skin tones. Hair comes in a wide variety of colors, none of which can be easily found in a paint bottle on a store shelf. Many figure modelers mix their own flesh tones.

Skin Tones: Musette

TOM GROSSMAN

This is an original-subject garage kit. Even though girl kits may not be everyone's first choice, the techniques used in painting Musette's skin can be adapted to paint the skin of any human subject (or alien or monster for that matter). Whatever the color, skin tones are usually built from dark to light with the darker colors being at the deeper points.

1. I cleaned Musette off and applied a uniform coat of an off-white primer, then sprayed on the deepest colors first, taking into account the light source, which I decided would be coming straight from the viewer. I sprayed magenta into the concavities, or deep points, in her musculature, providing a warmer base color for places that would naturally be darker (photo 1). (I used the same basic technique for the skin tones on Thor, a Darkstorm Studios resin garage kit. I first applied a darker skin tone in the shadowed areas of the torso and overpainted with a lighter skin tone.)

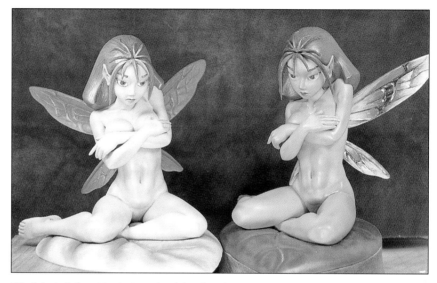

This photograph shows Musette in purple side by side with Musette in teal. Instead of magenta, mauve, and pink, the teal Musette's skin tones were built with teal and pale green built over a red basecoat. Her hair was streaked with VRush Pens using mixtures of teal, brick red, gold, and copper, and the leaf was airbrushed with dark green, cinnabar, and red. (Both kits are from Fogger Studios.)

2. The next layer was mauve, the midrange color for Musette's skin. I sprayed this in greater amounts in the areas not already colored with magenta. Only enough mauve was used to make a smooth blend with the magenta.

3. For highlights, I applied pink to the highest points of the raised surfaces. I attached the hair and painted it a light purple (photo 2).

4. I attached the wings and painted them a light purple. I sprayed thin layers of pink over the entire body until the colors were blended exactly as I wanted them. The streaks in the hair were done with VRush Pens using mixtures of purple, gold, and copper. The leaf was airbrushed with green, teal, and pale yellow. Photo 3 shows the finished piece.

Thor

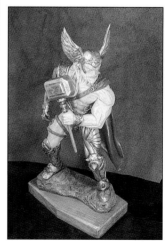

Airbrushing Woodcraft Items

Painting and embellishing unfinished wooden figures and objects is one of the more common pursuits of crafters all over the world. The bounty of wooden objects that can be be painted or otherwise decorated for display in one's home, garden, or workplace—or for one-of-a-kind gifts—is almost boundless.

Birdhouse Bag Dispenser

LINDY BROWN

In this demonstration I painted an unfinished pine wooden birdhouse (12 by 6 by 5 inches), available from Bentwood, designed for storing and dispensing plastic bags. All the colors specified in the steps below were Liquitex Concentrated Artist's Colors, mixed in a 1:1 ratio with Liquitex airbrush medium; the resulting consistency was thin enough to allow a smooth flow of paint and thick enough to adequately seal the porous wood.

1. I prepared the surface by sanding all edges and rough patches with fine-grit wood sandpaper (using a sanding pad), then wiping away the dust with a dry tack rag. (Any lint-free cloth will do, as long as it is not wet.) I then primed the sanded surface with several light coatings of titanium white, holding the airbrush 8 to 10 inches from the surface with a 0–10–0 trigger movement. Once the final primer coat was dry, I sprayed the basecoat—the same titanium white I used for the primer coats.

2. I masked off the birdhouse edge molding (trim) by centering a strip of ³/₄-inch-wide masking tape (sticky side down) on each of the vertical corner edges and pressing down ³/₈ inch of each side of the tape over the corners. Photo 1 shows the primed and base-coated piece with the masking tape on one edge in place.

3. To create the siding, I positioned ¹/₂-inch-wide wide strips of masking tape horizontally, one above the other on each side of the birdhouse, continuing until all four sides were covered from top to bottom. I then removed the lowest strip of masking tape. Using the bot-

tom edge of the tape just above the uncovered area as masking, I sprayed a light gray color over the uncovered area (airbrush 5 inches from the surface; half-on, half-off; 0–5–0 trigger movement), gradating from dark at the top to light at the bottom (photo 2). I repeated this process until all the rows of siding were painted.

4. Using a combination of grey and burnt umber, I sprayed the vertical edges of each masked corner (again, airbrush 5 inches from the surface; half-on, half-off; 0–5–0 trigger movement) (photo 3).

5. I removed the masking from the molding, and misted the edges of the unmasked areas with the same gray color I used for the siding (airbrush 2 to 3 inches from the surface; 0–3–0 trigger movement) (photo 4).

6. I sprayed an even coating of Swedish blue, with a touch of burnt umber to tone it down, over the roof section (8 inches from the surface, 0–7–0 trigger movement).

7. I cut a scallop pattern out of heavy stock paper. Starting at the bottom edge of the roof, I held the template in place and airbrushed the gray color along the scalloped edge to create the shadows (airbrush 3 inches from the surface; 0–3–0 trigger movement). For the next row up, I shifted the template to the right by one-half shingle before spraying; for the next row up I shifted the template to the left by one-half shingle. I repeated this process, spraying upward, until the entire roof was painted, then reassembled the hinges.

8. I airbrushed white on the tip of the shingles, providing a three-dimensional look.

9. Affixing a 5- by 6-inch ivy stencil to the roof with masking tape, I painted in the leaf areas with light overlapping horizontal passes using yellow paint (airbrush 6 inches from the surface; 0–4–0 trigger pattern. I selectively added green over the yellw leaf base to add dimensionality to the leaves. I outlined the leaves, and added thin veins selectively, with a very small paintbrush dipped in burnt umber.

Lindy Brown, who has worked in a number of different mediums over the years, currently combines her interest in decorative painting with her expertise in airbrushing. She has written several books, the latest of which was published in 1997: *Easy Airbrush Projects for Crafters and Decorative Painters*. She has done promotional work for several airbrush manufacturers, including Badger and Medea. Now semiretired, Lindy continues to be active in the world of crafts, airbrushing textiles and wood, and conducts workshops on airbrush technique, decorative painting, and quilting. Ms. Brown lives in Hesperia, California.

Tip

With any unfinished wood piece, as the first primer coat dries, it will raise the grain of the underlying wood. When the paint is dry, sand all surfaces with a sanding block and fine-grit sandpaper and spray another primer coat of paint. The basecoat should not be sprayed until no wood grain is apparent.

10. I shadowed the leaves by replacing the leaf stencil slightly down and to the left of its original placement and spraying directly on the edge of the stencil with smokey grey paint (airbrush 2 inches from the surface). The overspray created the shadows. Photo 5 shows the finished roof.

11. I repeated steps 9 and 10 to paint the ivy leaves cascading down the birdhouse.

12. Using the same smokey gray, I airbrushed the edge of the cut hole (airbrush 2 inches from the surface; trigger movement 0–2–0) to create the illusion of depth. When the paint was thoroughly dry, I sprayed Krylon matte finish varnish spray over all the painted surfaces. Photo 6 shows the finished dispenser.

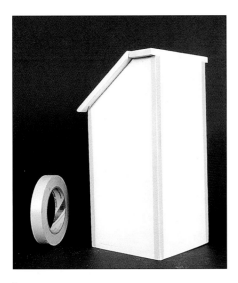

1

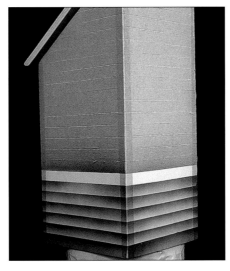

2

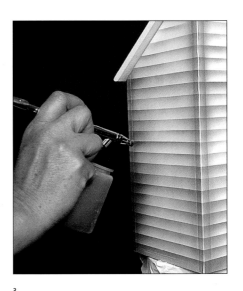

3

4

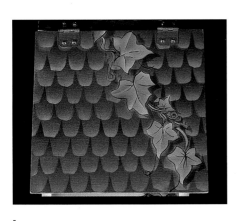

5

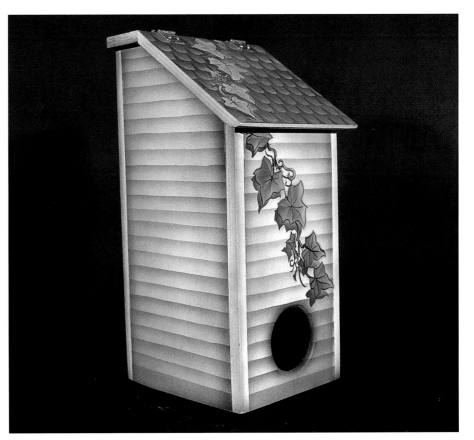

6

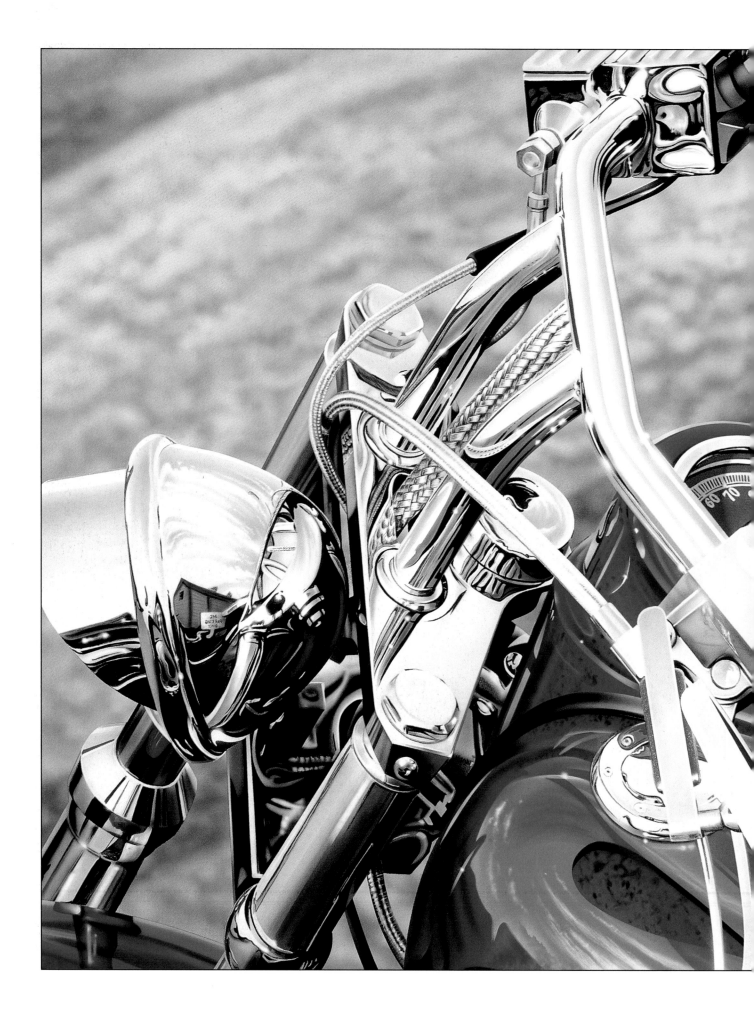

FINE ART
&
ILLUSTRATION

Whether you choose to call the art in this chapter fine art, commercial art, or illustration, together the pieces show just how versatile the airbrush really is. Featured are A. D. Cook's magically reflective motorcycle, Kirk Lybecker's airbrushed watercolors, with their brilliant transparency effects, and a wonderful miniature portrait by Andrea Mistretta that uses quintessential airbushing technique to create the look of a serigraph, or silk-screened surface. Pamela Shanteau's intricately detailed fantasy classics on Claybord seamlessly combine a myriad of different art tchniques. Richard Sturdevant's glowing artwork proves that oil and water really *do* mix, and Robert Anderson's collage-like work from his Pulp Western series reveals yet another facet of the truly astonishing range of airbrush effects.

Creating Reflective Effects

Ultimately, painting chrome is a process of working with both airbrush and paintbrushes to create an illusion—the illusion that the viewer is looking at a real reflective surface, rather than paint on canvas.

"Passing Time": A.D. COOK

1. The canvas I used for this piece is pure cotton duck stretched canvas prepared with acrylic gesso by the manufacturer), 36 by 48 inches and 1 inch thick. I projected my line art image onto the canvas from a reference photo which I shot at a recent motorcycle event. I copied the image—lightly, so the lead would not show through the paint—onto the canvas with a .5 mechanical pencil, then sprayed it with workable fixative. The goal when projecting the image is to put just enough information on the canvas to work from. Not every bit of detail is necessary in the drawing process, and the more lead there is on the canvas, the more danger there is of ending up with smudges.

Once I had masked off the motorcycle image (photo 1) I blocked in the background area with a basecoat of opaque iron yellow. Next, I added textural areas, in what could be described as "controlled scribbling," of opaque white; transparent black mixed with transparent bright red; and a variety of transparent and opaque colors including raw sienna, burnt sienna, raw umber, and other warm earth tones. Once I was happy with the general "feel" of the background, I softened the entire area with various blends of white mixed with some of the colors I'd used earlier. I wanted the background to appear "out of focus," bringing the motorcycle to the front of the painting and adding depth to the finished work. Photo 2 shows the finished background.

2. I started work on the motorcycle by painting the tanks and fenders first. I left the chrome for last, since all other colors are reflected in the chrome. I masked the areas to be painted in the same way I previously masked the background (photo 3). Additionally, I used clear acetate sheets (3- to 5-mil sheets) to define the crisp edges and reflection areas within the masked areas. I drew the shapes onto the acetate pieces I planned to use later with a permanent fine-line marker. I also made reference marks by tracing around some areas of the acetate and marking a few X's onto the acetate and masking tape to assist in repositioning my masks.

3. Before beginning to paint, I mixed enough to do the tank and fenders and still have some left for the chrome areas. My primary blue for the tank and fenders is a mixture of opaque phthalo blue, opaque ultramarine, transparent ultramarine, and a little transparent bright red. For the dark blue areas I mixed a combination of opaque phthalo blue, transparent ultramarine, transparent violet, and opaque repro cyan, creating a deep purple. Many of the highlight areas include opaque cobalt blue, my special "chrome blues" (see "A. D.'s Chrome Recipes," opposite), and white. I started by blocking in the main blue color, without much regard for gradations and blends, to establish the bike's base color (photo 4). Once those areas dried, I appied shadows and reflective colors freehand painting using acetate and hand-held shields.

For the aqua blue highlights on the tank foreground I mixed some opaque cobalt blue with a little transparent Kelly green. With the exception of white, black, and previously mixed colors, most additional colors on the tank and fender were applied using transparent colors, to create a polished look. I masked the areas I wanted to protect using masking tape and paper. Spraying both freehand and with acetate templates, I established reflections with my aqua mixture and white. Photo 5 shows the almost-finished tanks and fenders. Some fine details, shown being masked in photo 6, were added later.

A. D. Cook is the president and creative director of A.D. Cook + Associates, Inc., in Portland, Oregon. When he's not producing brochures or Web sites for his clients, he enjoys painting in the studio. Since buying his first airbrush in 1978, he has continued to paint in many mediums, including the creation of dozens of murals for the Hollywood Video stores. Most recently, A.D. has been creating paintings that reflect his passion in life with a current emphasis on large-scale paintings of motorcycles that challenge the viewer to say whether they are looking at a photograph or a painting. Visit A.D. Cook's Web site at www.adcook.com to see more examples of his murals and fine art paintings, or send an e-mail to ad@adcook.com.

"I prefer to work from my own reference material because I like knowing the piece is mine from beginning to end, and I enjoy the process of shooting good reference material. Additionally, I know there won't be any copyright issues when I use my own photos."
—A.D.C.

1

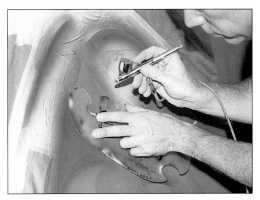

2

3

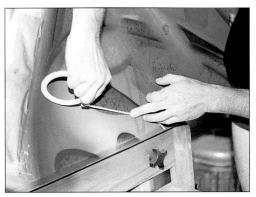

4

5

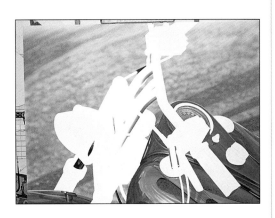

6

4. Next, I painted all the small miscellaneous items—turn signals, speedometer, etc. Photo 7 shows the painted-in speedometer and turn signals, with masking for the chrome area removed.

7

A.D.'s Chrome Recipes

The premixed colors for the chrome had to include not only all the colors that I had already used but also two special "chrome blues." Chrome 1 is equal amounts of opaque repro cyan and opaque white, some transparent royal blue and transparent ultramarine, a small amount of opaque phthalo blue, and a very small amount of transparent black—plus pure black and pure white, and, finally, a brownish gray for the smooth pieces of chrome that are reflecting the ground. Chrome 2 is mixed a little "muddier" by adding more black. The earthy gray was a mixture of all the browns I used for the background, with some added transparent black. My chrome blues are really more like blue-grays than straight blue; the splash of black helps to kick it back a little so that it doesn't look fake.

A simple version of chrome blue can be made with transparent ultramarine, some transparent ochre, and a little transparent black.

5. Before I began actually painting the chrome, I invested quite a bit of time studying my reference photo so that I understood what was reflected in the chrome, using a magnifying glass to examine the details. The masking techniques I used were the same as the ones I had used for the previous sections; I started out with 1/8-inch tape (photo 8) and worked around the individual large pieces.

Since there are a lot of pieces in a motorcycle, I look for pieces that reflect similar colors and paint them at the same time, which minimizes the need to change colors and reduces the need for excessive masking. In this case, I started with the headlight area because, due to its shape and reflective intracacies, it is the centerpiece of the painting. After masking off everything except the headlight housing, triple trees, and a couple of other areas (photo 9), I used my chrome blues and white to paint the sky's reflection and clouds. Using templates and acetate, I approached the chrome in the same way I had the tank and fenders. Crisp edges are essential in painting chrome, so I had to keep the hand-held templates close to the surface when spraying.

6. I started by freehand painting in the general areas with the lighter of the two chrome blues. (I wasn't too concerned about being exact at that point, since I knew that I would be coming back to those areas with other colors and templates to define them.) I sprayed darker chrome blue over the lighter blue to establish depth in the chrome.

7. Next, with a small fine-line paintbrush, using the airbrush colors, I painted the black solid areas and lines. A mahl stick, which is used to support the hand above the surface of the painting, is a very handy tool when hand-painting areas of this size. Once the black was brushed in, I airbrushed chrome blues, whites, and other colors using cut acetate stencils. First, I sprayed my chrome no. 1, which is the brighter blue of the two, then chrome no. 2. Once the blues were done, I defined shapes with browns, blacks (transparents and opaques), and white.

After I airbrushed all the colors, I went over the black again and added whites with a fine-line paintbrush to create contrast.

Photo 10a shows the headlight housing in progress. Photo 10b shows the finished housing, after I have added highlights, shadows, and details. Notice the complexity of the reflected details. The headlight is, essentially, a small landscape painting.

8. I didn't want all of the chrome areas to be crisp. Some parts of any bike, because of their relationship to other pieces or because they are made out of a slightly different material, are inherently softer. For example, the forks in this motorcycle were much less detailed than most of the other pieces. To paint those, I masked the larger areas and airbrushed the forks freehand. I added details using a few hand-held templates and acetate masks that I held slightly away from the surface to achieve softer edges.

9. For the cabling, I started by removing the masking from the areas to be painted. Using a #1 paintbrush, I hand-painted the cross-hatched texture of the braided steel cables as seen in the wiring, and clutch and brake cables, using colors from my existing color palette. I used an airbrush to to add highlights, shadows, and reflected colors, and to soften the blends so that the handlebar section wouldn't be too "punchy" compared with other parts of the painting. A closeup view of the handlebar section (photo 11) reveals the hundreds of fine paintbrush strokes that I needed to create the illusion of braided steel wiring.

10. With all my paintings, once the work is completely unmasked, I do general touch-up work and, if necessary, add details. Using small paintbrushes, I apply colors to clean up some of the edges where paint may have worked its way under the tape, or I touch up some of the curved shapes to hide masking seams and to tie all the pieces together.

The opening page of this chapter shows the completed painting, without the black acrylic border I had painted to give the piece a clean contemporary look.

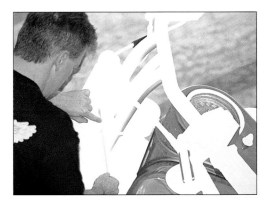

8

9

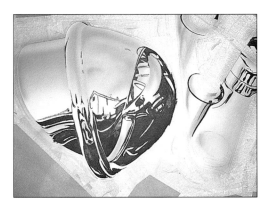

10a

10b

11

The Final Coats

I spray all my paintings with Krylon Crystal Clear acrylic coating, which provides a permanent protective gloss coating and helps to unify the finished product. Clear-coating also pops the contrast a little, which is great for paintings of shiny subject matter. I first spray a light, horizontal coat, and then add a couple of heavier layers in both horizontal and vertical directions, overlapping each coat slightly.

Masking

I keep a large supply of 3M masking tape on hand, in $1/8$- to 3-inch rolls because it doesn't leave residue and is easy to remove. For masking paper, I prefer 12-inch wide rolls commonly used by house painters. I find painters' tape (2-inch-wide rolled paper backed with a light adhesive) handy for the quick masking of small areas. I start by covering areas I'm not ready to paint by masking the shapes, using $1/8$- or $1/4$-inch tape for fine detail and other sizes as needed, then I fill in larger areas with tape and paper. To prevent paint from seeping under the tape, I press down all tape edges with my hand. Where the tape crosses over other pieces I use my fingernail to secure the intersections.

Airbrushing Watercolors

KIRK LYBECKER

Kirk Lybecker has a B.F.A. from Washburn University in drawing and sculpture and a M.F.A. from the University of Idaho in drawing. He has taught drawing, painting, and jewelry at the University of Idaho and Portland Community College (Oregon), and airbrush, illustration, and watercolor at Clark College in Vancouver. For over 25 years his work—at first traditional watercolors but more recently airbrush-paintbrush watercolors—has been exhibited at galleries across the country, and is in the permanent collections of over 20 galleries and museums. Mr. Lybecker's studio is in Portland (Website: www.lybeckerstudios.com).

"When airbrushing watercolors, choose a watercolor paper that is best able to take a wet wash. I like harder papers (ones with heavy sizing) for pieces that will feature sharply linear objects: I use T. H. Saunders for cityscape paintings and Arches (which allows a little more diffusion in the wet wash) for floral paintings." —K.L.

I got into watercolor by chance. I got into airbrushing because watercolor wasn't doing what I wanted it to do. The washes always seemed to be washed out at best and downright anemic at worst. They didn't have the color or intensity that oil paint could generate. I found that with an airbrush I could doctor up some of those washes, often with spectacular results. More and more, I began to incorporate the airbrush in creating my watercolor pieces. Both airbrush- and paintbrush-applied watercolor are based on the theory of transparent painting, and are in fact complementary techniques. Unfortunately, many people view airbrushes the same way they view computers—expensive, difficult to master, and perverse. But the newer generations of airbrushes, like the newer generations of computers, are significantly easier to operate, clean, and maintain than earlier generations. Leaning how to use an airbrush will save you time, money, and sanity.

For optimal effects, you'll need several different types of airbrush. Have one that offers a lot of control, such as an Iwata Custom Micron, which operates efficiently at low air pressures, thus reducing overspray, and is a superb detail brush. I use an Iwata HPC or RG-2 for backgrounds. These guns have a wider spray pattern, which is useful for blending larger areas.

"Another Day at the Hotel Rorschach" (29 by 41 inches). This painting was done by Kirk Lybecker on T.H. Saunders paper. It was mounted to the easel with double-stick tape. Because the airbrush wash will not warp this heavy paper, it was not necessary to stretch it.

There are numerous advantages to using an airbrush to apply watercolors:

- If you use a paintbrush to rewet a washed area, you will lift off some of the paint; in addition, paint tends to collect in the edges of the rewashed area like a water stain left by a wet glass on furniture. The airbrush, however, sprays what amounts to a thin, edgeless film of paint, which does not leave rewet lines in the underlying wash. You can also use an airbrush for your main wash.

- Areas rewashed with brushes can take a long time to dry, and until the area is dry you really don't know what it is going to look like. Paint applied with an airbrush, however, dries so quickly that you have the time to stand back and look at your work and get a feeling for what the final effect will be. It definitely makes for a less harried style of painting.

- Holding an airbrush at different distances from your painting surface creates different spray patterns. When an airbrush sprays watercolor, it breaks the paint up into microscopic bits of pigment, which appear as dots on the painting surface. The pattern of these dots depends on how far the airbrush is from the painting surface. Think of it this way: If you drop a handful of gravel from a foot above the floor, most of the stones will stay where they landed; only a few will disperse. But if you get up on a ladder and drop the same amount of gravel, the stones will disperse more evenly, over a larger area. With an airbrush, if your brush is close to the painting surface, they will collect close to one another, providing a quick, intense buildup of paint, which is very useful for painting fine details or working on small areas. On the other hand, if you hold your airbrush farther from the painting surface, the dispersion will build slowly over a larger area. This is especially useful when trying to modify or make a large wash such as a sky, as seen in "An Empire for the Forsaken," on the next page.

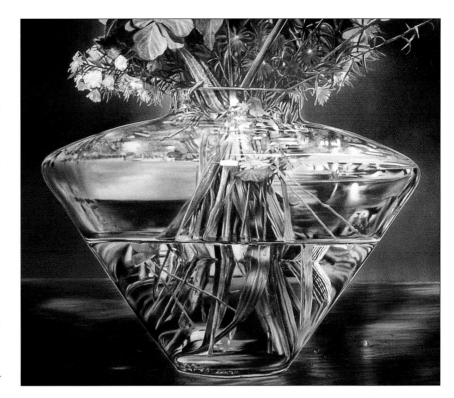

The transparent effects I achieved in these two paintings (top, "Looking Through the Glass," 25 by 40 inches; bottom, "North Light," 25 by 40 inches) would not have been possible to achieve with paintbrush-applied watercolors only.

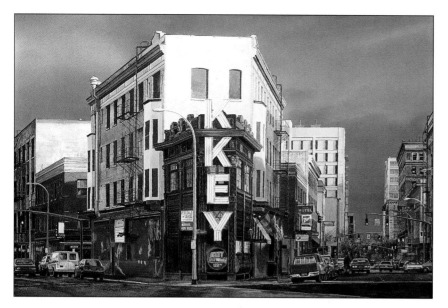

"An Empire for the Forsaken," Kirk Lybecker (25 by 40 inches).

For these flowers (detail, "Whispering to an Indifferent Moon"), I used the airbrush to mix paint on the paper. I started with a basic gray for the lower flowers and added touches of green-gray or violet-gray to differentiate between the individual petals.

To get the soft edges I wanted for these flowers (detail, "Whispering to an Indifferent Moon"), I used an airbrush to create the main wash. The brush I used was an Iwata Custom Micron, which sprays at such extremely low air pressures and produces such fine lines (hairline to ³/₄ inch), that I was able to paint within the area I wanted without masking.

To make one part of a painting jump out from the others, you need to consider all the contrasts, not just between light and dark or soft and hard, but between colors. Here the flowers airbrushed with a warm orange-gray are foils for the main flowers, the cool blue ones. Notice the contrast between soft and hard edges, between light and dark, and between the colors of the flower and the leaves and background. The areas that appear black were really created using deep tones of contrasting color; for example, the yellowish flowers stand out because of the violet-black I used at the edges. Shown here is the finished painting, "Whispering to an Indifferent Moon".

Tip

I find that Frisk Canvas Mask sticks better to rough-surfaced papers than other masking products. I use liquid masking for sharply defined shapes (e.g., geometric shapes) and frisket film for intricate, organic shapes, such as flowers and their component parts. Liquid masking can be removed by rubbing it with a rubber cement pick-up, available at most art supply stores.

- Painting with the airbrush allows you to build up or blend colors in the same way that oil paints can be built up or blended, a feat almost impossible to accomplish with paintbrush-applied watercolor. With the airbrush, you can apply a layer of paint so thin that it resembles an oil wash, providing two distinct advantages: you can add color in such slight amounts that you won't accidentally get too intense a value, and you can blend colors. For example, you can blend a sky from yellow at the horizon to black-violet at the top without leaving any obvious lines of demarcation between the gradations.
- It is relatively easy to use an airbrush to add just a touch of complement to an already sprayed color. For example, I can add a bit of violet to shadow yellow flowers or to add interest to a dark blue sky.
- With an airbrush, you can create a hard sharp edge, a soft, diffuse edge, and just about anything in between. Using airbrush plus frisket film or stencil, you can make lines so sharp that the painting looks like a collage. This is especially helpful to get a flower to "jump out" from its background.

● Owing to recent advances in pigment manufacture, there are many watercolor choices on the market that are distinctly different from what has been available in the past. Daniel Smith is employing many of these new pigments in their watercolor paint. I also like the M. Graham paints because they are very easy to work with a regular brush.

"A Gathering Storm of Unusual Shape" (26 by 40 inches). This painting, for which I used some of newer blues and greens, shows some of the variety of colors available. The leaves are all essentially green, yet the subtle variations achieved by the airbrush-pigment combinations allow each to appear as distinct.

"A Touch of Effortless Grace" (26 by 40 inches). For the parts of this painting which appear soft, such as the petals of the flowers and the out-of-focus parts of the background, I used the airbrush. The dense, relatively sharp areas, such as the leaves and the stems, were done with a paintbrush.

Combining Flat and Gradated Color

Andrea Mistretta's "La Veneziana," a fantasy miniature portrait of a woman dressed in a classic Venetian Carnevale costume, is a wonderful example of combined effects. The face and shoulder are quintessential airbrushing—glowing, gradated colors with a completely three-dimensional look—yet the costume has the flat, even tones of a serigraph.

La Veneziana

ANDREA MISTRETTA

1. After airbrushing black for the golves, head covering, and dress areas, I masked the painted areas surrounding the face and shoulders with transparent frisket film. I very lightly outlined the basic facial features—eyes, nose, and lips—with a .03mm HB lead mechanical pencil onto CS10 illustration board, a hard surface that supports the color-lifting technique of scratching and erasing repeatedly (photo 1). (Note that the seeming difference between the color of the masking in photos 1 and 2 and photos 3 and 4 is a result of the reflective properties of the masking. In photos 3 and 4, the light color of the masking is a result of the reflection caused by the camera's flash.)

2. I smudged the graphite drawing with a tortillon paper stump, which softened the pencil lines. See photo 2. The small photograph at the left is a picture of my client, which she supplied as a reference.

3. For the face I airbrushed the colors red, yellow, ochre, and smoke, in that order, using red and smoke in the shaded areas and yellow and ochre in the lighter areas. (I use Com-Art transparent colors for the base colors in my portrait work because they can be easily lifted using erasers, blades, and scratching tools.) I used a battery-powered eraser to lift color from the lightest value areas of the face, such as the nose and cheeks. I repeated the airbrushing of red, smoke, ochre, and yellow on top of the erased areas, being careful not to obscure the highlights. The paint for the skin tones (before adding shadows and highlights) was a mixture of Com-Art transparent bright yellow and transparent ochre). For the decorative detailing (the iridescent blues and pinks at the top of the mask area), I used Dr. Martin's metallic iridescent inks.

4. I created facial shadows and contours with an Iwata Micron CMC airbrush and Medea/ Artool Mini-Shield and Nail Master hand-held shields (photo 3). These shields are indispensable for miniature portraiture. (As with all hand-held shields, some dexterity and practice are required to use these custom shields, but the effort is worth the result. For fine detail and sharp shadows, hold the shield right against the edge of the painting surface. For softer edges, try holding the shield at varying distances from the surface. The only way to control the direction of spray when working on a small scale, as in this demonstration, is to master the two-handed technique of maneuvering the shield while simultaneously spraying with the airbrush. It's best to keep the shield in constant motion by making small, circular, rotating movements as you airbrush.)

5. I painted in the lips, eyes, eyelashes. and other facial features with small sable paintbrushes (000 to 00) (photo 4).

6. Once the face and shoulder were finished and the paint had dried, I masked those areas and began work on the costume. For the base color of the costume, I airbrushed P.H. Martin's Spectralite opaque black matte acrylic paint, which simulates the serigraphed (silk-screened) look I wanted.

7. Using a paintbrush, I applied P.H. Martin's Spectralite opaque light gray acrylic paint as a base color for the lace pattern of the gown (photo 5). The rest of the steps I used to create the costume are keyed to the letters shown on the finished work on the page 128 .

Andrea Mistretta is a master of many mediums, including watercolor, pastel, pen and ink, silkscreening (which she learned in her father's—John Mistretta's—shop), and of course airbrushing. Her work has received several awards, including the prestigious Vargas Award. Since 1995 she has been a judge for *Airbrush Action*'s annual Airbrush Excellence Awards. Ms. Mistretta is best known for the enchanting images she has been creating since 1986 for New Orleans' Mardi Gras posters and for her holiday and celebration theme art. (An illustration from her holiday series is shown on page 129.)

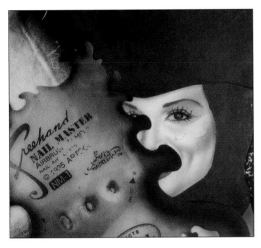

1

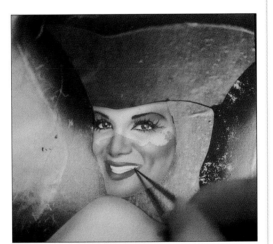

2

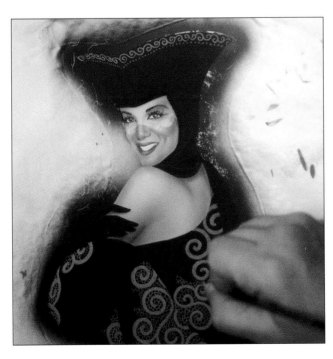

3

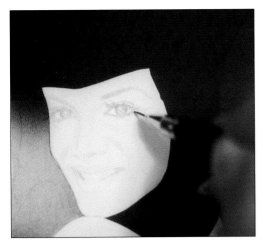

4

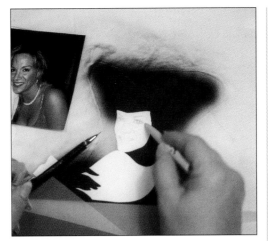

5

"I believe commercial art is derived from existing sources and/or the imagination. Then the images are assembled for utilitarian purposes to put forth a message in a timely manner for a definite financial reward. Fine art is imagery created with all the perfection and idiosyncrasies of an individual's soul, spirit, and skills to put forth not a message, but an idea and a feeling—and not necessarily with the motivation of financial gain." —A.M.

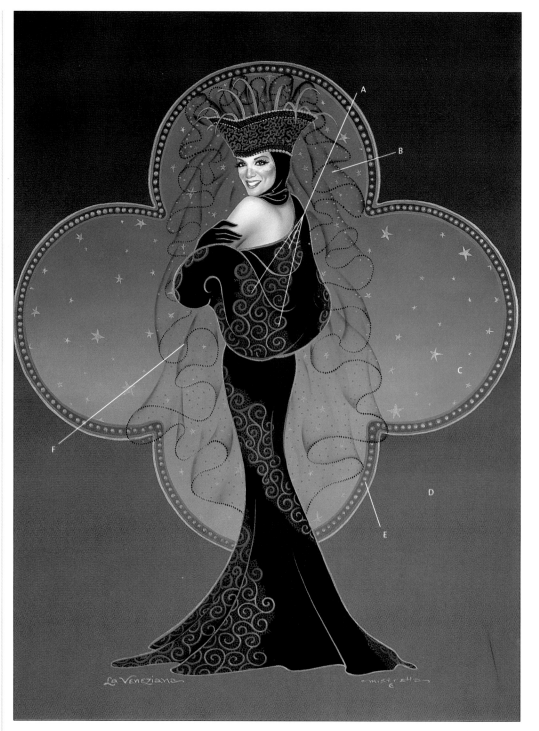

A. I airbrushed Spectralite transparent violet, blue, and green over the gray lace pattern randomly.

B. I airbrushed the top of the background airbrushed with Spectralite opaque blue acrylic paint.

C. I continued downward with Spectralite transparent blue paint, gradating from dark to light, creating an effect that reinforced the serigraph look I was striving for.

D. I airbrushed the solid gray background with P. H. Martin's Spectralite matte finish paint, further enhancing the serigraph effect.

E. Using a #1 sable brush, I painted a design on the matte grey background immediately adjacent to the blue background with P.H. Martin's iridescent gold paint.

F. For the outlines of the veil I hand-brushed tiny dots with black acrylic, using a #00 brush. For the shadow accents, I airbrushed Com-Art transparent smoke acrylic paint to create the sheer effect.

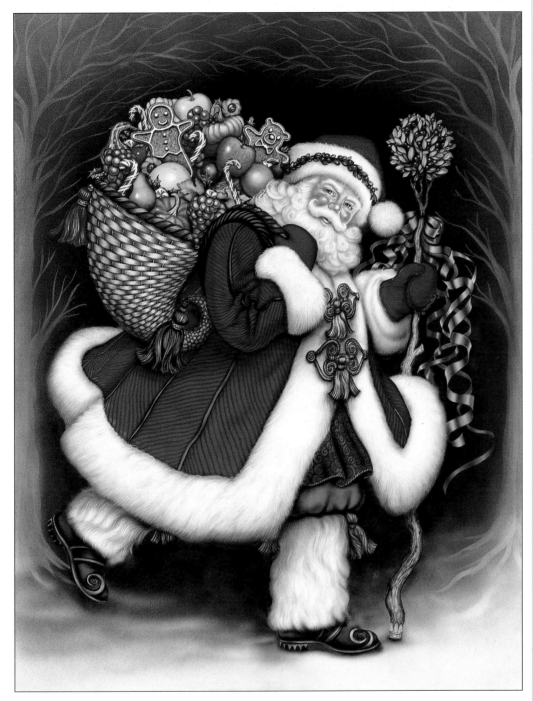

"Santa-Plenty," one of Andrea Mistretta's popular holiday series, was drawn onto CS-10 illustration board with a #3 HB lead mechanical pencil. First, fine details were painted with small sable paintbrushes (00 to 4). An Iwata CMC Micron airbrush was used to color small areas, and an Iwata HP-C to color larger areas, such as the background. The white fur and beard were airbrushed with white acrylic paint. Subtle grays were dry-brushed over the airbrushing and then scratched with a #11 X-Acto knife to create highlights. For the basket, as for Santa, the details were painted in first, then light coats were sprayed on with the airbrush. The texture was scratched in with the X-Acto knife. For Santa's face, an Artool Mini-Shield and Nail Master hand-held shield were used to model the shapes and contrours. The background was airbrushed with Spectralite black, then masked. The trees were then painted in with white Spectralite, using a sable brush. The final step was to airbrush green (Dr. Martin's true blue and emerald green) over the trees and background.

Airbrushing on Scratchboard

Scratchboard is a coated surface on which images or highlights are created by scratching out areas of the coating. In the nineteenth century, and for much of the twentieth century, most scratchboards used by artists consisted of cardboard coated with chalk, which could then be painted over with black or colored ink and the design scratched out with sharp-pointed tools. Over the last two decades, scratchboard has enjoyed renewed popularity, and artists can add color in a number of ways, including applying color by hand into the revealed white areas or scanning the piece to produce a digital version that can be colored using Photoshop.

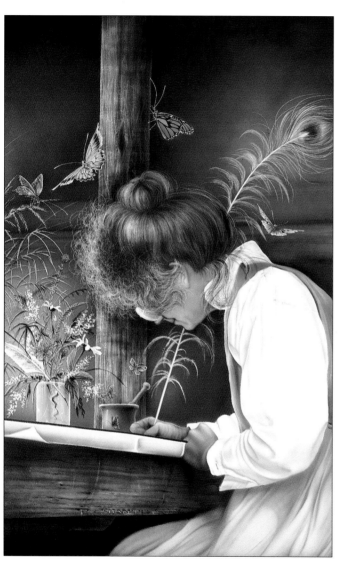

"Madame Butterfly." This painting is a tour de force of Claybord technique. No white was used; all apparent whites and highlights are exposed Claybord, scratched out with scratching tools of various sizes and coarse, medium, and fine artist's grade steel wool.

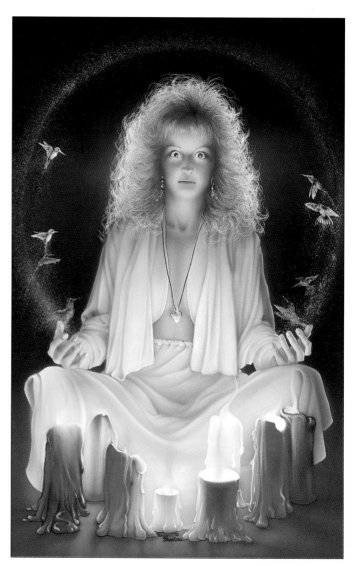

"Serena." This fantasy image is loosely based on a photograph Pamela Shanteau shot of a friend. The backlighting on the air hair dramatically frames the face in a halo of light that overpowers the foreground candlelight to draw the viewer into Serena's compelling gaze.

The best of the scratchboards available today is probably Claybord. Claybord comes in standard sizes, and is available with different finishes: textured clay (for watercolor), gessoed clay (for oils), clay coated with marble dust (for pastels), and clay coated with black ink. For airbrushing, the best choice is Original Claybord Smooth, which has a hardboard backing covered by a smooth coating of clay that readily holds graphite drawings and is perfect for stenciling. This version of Claybord offers two truly remarkable advantages:

1. Extensive erasing does not affect the integrity of the surface. You can make multiple corrections, for example, removing paint with artist's-grade steel wool and repainting the area, without degrading the clay coating. If you scratch into or scrub the surface of paper, canvas, or illustration board with steel tools, the paper or cotton fibers separate and the painting surface begins to shred.

2. You can create realistic textures and complex color combinations by *removing* paint rather than adding it. You can use sgraffito (scratching) tools to expose the white clay, then recolor the exposed clay with whatever values you need or to create highlights or details. This technique both creates a sense of depth not readily obtainable by repainting an area and eliminates problems incurred from overworking a painting.

"Faeries Wear Boots"
PAMELA SHANTEAU

This demonstration describes how the cow and attending faeries were airbrushed and detailed using the Claybord method. The size of the painting is 30 by 40 inches. The numbered steps show the techniques I used for various details, and each number corresponds to a callout number on the finished artwork on page 133 showing the detail in the context of the work as a whole.

1

3

4

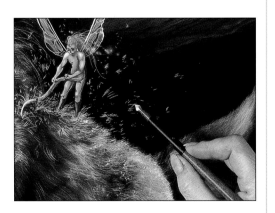

2

1. I used a fiberglass eraser to remove paint in one of the areas that needed to be brightened. These erasers do not scratch into the clay, but remove a small amount of paint and smear the rest in the direction of the stroke. I use them like a paintbrush to pull paint out of or into an area of the painting.

2. I used a curved-edge carver to remove paint, exposing a bright clay highlight in the eye.

3. Small strokes made with artist's-grade steel wool created the texture I wanted for the tuft of hair at the top of the cow's head. I scratched and repainted this area, using values of the same transparent brown, seven or eight times to create the depth I wanted. Notice that I am only using the corner of the steel wool and pressing it firmly onto the surface with my fingertips.

4. I used an arrowhead scratching tool to scratch fine lines into the black background to render the flying fur.

5. The stiff wire brush used here to carve into the clay and remove paint has a very different effect from the steel wool. It scratches deep into the clay, making well-defined scratch marks. After painting the hair with the airbrush (using various tones of brown and black), I began scratching into the paint with the wire brush. After scratching a layer of hair (exposing the white clay), I colored the layer with the airbrush, then scratched out another layer of hair over and around the first layer. I recolored the newly scratched layer with either black or brown paint sprayed to create different values. After several layers of hair had been scratched and colored, the haphazard pattern of the scratch marks, and the varied color values, simulated the cow's hair perfectly.

6. I used a small battery-operated erasure tool to make a light-colored grain streak in the wood by turning it on and dragging out the line of the wood grain. These tools, unlike sgraffito tools, do not remove clay along with the paint, and can be used to create soft highlights with faded edges.

7. I used an Iwata HP-C gravity-feed airbrush and transparent Com-Art acrylic paint and transparent Holbein Aeroflash acrylic paint to color the wooden slats. I alternated between scratching and painting to render the effect of real texture. Notice the light-colored (soon to be painted) scratches to the right of the airbrush.

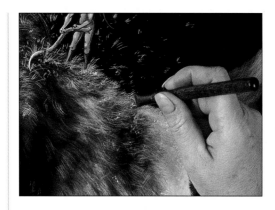

5

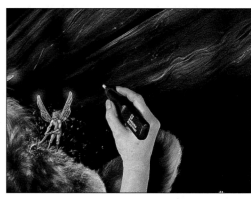

6

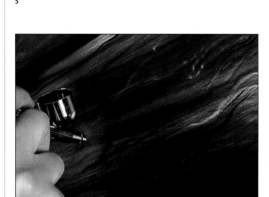

7

8

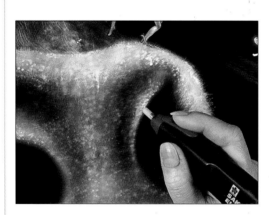

9

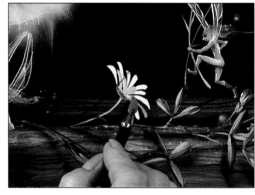

10

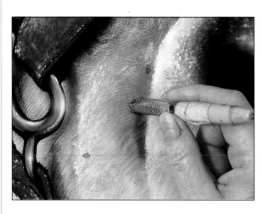

11

12

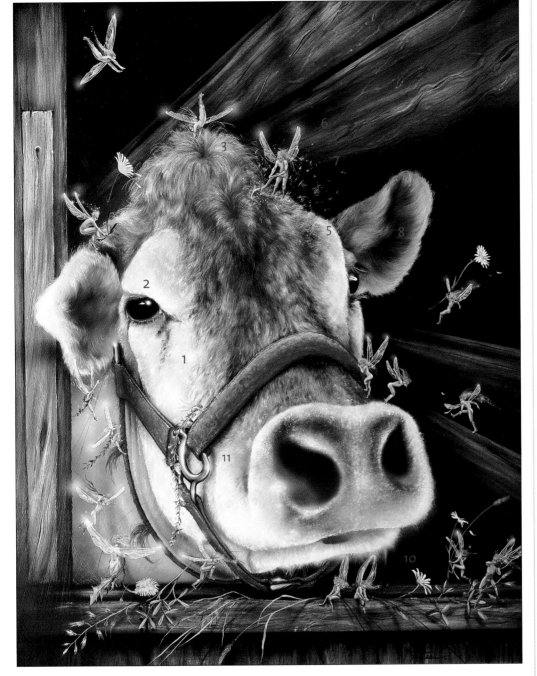

The finished artwork, with numbers keyed to the techniques described in the demonstration.

8. I used ultrafine artist's-grade steel wool to rub highlights back into the edge of the cow's ear. Ultrafine steel wool can also be used to erase mistakes.

9. I used the same battery-powered erasure tool that is seen in photo 6, but instead of holding it against the surface and dragging it, I tapped the spinning tip of the tool on the surface repeatedly. This created exactly the dimpled texture I wanted for the cow's muzzle.

10. I carved the flower petals into the background with a curved-edge carver.

11. I used a fiberglass eraser (as in step 1) to create the fine fur texture on the muzzle.

12. I put a small drop of paint on my fingertip and smeared it around on the cow's halter to create a weathered look.

Airbrush in Mixed Media

The airbrush is a wonderful tool, one that can be used with almost any medium or technique. The beautiful thing about art is that anything is possible: Artists are limited only by their imaginations. Have fun with the airbrush, and see for yourself how exciting it can be to experiment with more traditional media while still utilizing the airbrush.

Oil and Water Do Mix

RICHARD STURDEVANT

In this painting, I enjoyed the best of two mediums: I was able to use the versatility of the airbrush to create myriad special effects, yet the finished work has a distinctly "painterly" feel made possible by the fine brushwork that can be achieved only with oils.

I penciled in the drawing with erasable color pencils, then blended it with a damp brush. The underpainting was airbrushed in using water-based airbrush colors. Just before sealing the water-based paints with a solvent-based lacquer, I misted the entire surface with transparent yellow ochre and scratched in some texture for the cubs' fur.

Once the lacquer coat was fully dry, I applied a light oil wash made of transparent oxide yellow mixed 50:50 with alkyd gel medium to which I added some thinner so I would have a very transparent color. When the oil wash was dry, I applied oils with a variety of brushes to detail the rocks, branches, cubs, and grass. (For the grass alone, I used a fan brush, a dagger stripper, a triple loader, and a ¼-inch flat brush.) I let the oils dry for three days, then sealed them with two coats of lacquer.

The next layer was done using the airbrush once again, loaded with airbrush-ready acrylic paints, then sealed. I created the final details and effects with oils: the "wild" look of the grass, more white for the cubs, yellow and orange glazes to simulate sunlight hitting the rocks and tree branch, additional branches painted in front of the cubs to create depth, the cubs' whiskers, the finishing touches for the butterflies, and highlights.

Richard Sturdevant is an award-winning artist best known for his mixed-media wildlife fine art and commissioned portraits. He has achieved wide popularity as an instructor in the field of mixed-media painting with airbrush, and has taught his techniques and theories throughout the United States—at art stores, airbrush getaways, schools, and trade shows, such as the Art Methods and Materials show in Pasadena, California. He is a regular contributor to trade magazines such as *Airbrush Action* and *Airbrush Talk*.

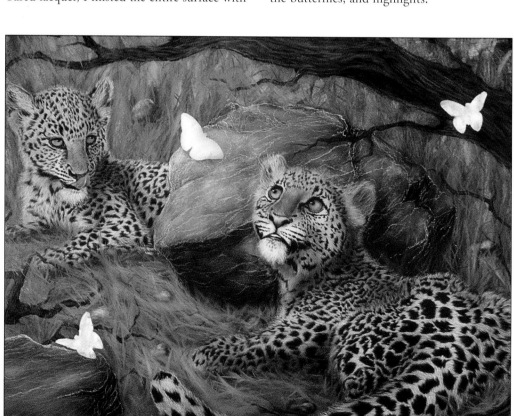

The first airbrushed layer is complete.

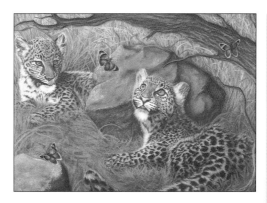

The cubs after the first application of oils. Notice how the lightening of the colors has added depth to the painting. Also notice how much furrier the cubs look. I created this effect with a stiff bristle brush. (It may look as though I have covered up much of what I had airbrushed in. But I knew that since the paints applied in these stages were glazes, much of what had already been painted would show through, giving the painting incredible depth in the end.)

The painting after the second airbrushed layer. The heart of the painting has really come to life. Once again, I used a bristle brush on the fur, with Holbein transparent sienna brown, so that the previously sealed oils would show through. I dulled down the shadowy areas of the cubs, rocks, and branches with a mixture of violet with a few drops of smoke. I used Faber-Castell watercolor sticks to create color variation and texture in the large branches, add color and highlights to the shadow area of the rocks, and to add even more texture to the fur of the cubs. Notice that I have painted grass over the branch that was in the lower left-hand corner of the piece.

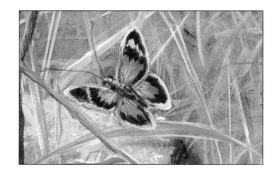

Butterfly detail. I drew the butterflies freehand on Transferite transfer tape, then cut them out and placed them on the canvas until I was ready to paint them. The airbrush underpainting was Com-Art transparent phthlo blue for the wings and Holbein deep yellow for the outer areas of the wings. I used sepia for the dark areas. During the final application of oils, I glazed a mixture of cerulean blue and white into the blue part of the wings, then glazed a little viridian green into the lighter areas of the wings. For the gold bits, I brushed on a mixture of lemon yellow and orange. I added highlights with white mixed with a little yellow ochre.

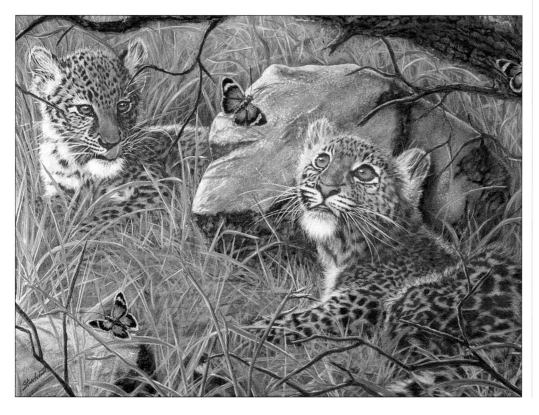

The final details and touch-ups were done in oils: I narrowed the big branch, added more branches in the foreground in front of the cubs, added some cerulean blue mixed with white into the cooler areas of the rocks and branches, glazed Naples yellow and burnt sienna over the lighter areas of the rocks and branches, shaded the grass with a darker mixture of sap green and yellow ochre, gave the cubs their whiskers, and added more detail to the lighter areas of their fur.

Mixed-Media Mascot

RICHARD STURDEVANT

Arty is a character that Robin Armstrong and I co-created for the MJDesigns Craft Store chain to add a fun and interactive approach to the company's advertising campaigns. As the company's mascot, Arty appears on billboards, newspaper inserts, and in-store signage to promote products, pricing, and promotions. Arty's appearance can be changed at any time, to reflect any occasion—and it's easy to do. In the following demonstration, I show how Uncle Sam Arty was created for MJDesigns Fourth of July promotions. Arty is a product of my imagination, but both the famous World War II Army Uncle Sam poster and the boxing trunks worn by Apollo Creed in *Rocky* helped me with color selection and creating the first draft of the image.

1. Once the final pencil drawing of Arty's latest incarnation was finished and approved by the client, I made a photocopy of it at a reduced size, so that it would fit into my projector. Using white artist's tape, I taped off a ³/₄-inch border on Crescent's R9208 high-line illustration board. I projected Arty's image on the board, and outlined it using red, blue, and brown erasable colored pencils that closely matched the colors that would be in the final painting. I made sure the colored lines would be visible through the masking film I was using (photo 1).

2. Once Arty's outline was completed, I covered the board with adhesive-backed transfer film, then used an X-Acto knife with a new, sharp #11 blade to cut around the image, making sure not to cut into the illustration, and removed the film covering the background.

3. Using a stiff bristle 3-inch brush and Com-Art opaque sienna brown, I slapped the paint on the paint in all different directions. While the paint was still damp, I dipped the brush, without cleaning it, into Com-Art transparent violet, and continued to slap on color. I started at the top of the painting, working the brushstrokes down into the sienna. I let the paint dry for about a minute, then wiped off any excess (photo 2).

4. Using an Iwata HPSB airbrush, I airbrushed Com-Art transparent violet, starting at the the top of the painting and slowly fading down from dark to light to create a feeling of depth. Since the existing background colors at this point were warm and the violet is transparent, it created a dark brown tone. I laid the painting flat. Holding a container of liquid window cleaner about 3 feet above the surface, I pulled the pump handle in short, quick bursts, allowing small droplets of window cleaner to fall onto the background. I let the painting set for about 3 minutes, then blotted gently to remove any excess cleaner (photo 3). (Medea airbrush cleaner can be used the same way).

5. I placed transparent violet under Arty, spraying soft dagger strokes between his shoes to create a shadow. For the background stars, I drew a couple of different-size stars on a piece of masking film. I put the film on a cutting mat, cut out the stars with an X-Acto knife, and reserved the piece of film with the negative-space stars. I loosely placed the star mask on one part of the background and sprayed the negative star shapes with a thin coat of Holbein opaque white. (I wanted the starts to seem to fade into the background.) Once all the stars had been sprayed with white, I sprayed Com-Art transparent phthalo blue over both the stars and the violet background, which made the stars recede into the background and gave them a blue tint without affecting the violet background. Photo 4 shows the finished background, with the masking film removed from Arty.

6. I covered the entire area of Arty's face—the artist's palette—with masking film, and used transfer tape to tape around the film to prevent overspray from getting on the background. Using an X-Acto knife, I cut out only those areas that would show in the final painting as the wood and discarded them. Using a 50:50 mix of Com-Art opaque white and opaque sienna brown, I sprayed a heavy coat of paint over the entire palette area. Next, I

1

2

3

4

dampened the 3-inch brush with window cleaner with ammonia and lightly blotted it to make sure no cleaner would drip. I got the streaked effect of the wood by pulling the brush in one direction with firm, downward strokes (photo 5). I let the paint dry for about 15 minutes.

7. Using the HPSB airbrush, I sprayed a light mist of Com-Art transparent yellow ochre over the entire wood area, giving the wood a warm color shift. I used a mixture of $^1/_8$ ounce of Com-Art opaque burnt umber plus a few drops of Com-Art transparent smoke to shade under the hat, glasses, and around the paint puddles on the palette. I also airbrushed around the mouth area and created the shadow from the hand with the same color. To enhance the texture, I sprayed the same burnt umber–smoke mixture to create

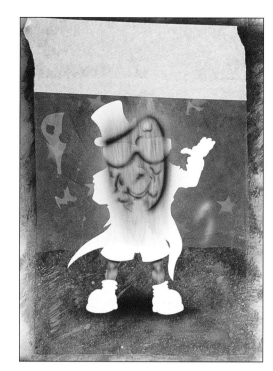

5

SKIN TONES

To mix skin tones, you need to have exact color recipes. Com-Art bottles with twist tops allow you to pour controlled drops of paint, so that you can get the same color every time. Here is the Com-Art recipe I used for Arty's skin: 240 drops of transparent bright red, 240 drops of transparent cadmium yellow, 240 drops of transparent sienna brown, 80 drops of transparent smoke, 35 drops of opaque white, 20 drops of transparent forest green.

The only way to learn how to get the skin tones you want is (1) to learn anything and everything you can about color theory and (2) experiment, experiment, experiment. The skin tones in the two portraits shown here are very different, yet both are supremely realistic.

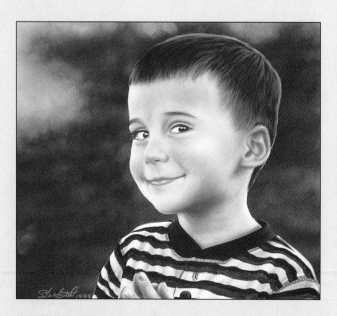

"Daniel." Mixed-media airbrush acrylics with colored pencils on illustration board.

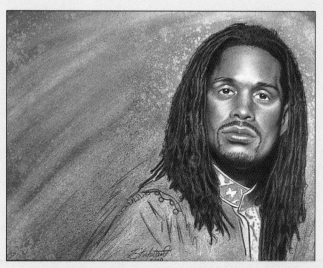

"Portrait Study." Airbrushed watercolor and colored pencil on watercolor paper. This demonstration piece I painted for one of my classes was intentended to show how the airbrush can be used with watercolor to achieve realistic skin tones.

interesting variations in the wood grain with small dagger strokes. Using a large freehand Artool Big shield, I shaded the side of the palette to add depth and help keep the edge crisp. To complete the effect, I misted yellow ochre over the entire wood area once again (photo 5).

8. Using a MicronSB airbrush I sprayed Arty's legs and arm with my skin tone mixture (see Box). Once the basic and value was in, I added two drops of violet and one drop of smoke to the color left in the airbrush and sprayed the shadows cast on Arty's skin by his clothing (photo 5). I removed all masking.

9. Before beginning the next airbrushing stage, I rendered the shape and folds of the clothing with blue and red erasable colored pencils. Once all the clothing was rendered, I used a blending stump to smooth the colors, then a pink pearl eraser create soft highlights (photo 6).

10. I once again placed adhesive masking over the entire illustration, then cut and removed all areas to be airbrushed blue, which included the lenses of Arty's glasses. Using a mixture of 30 drops of transparent phthalo blue, 5 drops of transparent violet, and 5 drops of transparent black, I shaded and built the folds of the blue areas, following the penciled color guides. I then misted phthalo blue over all of the blue areas. With the pink pearl eraser, and working carefully so as not to lift any color off the painting, I created the highlights (photo 7). I then removed all of the masking and discarded it.

11. I placed new adhesive masking film over the surface, and cut out all the areas to be painted red. I painted all the red areas, except the gloves (At that point, I wasn't sure whether I wanted them to be red or white). I used transparent violet to build the darker values and airbrushed transparent Holbein scarlet over the red areas. The transparent violet showed through the red, creating middle and dark values of that color. Again, I created highlights by removing paint with the pink pearl eraser.

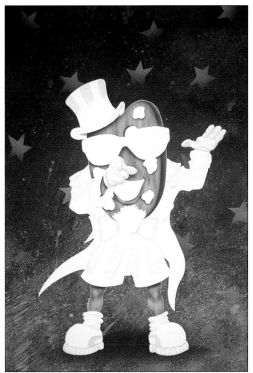

6

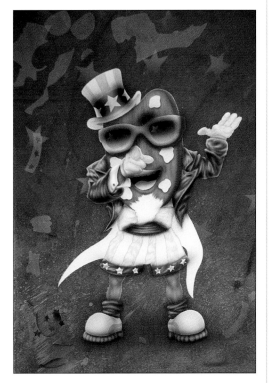

7

Tip

I find it easier to use fresh masking at each stage rather than saving previously used masking and trying to place it exactly where it was before.

12. I cut and removed the masking film from the white areas and airbrushed them with a mixture of 20 drops of Com-Art transparent ultramarine, 3 drops of Holbien transparent orange, 2 drops of Com-Art transparent violet, 2 drops of Com-Art transparent black, and 10 drops of water. I built up the values in the white areas very slowly, so as not to end up with a darker color than I wanted. Photo 8 shows Arty with the reds and blues airbrushed in. The brim of his hat, the paint blobs on the palette, his beard, and his shirt cuffs are still masked.

13. I used transfer tape to mask off the glasses area, and cut out and removed the frames. With the airbrush and Com-Art transparent black I sprayed the color using soft, short dagger strokes around the edges of the glasses. I let the small amount of overspray carry over into the center of the frames, which helped to give the appearance of roundness, leaving light areas for highlights (photo 9). I created the star reflections on the glasses the same way I created the stars for the background.

14. I decided I wanted Arty's gloves to be red, after all. Using the same mixtures and method I used for the other reds, I unmasked and sprayed Arty's gloves. I painted the colors of the paint puddles on the palette with a paintbrush, using gouache in process blue, green, violet, red, and cadmium yellow. I airbrushed Com-Art transparent violet around the edges of the puddles to help create depth. (See photo 10.)

15. With the painting lying flat, I sprayed a bump (light) coat of SureGuard Retouch Lacquer PL55, starting at the bottom and moving toward to the top, working from side to side. The first coat must be light, because although this laquer is very aggressive chemically, a light coat bonds nicely with the paint. After the light coat dried, I sprayed a heavier coat, creating the smooth finish I would need for the final touches with colored pencil. I then let the painting dry for an hour.

16. Using Sanford's Prisma Color wax colored pencils (which glide like butter over the lacquer sealant), I added subtle color shifts to enhance the airbrush work, added highlights, and cleaned up all rough edges. When I was satisfied with the detail work, I laid the painting flat and again sprayed two coats of SureGuard over the entire surface. Photo 11 shows Arty ready for action.

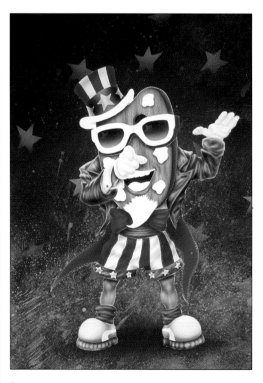

8

9

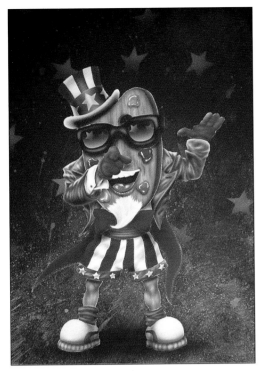

10

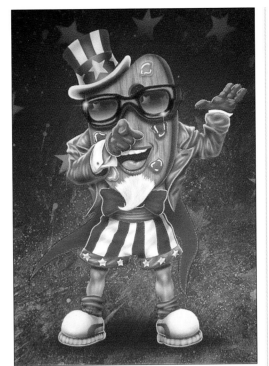

11

PORTRAIT STUDIES

Portraits can be of people or of animals, and painted from life or from photographs. In fact, the painting of the leopard cubs on page 135 is a portrait. If you are painting an animal portrait, find out as much as you can about the animal before starting to paint. You can look at pictures in books and magazines, go to the zoo, and/or watch a *National Geographic* video of the animal. When painting a commissioned portrait, find out as much as you can about the person you will be painting. When the opportunity to paint from life presents itself, make the most of it. The more drawing and painting you do from life, the more skillful you will become at expressing your subject's personality and capturing his or her unique life force on canvas.

Two portraits of people are included in the Box on page 138. Shown here is one of my favorite animal portraits. It has a very different feel from the zebra shown on the opening page of Chapter 2, which is painted in a more realistic style.

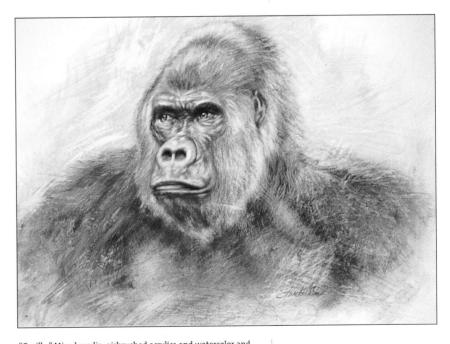

"Gorilla." Mixed media: airbrushed acrylics and watercolor and colored pencil on illustration board. Until I did this portrait, most of my wildlife art was very tight and realistic, and that was my original intent for this one. But I finally decided not to be a slave to my reference, but to just let loose to see what would happen. The result was a ground-breaking turn in my painting style, a completely new—for me—freedom.

Of Cows and Cowboys

Printmaker and painter Robert Anderson, who lives and works in Cedar Grove, N. J., received his M.F.A. from Pratt Institute in 1972 and in 1985 was awarded a National Endowment for the Arts Fellowship. Since 1986 he has been exploring the world of digital printmaking, and is one of many contemporary artists who make their work available through the giclée printing process. Mr. Anderson has written numerous articles for trade magazines, such as *Airbrush Action,* and was co-author, with Robert Paschal, of *The Art of the Dot: Advanced Airbrush Techniques.* He is currently a technical and fine art consultant for Liquitex. Web site: www.arttekstudios.com.

MOONDRIAN MEETS MOONA LISA

Robert Anderson was one of 28 artists selected to participate in CowParade 2000, New Jersey. (For the information of readers unfamiliar with the CowParades, the idea for which originated in Switzerland, these public art exhibitions featured scores of life-size fiberglass cows, painted by local artists, which were on display in various cities in Europe and the United States. After a limited time period, the cows were then auctioned off, with the proceeds going to charities and local community organizations.)

These two entries were both primed first, then airbrushed with Liquitex medium-viscosity acrylic Artist's colors. For Moona Lisa, Anderson masked around the face and area with frisket film, then sprayed on the skin tone and hair colors with Liquitex Airbrush Medium mixed with the Liquitex paints. He did the background using both airbrush and paintbrushes. The line of demarcation between the bottom of Moona Lisa's body and the top was created with a paintbrush/splatter technique. The front view of Moondrian (a pun on the name of the Dutch abstractionist Piet Mondrian) shows the cow's "split personality," an effect Anderson created deliberately. Both cows were clear-coated with Liquitex Soluvar Final Varnish.

PULP WESTERNS

"Motel Chief" is from Mr. Anderson's latest series, Pulp Western, which combines images borrowed from historical and film sources, Western collectibles, and the pulp fiction cover illustrations of the 1930s and 1940s. Like those covers, with their saturated colors and dark-side-of-life imagery, Anderson's Pulp Fiction works are intend to conjure up forbidden fantasies of adventure and seduction.

Moondrian

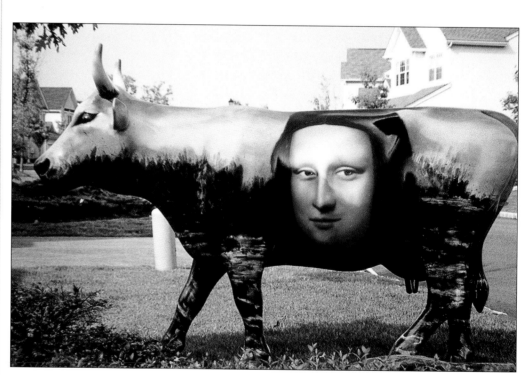

Moona Lisa

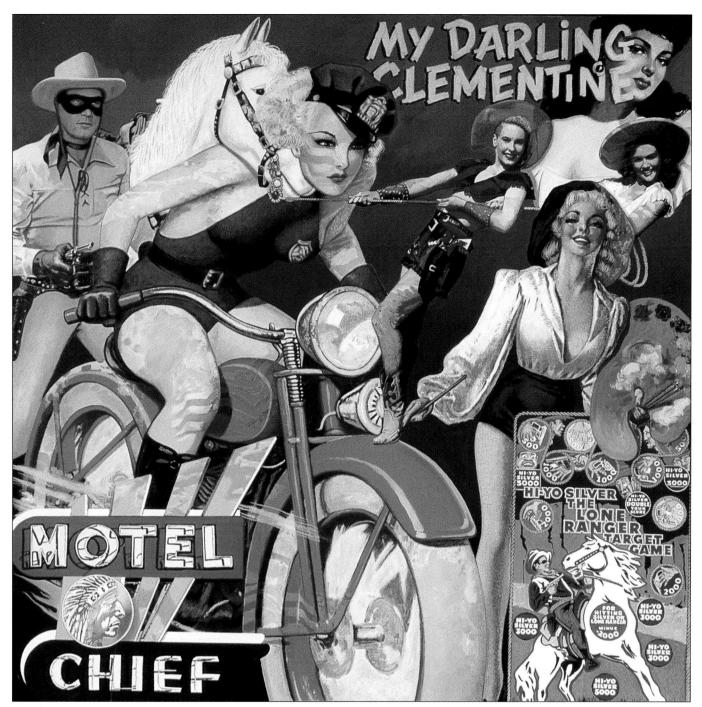

"Motel Chief."

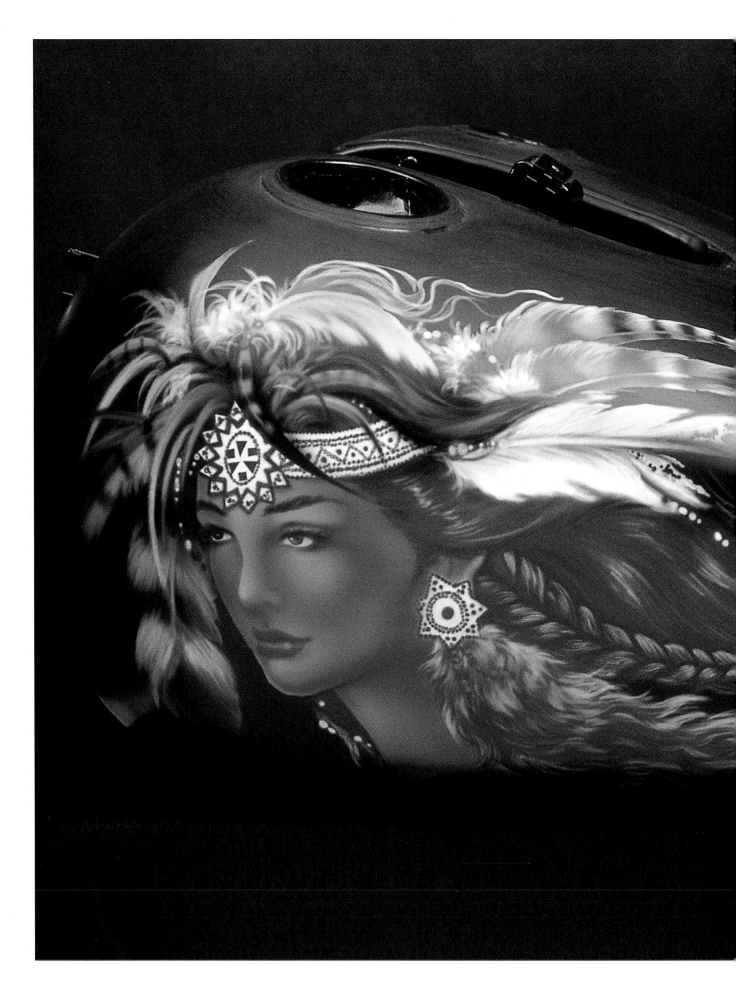

AUTOMOTIVE
AIRBRUSHING

Automotive airbrushing may be the most difficult niche in the field of airbrushing in terms of technical knowledge and technique. In addition, anyone who commissions a custom automotive job generally regards the vehicle as a member of the family, and will not tolerate a finished product that is less than perfect. Experienced and talented airbrush artists, however, who meet the challenges of this rewarding discipline head-on can not only create memorable designs but also earn a terrific income.

Surface Preparation

The unforgiving nature of nonabsorbent substrates will magnify any deficiencies in airbrush control or technique. Painting on the curved metal, fiberglass, plastic, or carbon fiber surfaces of automobiles and motorcycles poses unique challenges when masking and positioning designs. Repairing a mistake on a these surfaces is possible, but it is much more difficult to accomplish than repairing a mistake on paper, canvas, or other traditional substrates. It is therefore imperative to do the job properly on the first attempt. Without the proper surface preparation, is is impossible to achieve success with your final design.

Most car and motorcycle parts that are to be painted start out as bare steel, fiberglass, carbon fiber, or aluminum. Whatever the surface you are painting on, it must be coated with primer paint, which is sprayed with an airgun with a 1.3- to 2.5-mm paint nozzle to ensure uniform coverage. The primer is sanded with 600-grit wet-dry sandpaper before the base color is applied over it. When the base color coat is thoroughly dry, the clearcoat is sprayed on. Both the basecoat and the clearcoat are sprayed on with the same size airgun that was used to spray the primer coat. The clearcoat seals and protects the color coat from scratches and dirt, and gives the color finish its shine.

Before airbrushing any part of the design, the clearcoat must be wet-sanded with wet 600- to 1500-grit sandpaper and water to smooth out any surface deficiencies and create enough tooth in the clearcoat so the airbrushed paint will have maximum adhesion. Immerse the wet-dry sandpaper in a bucket of clean water, and wet the part to be painted with a clean sponge. Sand the entire surface to a uniform dullness. Keep the sandpaper wet; if necessary, keep dipping it in the bucket.

For most blemishes, such as those listed here, 600-grit sandpaper should be used.

- **Orange peel** (an uneven pockmark-like effect caused by any one of a number of factors, including use of the wrong reducer, improper mixing or spraying, or spraying on an uneven substrate such as fiberglass or some gel coats)
- **Fisheye** (an area where the paint has not adhered because of the presence of oil or another contaminant)
- **Dimples** (raised blemishes on the dried finish, most often caused by dust particles or insects that have settled on the finish when it was still wet)

When you are airbrushing a design over a quality paint job that is free of blemishes, 1000- to 1500-grit paper will suffice.

Be careful not to sand completely through the clearcoat into the color coat, especially when you wet-sanding over custom paint finishes, such as pearl, candy color, or metal flake finishes. These paints are formulated to distribute their pigments or metal flakes in a specific manner as they dry, and sanding marks will disturb the process and ruin the effect.

Once the clearcoat has been sanded to a uniform dullness, use a wet, soft cloth or soft paper towel saturated with a degreaser, such as R&M No. 139 Final Wash, to remove any oily fingerprints or foreign materials. Dry the degreased part immediately with another clean towel. If you allow the cleaner to evaporate before you wipe it dry, rings will appear. Some cleaners are too harsh to use with airbrushing. Test the cleaner you are using by wiping it over some fresh airbrushing, if it wipes away some of the finest details, it is too strong.

Automotive Painting & Masking Techinques

Traditional solvent-based automotive paints are one of three types: lacquer, urethane, or enamel. Common brands of solvent-based automotive paints in the United States include offerings from R+M, Dupont, PPG, and House of Kolor.

Water-based automotive paints that are premixed for airbrushing have recently been introduced to the world. At the time of this writing, Createx was offering a water-based paint called Auto Air, which has an adhesion promoter and catalyst to help it adhere to the base paint. After it has dried, it can be sealed with automotive enamel or urethane clearcoat. Another water-based automotive paint is Metal Craft, developed by Dr. P.H. Martin, which resembles a mix between lacquers and enamels. It dries quickly and requires no surface preparation other than cleaning to have the paint bond to the metal. You can get good results with either brand by following the directions on the packaging.

PAINTS

Mixing

Following are some general guidelines to use in choosing, mixing, and storing paints for airbrushing automotive parts.

THINNERS AND REDUCERS. Thin, or reduce, automotive solvent-based paints to be sprayed with an airbrush by twice the recommended rate on the paint label. For example, if the label says mix the paint and reducer at a 1:1 ratio, you should mix two parts reducer to one part of paint. The extra-thin paint flows very readily through the airbrush and dries immediately upon hitting the surface. If you are using a large airgun, follow the label instructions for mixing the paint and reducer. Paint that has been thinned with reducer can be stored in a separate container almost indefinitely, provided a catalyst has not been added to the paint.

COMPATIBILITY. Remember the Rule of Introduction: Test any combination of paints, clearcoats, thinners, etc., before using them together. It is always safe to airbrush with the same brand and type of paint that was used for the basecoat. This eliminates any unwanted reactions between incompatible paints. It is important to know the type and brand of paint you are airbrushing on. If different brands of paint are combined and are not chemically compatible, undesirable effects may occur. Some brands of paint from different manufacturers are compatible; for example, PPG automotive paints can be airbrushed over Dupont basecoats or clearcoats.

CATALYSTS. If you are using an automotive paint that requires that you add a catalyst in addition to a reducer, such as House of Kolors Kandie paints, always use the recommended amount of catalyst that is suggested on the label. Paints that require catalysts will not dry unless the catalyst is used. Paint to which a catalyst has been added will harden in the paint jar after a few hours. How long it takes to harden depends on the humidity and ambient temperature. Storing catalyzed paints in a refrigerator at approximately 50°F will extend the shelf life of the catalyzed paint by a few hours. Make sure the paint has been warmed to room temperature before airbrushing with it.

Catalyzed paints have a working temperature range that must be observed for them to spray and cure properly, as well as a working time frame within which they can be sprayed. Temperature and time ranges are provided on the label. Catalyzed paint cannot be added back into uncatalyzed paint or stored on the shelf. It must be completely cleaned out of both your airbrush and the paint jars. Safely dispose of any unused catalyzed paint in accordance with your local safety codes.

Appling the Paint

For all automotive paint applications, make sure you have the proper safety equipment. (See "Safety Tips," page 38.)

First and most importantly, when it comes to paint application rates and automotive finishes, thin, light coats produce a smoother, more controlled color blend than thicker coats of paint. Because the metal does not absorb any of the paint, only small amounts of paint are needed to render details. If the paint is overapplied, it will puddle and run. An airbrush that sprays small volumes of paint effectively is essential. If you have applied too much paint, the best course of action is to wait for the paint to dry thoroughly, then wet-sand the offending area with 1000- to 1500-grit sandpaper.

Once your airbrushed design is finished, and before clear-coating, use a mild wax/grease remover (see the Sources section, page 56) and a soft clean towel to clean away any overspray, fingerprints, or dust.

The clearcoat used over the airbrushed design should be the same brand as the basecoat since it permeates the airbrushing and chemically bonds with the basecoat. This process completely seals the airbrushing between the two coats of paint. Apply the clearcoat according to the instructions on the original container. Once the clearcoat has dried, it can be buffed to a high polish.

MASKING MATERIALS AND TECHNIQUES

Mylar Drafting Film

For a general discussion on masking techniques with frisket or Mylar film, see pages 45 to 47. The procedure for using Mylar drafting film as masking in automotive applications is straightforward. You first cut out the shapes on one sheet of Mylar with an X-Acto knife with a #11 blade or a stencil burner. Leaving the design in one piece, spray repositionable adhesive on the back of the film, and then place the design on the surface, making sure the cut edges are firmly attached to the surface. Peel away the masking from the first area to be painted. After airbrushing inside the exposed area, clean any residual adhesive with a mild wax and grease remover. Let the paint dry, then replace the masking over the freshly painted area. Expose the next area to be painted, and repeat the previous steps until the entire design has been painted on.

Masking Tape

A quality automotive masking job always requires extensive use of fine-line tape, which has a very low profile so paint cannot build a high edge against its edge. (A photograph of various sizes of fine-line tape is shown in Chapter 1, page 33).

Regular fine-line tape, which is usually green or olive and is available in widths of $1/16$ to $3/4$ inch, works best for straight lines or graphics that do not have tight bends, since it has limited stretch. If your design has tight curves or small detailed areas, you will need to begin with a thin width ($1/16$ or $1/8$ inch) to lay out the initial outline of the design and surround it with larger widths as you extend the masking outward from the painting . If your project is mostly straight lines, you can lay out the design with $1/4$- or $1/2$-inch fine-line tape and surround it with $3/4$-inch paper tape and masking paper.

Blue fine-line tape is available in the same widths as the green. It is much more flexible, meaning it stretches to make shapes like flames and circles. It has the same thin profile so paint cannot build against its edge. Once the tight curved areas of the design are masked out, paper tape and masking paper can be used to mask the remaining exposed areas that are not being painted.

For photographs of fine-line masking tape in action, see the Chevy Funny Car demonstration below, page 152.

Indian Princess Motorcycle Mural

PAMELA SHANTEAU

1. I first drew a a well-developed pencil rendering designed to fit the shape of the motorcycle tank sides, using a 5B lead pencil for the shading (photo 1).

1

2. Using a 7H lead pencil, I traced a simplified outline on the matte side of the Mylar sheet, laid the design on a glass surface, and used a stencil burner to burn around the outer edges of the entire drawing. Once cut, I removed the center (positive) image.

3. I placed small pieces of masking tape on the slick side of the positive masking and positioned it in the appropriate area of the tank (photo 2).

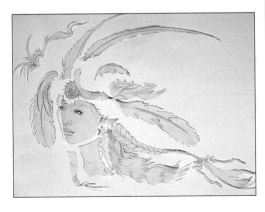

2

4. I cut the negative masking into smaller pieces and sprayed a light-tack coat of artist's repositionable adhesive to the slick side of the masking. I arranged the smaller negative shapes around the positive piece, slightly overlapping the edges to accommodate the curvature of the motorcycle tank. I used masking tape to cover all the seams surrounding the pattern (photo 3).

5. After all the seams had been securely taped, I removed the positive image and cleaned the exposed area with a mild wax and grease remover. I mixed a very pale yellow and sprayed thin coats of color on the exposed area, avoiding paint buildup near the edges of the masking. I then used a stencil burner to cut apart the major components of the positive image, separating the face, neck, braided hair, feathers, and beaded headband (photo 4). I sprayed artist's adhesive lightly to the slick side of each of the separated pieces.

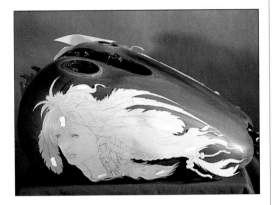

3

6. I positioned the beaded headband and larger eagle feather sections on the pale yellow base that I had airbrushed earlier, then airbrushed yellow ochre lightly near the front of the design, covering the headband and feather pieces.

7. I affixed the fur tailpiece and braided hair masking sections to the tank. I darkened the hair with sienna brown, then added a few

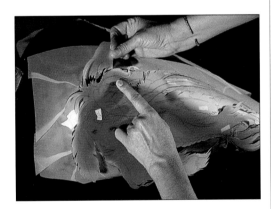

4

Trigger Positions

For the trigger positions referred to in this demonstration, refer to the trigger-position diagram on page 41.

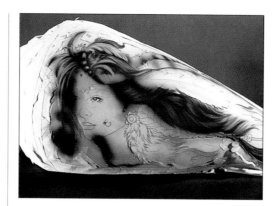

5

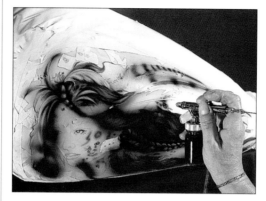

6

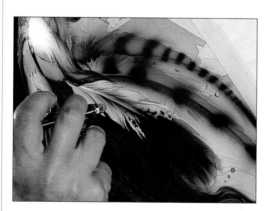

7

drops of black to the sienna brown remaining in the paint holder and airbushed the darker color freehand, with dagger strokes, to get the texture I wanted in the hair and feathers (photo 5).

8. I removed the masking sections covering the fur tailpiece and the braid, exposing the lighter sienna brown. I wiped away some remaining adhesive residue, and again using the sienna brown with added black, created the soft, furry texture of the tail and braided hair. I held the airbrush very close to the surface ($\frac{1}{10}$ to $\frac{1}{4}$ inch) and sprayed the fine details with 0–1–0 trigger movements.

9. I removed the eagle feather pattern from the tank, placed it on a glass surface, and cut it out with a stencil burner. I replaced the lower part of the feather masking to protect the pale yellow and airbrushed black on the exposed area (photo 6).

10. I removed the remaining Mylar piece from the eagle feather. Holding the airbrush $\frac{1}{8}$ inch from the surface, I completed the eagle feather using mini–dagger strokes (0–1–0 trigger position) (photo 7).

11. To create the leather effect for the wrap at the end of the braid, I airbrushed mini-gradations freehand with tan and brown colors. For the beads, I airbrushed tourquoise, coral, and golden yellow ochre colors freehand (photo 8). I used mini-gradations to shade in the beads.

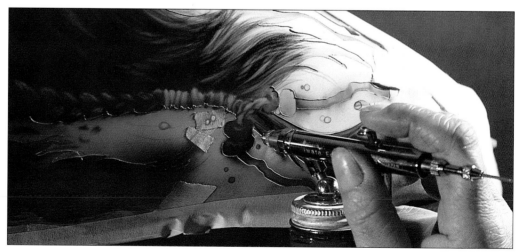

8

12. I removed the face and neck masking pieces, exposing the next areas to be painted. I cut out the eyebrows, nostril, and upper lip areas from the face masking with an X-Acto knife, then replaced the face masking on the tank (photo 9). I airbrushed a rich henna along the jaw line to create the shadows on the neck and sprayed the newly exposed areas with the same color.

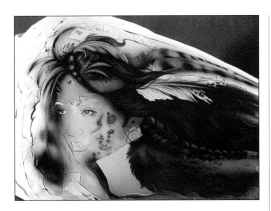

9

13. I removed the Mylar pieces covering the headband and earring, cleaned up the residual adhesive, and completed the detailing around the eyes and nose freehand, using the same dark brown that I used for the hair and feather details. Leaving in place the masking for the beaded headband and earring, I cut the lower lip from the pattern and repositioned the face masking. I sprayed the same color I had used for the jaw line on the exposed areas of the upper lip, nostril, and eyebrows (photo 10).

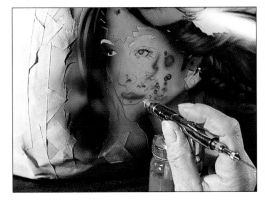

10

14. I removed the face masking once again, and cut out the eye areas. I used a creamy beige to spray the whites of the eyes.

15. I removed the Mylar pieces covering the headband and earring, completed the detailing around the the eyes and nose using dark brown, and cleaned up the residual adhesive on the exposed areas (photo 11).

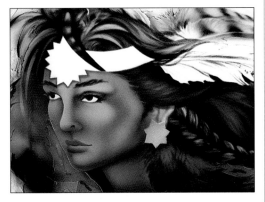

11

16. I wanted the earring to be similar in shape to the headband medallion. I cut the star shape from Mylar and used the negative part of the mask as a hand-held shield as I sprayed a very pale yellow.

17. For the beadwork, I sprayed small ultramarine and coral red dots (photo 12).

18. I removed all the masking from the tank, and airbrushed freehand flames with yellow, orange, and red. The finished art is shown at the beginning of this chapter, on page 144.

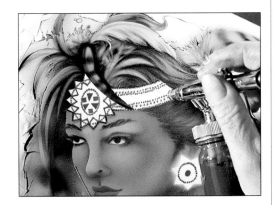

12

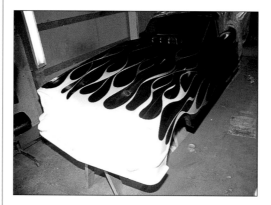

1

2

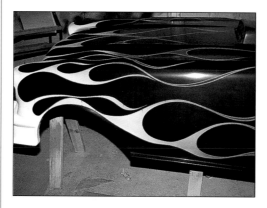

3a

3b

57 Chevy Mini Funny Car

PAMELA SHANTEAU

The owner of this car requested that the car have a black body, with the main design motif being flames on the hood. He also wanted all the chrome, lettering, etc., to be realistically airbrushed. The fiberglass race car body was painted with black lacquer paint and wet-sanded with 600-grit wet sandpaper to prepare it for the airbrushing. The airbrushing was done with the same brand lacquer paint used for the base color. Between each color application the airgun was flushed with paint thinner.

1. I laid the flame design out with blue fine-line masking tape, and used masking paper to cover the larger areas between the flames (photo 1).

2. After all the masking was in place, I sprayed a white basecoat over the entire taped-out flame design with an airgun (photo 2). Once the white basecoat was dry, I flushed the gun with paint thinner and mixed yellow lacquer paint. I sprayed the yellow on darkest at the flame then gradated forward and blended out to nothing in the middle section of the flame area. I next sprayed orange lacquer, going from dark to light starting at the flame tips and ending in the center portion of the flame licks. I applied red paint to the flame ends only, with an airbrush rather than an airgun to keep the paint from building up at the tips.

3. After viewing the flames with the masking removed, I decided that they needed a ¹/₈-inch blue outline to make them "jump off" from the black basecoat. To accomplish this, I laid out ¹/₈-inch blue fine-line masking tape around the exact outline of the flame design and butted up the same tape against both sides of the original outline. Once both sides of the original ¹/₈-inch outline tape were masked, I removed the tape, creating an exact ¹/₈-inch stripe (photo 3a). I remasked the entire flame area to protect it from overspray, leaving only the ¹/₈-inch stripes exposed, then airbrushed blue paint onto the exposed stripe. Photo 3b shows the finished flames, after all masking

has been removed and the area cleaned with a mild wax and grease remover.

4. To render the chrome panel and chrome trim on the side of the car, I masked the entire area and sprayed a white basecoat. When the paint was dry, I laid out $^1/_{16}$-inch green fine-line tape in the exact position of the horizontal strakes. As with the flame outline, I protected both sides of each of the $^1/_{16}$-inch tape strakes with masking and removed the center $^1/_{16}$-inch pieces. Once the strakes were all masked, I airbrushed them with silver and black, to get a beveled effect. I used the same process, but with wider tape, to render the trim surrounding the chrome panel, Photo 4 shows the finished strakes and trim.

5. I masked off the rear of the car to leave only the areas of the bumper and trim exposed, then airbrushed silver, black, and white colors freehand to simulate the chrome effect. Photo 5 shows the rear of the car after the masking was removed.

6. I used the same techniques as in step 5 to render the chrome window trim. Notice how the bit of white paint on the window effectively simulates the reflective properties of glass (photo 6).

7. I masked the fins, cut Mylar masking into the shape of the Bel-Air emblem, and taped the cut-out letters on the fin (photo 7). I sprayed the letters with gold and white paint.

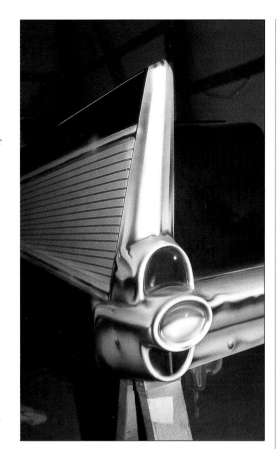

5

6

4

7

8

9

8. The grill area still had its white base-coat (see photo 2). For the grill, I laid out $^1/_8$-inch fine-line masking tape on the white base, then sprayed gold paint over the entire grill area. When the tape was removed, the grill pattern was evident (photo 8). I sprayed black and silver on the grill to simulate chrome.

9. To create the emblem and bumper section, I masked around the areas to be painted (photo 9).

10. Photo 10 shows the finished front end, including the headlights, bumper, grill, chrome trim, and emblem. Photo 11 shows the finished car, including the MINI *Sport* letters, which I cut out of Mylar film and then airbrushed.

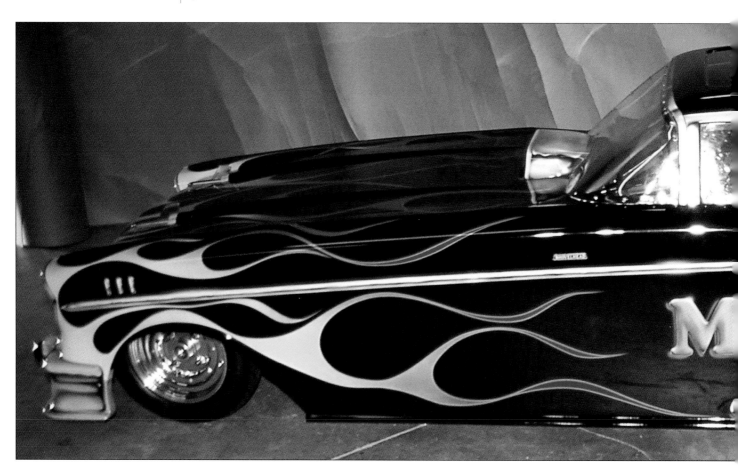

11

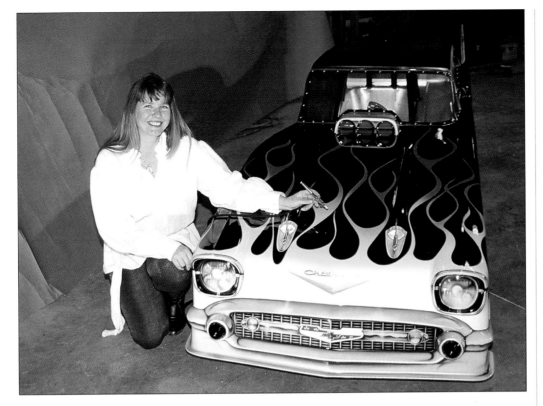

10

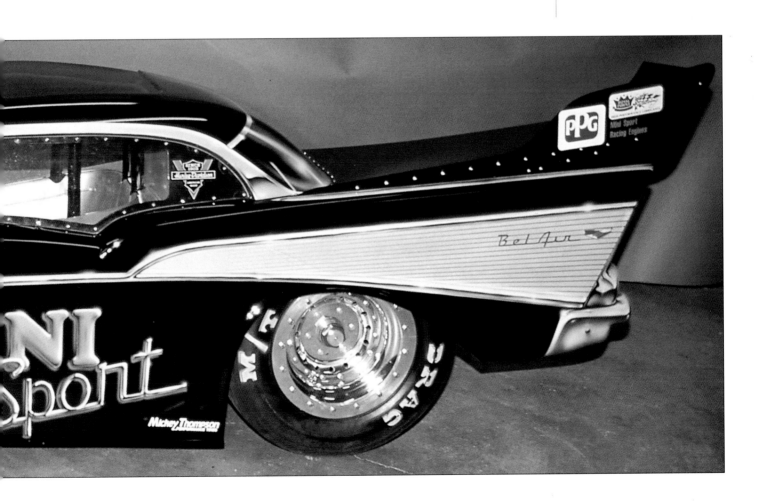

Source Directory

SUPPLIES

The following sources are listed alphabetically. The sources marked with an asterisk generously supplied illustrations of some of their products for use in this book.

Airbrushes, Airguns, and Related Equipment

***Ampersand Art Supply**
1500 East Fourth Street
St. Austin, TX 78702.
www.ampersandart.com
(800) 822-1939
Manufacturers and wholesalers of Claybord and other specialized substrates. For information on retailers that carry their products, visit their Web site or call the 800 number.

***Artist's Merchantile**
40 Louise Street
San Rafael, CA 94901
(415) 460-0922
A full line of Schmenke paints and DaVinci paintbrushes.

Autobody Supply, Inc.
www.autobodysupply.net
(877) 467 0488
A central listing of sources for retail suppliers of products for use in automotive airbrushing applications, including paints, masking materials of all types, safety supplies, welding equipment, and spray booths.

***Createx Color**
14 Airport Park Road
East Granby, CT 06026
www.createxcolors.com
A full line of airbrush supplies, including specialty airbrush paints (e.g., for textile and for automotive applications), airbrush mediums, airbrushes, frisket film, and spray booths.

***Medea/Artool**
79 S.E. Taylor Street
Portland, OR 97214
www.medea-artool.com
(800) 253-7308
A full line of airbrush equipment including Iwata airbrushes and airguns, Shark and Power Jet air compressors, airbrush bottles and siphon-feed bottle caps, Com-Art paints, Jurek textile paints, and temporary tattoo stencils, transfers, and inks.

***One-Shot Paints**
5300 Fifth Avenue
P.O. Box 6369
Gary, IN 46406
www.1shot.com
(219) 949-1684
Sign-painting enamels; topcoats, clearcoats, and gloss coats; oil-based paints; acrylic primers; cleaning solutions, hardeners and reducers.

***Paasche**
7440 W. Lawrence Avenue
Harwood Heights, IL 60706- 3412
www.paascheairbrush.com
(706) 867-9191
Paasche airbrushes and airguns, Paasche air compressors, a full line of accessories, and a list of books and videos for airbrushers.

***Dr. Ph. Martin**
Salis International Inc.
4093 North 28th Way
Hollywood, FL 33020
www.docmartins.com
(954) 921-6971
P.H. Martin airbrush acrylics, watercolors, metal craft paints, inks, and dyes.

The Tool Man
7621 Lake Highland Drive
Ft. Worth TX 76129
(817) 626 3469
www.hobbytools.com
A full line of tools for crafters, hobbyists, and airbrushers, including scissors, clamps, and a variety of cutting tools, as well as a large selection of Badger products, including Totally Tattoo transfers and body art paints.

Body Art
***Temptu Body Art**
26 West 17th Street
New York, NY 10011
(212) 675-4500
www.temptu.com
A complete of paints and accessories for temporary body art tattoos.

Scale Models
International Plastic Modeler's Society/USA
Department H
P.O. Box 2475
Canton, OH 44720-2475
www.ipmsusa.org
The Web site provides links to hundreds of sites of interest to modelers, including sites providing general information and sites specializing in aircraft, armor, cars, sci-fi, and figures.

Miscellaneous Products
Clay shapers. Crafts and hobby shops;
www.hummingline.com;
www.clayartcenter.com.
Cleaning and degreasing products
(PineSol, R&M No. 139 Final Wash, Simple Green, Castrol Super Clean, Castrol Formula 409). Home improvement stores; for Castrol products, automotive supply stores.

Masking materials. www.mmm.com
(3M products).
Parafilm. www.2spi.com.
Sgraffito (cutting) tools. Crafts and hobby shops; www.dickblick.com.
Sign-making systems. Software for converting designs created with Adobe Illustrator, PhotoShop etc., for use on vinyl plotting and cutting machines, Sign Mate Express 6.5 (www.signmaking.com/express.html); letter plotting and cutting, CAMM-1 Roland Vinyl Cutter (www.signmaking.com/cx-24.html).
Wet-dry sandpaper, Home improvement stores; automotive supply stores.

TRADE MAGAZINES
Airbrush Action
(732) 364-2111
www.airbrushaction.com

Airbrush Talk
www.airbrushtalk.com

Arttalk
www.arttalk.com

Modeler's Resource
www.modelersresource.com

Index

Adhesive, spray, 31, 82
Airbrush
 air pressure (psi), 12, 13, 15, 22, 37
 body art, 93
 nail art, 97
 regulator, 12, 13
 air sources, 13
 cleaning, 54–55
 compressors, 12–15, 74
 control of paint volume, 38
 costs, 22
 dual-action, 17–18, 41–44, 97
 external-mix, 16
 gravity-feed, 19, 37, 73
 grip, 36
 holder, 19
 horsepower, 12, 22
 internal-mix, 16
 lubricants, 55
 mediums. *See* Mediums
 needle, 12, 16
 cleaning, 54, 55
 nozzle, 12, 16
 cleaning, 54, 55
 orifice, 12, 16
 paint flow control, 17, 18, 39
 paints. *See* Paints
 reassembling, after cleaning, 55
 side-feed, 18, 37, 73
 single-action, 17, 38–40
 siphon-feed, 18, 37, 73
 storage tank, 12, 14, 22, 25
 studio setups. *See* Studio setups
 systems, choosing, 22–23
 techniques, basic, 38–44
 See also Dots, Lines, Dagger strokes, Gradations
 trigger action, 17, 38, 41
Airgun, 20–21
 cleaning, 56
 high-volume, low-pressure (HVLP), 20
 operation of, 56
Air line, 15, 36
 quick-disconnect fitting, 15, 36
Air pressure, 12, 13, 15, 22, 37
 regulator, 13
 setting, 37
 welding-style regulator, 15
Air source, 13–15, 36

Anderson, Robert, 142
Atomization, 12, 20
 See also Spray pattern
Automatic shut-off, 13
Automotive airbrushing, 145–155
 applying paints, 148
 clearcoats, 146
 masking techniques, 148, 152–155
 paints, 147
 surface preparation, 146

Backing, for textile applications, 66
Barbell shapes, 39
Basecoats
 nail art, 98
 scale models, 111, 112
Body art, 92–96
 airbrush choices, 93
 freehand, 96
 paints, 93–94
 stencil-style tattoos, 93–94
 supplies, 93
 temporary tattoos, 92
 transfer-style tattoos, 95
Bonding agent, 67
Brown, Lindy, 114
Brushes, 30, 93, 126

Cameras
 digital cameras, 62
 lenses, 61
Canned propellants, 13
Carbon dioxide (CO_2) tanks, 15, 22, 36
Catalyst, 67, 147
Clay shapers, 108
Claybord, 29, 130, 131
Cleaning the airbrush, 54, 55
 between color changes, 50
Clearcoats, 121
 nail art, 103
 scale models, 109
 textiles, 67
CO_2 tanks, 15, 22, 36
Color
 blending, 26, 50–53, 124
 flat and gradated, combined, 126
 theory, applied to airbrushing interiors, 78
Compatibility, of different airbrush products, 106, 109, 111, 147

Composition, 80
Compressors, electric, 13–15
 diaphragm, 14
 for interior applications, 74
 piston-driven, 14–15, 25
 silent, 14–15, 23, 74
Computerized plotting and cutting systems, 69, 86
Consistency, paint, 107
 See also Paint mixing/thinning
Cook, A. D., 118
 A. D. Cook's chrome blues, 119
Copyright infringement, 60
Cow Parade, 142
Cutting rails, 31
Cutting tools, 31

Dagger strokes, 42–43
Decals, on scale models, 109
Digital photographs, for reference, 62
Dimples, 146
Dots
 dual-action, 41
 single-action, 39
Downdraft paint booth, 24, 25
Drawing aids, 31
Dual-action airbrushes, 17–18, 41–44
 for nail art, 97

Easels, 30
Eraser
 battery-operated, 132, 133
 for highlights, 139
Exhaust fans, 24, 25

Fair use, 60
Fine-line tape, 33,
 in automotive airbrushing, 148 152, 153, 154
 masking techniques, general, 121
Finishes
 acrylic, 121
 automotive applications, 146
 lacquer, 140
 nail art, 98–99
 for retouching, 140
 scale models, 109
 textile, 67
Fisheye effect, 146

Freehand airbrushing, body art, 96

Frisk Canvas Mask, 124

Frisket film, 32, 76

Giclée printing, 142

Gloss coats
 scale models, 109
 textiles, 67

Gradations
 dual-action, 43–44
 masks and, 44
 single-action, 40

Graphite transfer technique, 46

Grid transfer technique, 63

Grip, of airbrush, 36

Grossman, Tom, 112

Hand-held shields, 33
 Artool, 88, 89
 improvised, 47
 for miniature portraits, 125
 for nail art, 100, 101

Heat-setting, textiles, 68, 69

High-volume, low-pressure (HVLP) airgun, 20

Hoeger, Sheri, 76, 81

Interiors, 72–85
 airbrush choices, 73
 color tips, 78
 composition
 ladders, 72
 scaffolds, 72
 surface preparation, 72

Leather, airbrushing, 68

Le Grice, Lyn, 75

Light source, 51

Lines
 dual-action, 42
 single-action, 39

Liquid masking, 124

Lubricants, 55

Lybecker, Kirk, 122

Mahl stick, 120

Markers, 30

Masking supplies, 31–33
 adhesive, spray, 31, 82
 automotive applications, 148
 cutting rails, 31
 cutting tools, 31
 Frisk Canvas Mask, 124
 frisket film, 32, 76

hand-held shields. *See* hand-held shields
 liquid, 124
 Mylar (drafting film), 32, 76, 82, 148
 painter's tape, 121
 Parafilm, 107, 108
 plastic sheeting, 33
 Post-Its, 112
 tape, 32–33
 See also Fine-line tape

Masking tape, 32–33

Masking techniques, 45–49, 107–108, 121, 139
 automotive applications, 148, 152–155
 cutting stencils and masks, 76
 interiors (in airbrushing), 81
 nail art, 99, 100, 101
 for soft edges, 120

Mechs, 111

Mediums, 67

Mehndi, 92

Mistretta, Andrea, 126

Mixed media, 134–138

Models (see Scale models)

Moisture trap, 13

Morgan-Glass, Laura, 99, 102

Murals, interior, 72–82

Mylar (drafting film), 32, 76, 82, 148

Nail art, 97–103
 basecoats and finishes, 98–99
 choosing a system, 97
 cleaning overspray, 98
 paint, 97
 professional tips, 102–103

Oil filter, 13

Oils, airbrushing, 134–135

Orange peel effect, 146

Overheating, 13, 24

Overspray, 24, 37, 38, 49
 avoiding paint buildup, 50–51

Painting surfaces, 29
 for airbrushed watercolors, 122
 canvas, 29, 118
 Claybord, 29, 130, 131
 illustration board, 29
 interiors, 72
 paper, 31

scratchboard, 29
 textiles, 66

Painter's tape, 121

Paint mixing/thinning,
 acrylics, 27–28
 in automotive applications, 147
 consistency, getting it right, 107
 gouache, 27
 oils, 28
 sign paints, 29
 textile paints, 66
 watercolors, 26

Paints, 26–29
 acrylics, 27–28, 134–135
 automotive, 147–148
 body art, 92–93
 chameleon, 66
 consistency, 26, 27, 28, 29
 dyes, 26
 fluorescent, 66
 gouache, 26
 inks, 26
 iridescent, 66
 nail art, 97
 oil, 28, 134–135
 opaque, 50, 66
 pearl, 66
 for scale models, 106–107
 sign, 28–29, 86
 storing, 106
 tempera, 26
 transparent, 50, 66
 watercolors, 26

Paper, for shields, 30–31

Parafilm, 107, 108

Pencils, 30, 149
 wax colored, 140

Photographs, for reference, 61–62

Preparation, 36–37

Pulp Western series, Robert Anderson, 142

Reassembling airbrush after cleaning, 55

Reducers, 28

References, 60–61, 118
 photographs, 61–62

Reflective effects, 118–121

Respiratory masks, 38

Rule of Introduction, 106, 109, 111, 147

Rush, Mark, 68

Safety precautions, 38, 111
Sandpaper, wet-dry, 146
Scaffolds, 72
Scale models, 106–113
 accessories, 110
 decals, 109
 figures, 113
 garage kits, 106
 mainstream kits, 106
 masking materials, 107–109
 mechs, 111
 paints, 106, 107
 sealers and finishes, 109
 skin tones, 113
 vehicles and military hard-
 ware, 110–112
 weathering, 110–111
Scratchboard, 29, 130
Scratching (sgraffito) tools, 131,
 132
Sealers and primers, 109, 114
Serigraph effects, 126
Setting powder, in body art, 93
Setting up to paint, 36–37
Sgraffito (scratching) tools, 131,
 132
Shadows, airbrushing, 81, 84, 115
Shanteau, Donn, 62
Shanteau, Pamela, 149, 152
Signs, 86–89
Silent compressors, 14–15, 23, 74,
 103
Skin tones, 138
 scale models, 113
Spray booth, 24
 downdraft booths, 24, 25

Spray pattern, 37
 single-action airbrush, 97
 volume control, 37, 38
 wide, 122, 123
Special effects, and lettering,
 86–89
Starting over, models, 111
Stencil Artisan's League, Inc.
 (SALI), 75
Stencil brushes, 110
Stencil burners, 31, 76, 149
Stencils:
 Artool (hand-held), 88, 89
 for body art, 93–94
 bridgeless, 75
 commercial, 74–75
 contouring, 75, 82
 cutting stencils, 76
 for nail art, 99, 100, 101
 original, 75
 theorem, 74, 75
Steel wool, use for texture, 133
Studio setups, 23–25
 large, 24
 medium size, 24
 portable, 23
 small, 23
Substrate. See Painting surfaces
Surface preparation
 automotive surfaces, 146
 interiors, 72
 woodcraft, 114

Temporary tattoos. See Body art
Textiles, airbrushing, 66–69
 heat-setting, 68

textile airbrush mediums, 67
textile airbrush paints, 66
Topcoats, nail art, 98
Transfer tattoos, 95
Transfer tape, 86, 87, 140
Transfer techniques:
 graphing (grid), 63
 graphite transfer, 46, 50, 76
 photocopiers, 63
 projection, 63, 136
Trigger action and control
 single-action airbrush, 17, 39,
 40
 dual-action airbrush, 18, 38,
 41–44
Trompe l'oeil, 81–86
Troubleshooting, 57

Varnish coats, 98
Viscosity, 12, 26, 27
Volume control, paint, 38

Watercolors, airbrushing, 122–125
 new pigments, 125
 transparency effects, 123
Wax colored pencils, 140
Weathering effects
 scale models, 110–111
 trompe l'oeil, 84
Weeding, in sign lettering, 86–87,
 88, 89
Wet-dry sandpaper, 146
Woodcraft, airbrush techniques,
 114–115